P9-BBV-884

The Art People Love

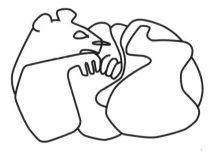

THE ART PEOPLE LOVE

Stories of Richard S. Beyer's Life and His Sculpture

Margaret W. Beyer Foreword by Fred Bassetti

WSU
PRESS

Washington State University Press
Pullman, Washington

Washington State University Press
PO Box 645910
Pullman, WA 99164-5910
phone: 800-354-7360
fax: 509-335-8568
e-mail: wsupress@wsu.edu
web site: www.publications.wsu.edu/wsupress

©1999 by the Board of Regents of Washington State University
All rights reserved
First printing 1999

The WSU Press gratefully acknowledges the support from Bill Layman and the Board of the Glorieta School, Inc.

Printed and bound in the United States of America on pH neutral, acid-free paper. Reproduction or transmission of material contained in this publication in excess of that permitted by copyright law is prohibited without permission in writing from the publisher.

Library of Congress Cataloging-in-Publication Data

Beyer, Margaret W.
 The art people love : stories of Richard S. Beyer's life and his sculpture / Margaret W. Beyer ; foreword by Fred Bassetti.
 p. cm.
 Includes index.
 ISBN 0-87422-183-8 (alk. paper) — ISBN 0-87422-184-6 (pbk. : alk. paper)
 1. Beyer, Richard S., 1925- 2. Sculptors—United States—Biography.
 3. Public sculpture—Northwest, Pacific. I. Title.

NB237.B458 B49 1999
730'.92—dc21
[B]
 99-052062

Cover: ©Photo by Trisha Hines, 1979

Contents

Acknowledgments

The writing of a mere "thank-you" does not adequately cover the gamut of good feelings I hold for each of you named below.

My gratitude goes first to Fred Bassetti for his continuing interest in Rich's career.

Next, thanks go to sixteen family friends who in the winter of 1997 gave me the push to write this story, and to Glen Lindeman of WSU Press for advocating it; to Mary Koch for expert help in organization and style; to Mike Rosen for legal expertise; to Lyman Legters for the book's postscript; to Bob and Kathy Nolan for proofreading and computer work; and to Bill Layman and the Board of the Glorieta School for raising the requested title subsidy.

The Glorieta School, Inc., is a nonprofit organization that carries a 501(C)(3) status with the IRS. Glorieta School, Inc., promotes creative and innovative projects for enhancing community life. Its Board chose this project because of Rich Beyer's deep commitment to public art.

I thank all of the contributing photographers who have enhanced the book. Marie Hanak has photographed Rich's sculptures for 31 years. Mary Randlett photographed his work for this and other recent publications. Photos not specifically acknowledged are from my own camera. The *Stations of the Cross* in Roseburg, Oregon, were photographed in 1967 by the Peter Pan Studio, now long out of business.

I thank all of the people listed below who generously contributed to the title subsidy for this book.

Andy and Joyce Andersson
An anonymous donor
John E. Andrist and Mary Koch
Scott and Elizabeth Athair
Bob and Liz Bagshaw
John Barker
Fred and Gwen Bassetti
Hal Beattie
Dick Bell
Patricia Belyea
John Bennett
Don Beyer, Volvo, Inc.
Donald and Nancy Beyer
James Beyer
Morten and Catherine Beyer
Will Beyer
Libby Blackwell
David and Midge Bowman
Carol Campbell
Jim Valentine Campbell
Clifford Carpenter
Curtis Chapel, Resistance Electric
"In loving memory of Curtis A. Chapel"
A. Clare Chesledon
Cecilia Corr
John Corr
Frances H. Costikyan
Gabrielle Coulon
Bruce Crowley and Brenda Matter
Lee Crowthers
Jorge and Fire Cruxent
Tom and Rosemary Darley

John Day and Nikki Parfitt
Cynthia Dilling
Dick and Peggy Dion
James W. Donaldson
Paul Dorpat
Sandra Driscoll
Peggy Enderlein
Tom and Priscilla Enright
J.T. Enterprise
Charles Evans
Jean Burch Falls
Jenny Favell
Muriel Ferris
Dick and Marilyn Fike
John Franco
Bill (Jr.) and Marilyn Fravel
Donald and Ann Frothingham
Arthur Gardiner
John and Joan Gardiner
Letitia Gardner
Craig M. Garver and Barbara R. Hume
Solveig Geibel
Mary Gibson and Barry Hatten
Peter and Georgia Goldmark
John Grant
Jerry and Iris Graville
Richard and Sandi Griffiths
Sally Gulacsik
Richard Haag and Cheryl Trivison
Betty Hagenbuch
Frank and Louise Haiman
Ethel Hansen
Louise G. Harper

John and Lee Hart
B.J. Hastings
Bob and Jane Hensel
Larry Hibbard and Mary Murphy
John Huston
Claudia Hutchison
Industrial Electric
Harvey Jackins
Kurt and Lois Jacobsen
Jeff and Hazel Johnson
Lynn B. Johnson
Grant Jones
Don and Sally Jordan
Joe and Hilda Kahle
Art and Effie Kimball
Mark and Joan Klyn
Jack Kniskern
Shirley Kueter
Larry Lacock
Dominick and Catherine
 Ladolcetta
Wayland Lambert
Lyman H. Legters
Jim and Colleen Lourie
Steve Love and Rosie Sirek
Shirley Lowe
Chuck Ludwig
Will Lund
Henry and Jean Maier
Kenneth A. MacDonald
Kevin and Kate McCarthy
Ron McGaughey and Jill Risley
Duncan Y. McKiernan
Scott and Maggie McManus
Florence McMullin
Shirley McRae
Jeanne McTavish and Paul Farrar
Ward and Alice Miles
Jim and Fran Miller
Art and Lynn Mink
Brian and Joyce Morgan
Bruce Morrison
Naomi Mullin
Frank and Beryl Nolan
Fred Noland and Susan Rushton
Carol Nygren and Associates
Earl and Nancy Odion
Frank and Helen Ossiander
David and Barbara Parker
Linda Evans Parlette

Julie A. Prather
Kathleen Pryor
D.P. Richardson
Anne Dunbar Richman
Junius Rochester
Betsy Roeth
Tom and Barbara Rona
Michael and Annie Rosen
Joan A. Rudd
D.M. Sakrison
Dee Saunders
Richard and Sandi Schmidt
Robert and Dorothy Scholz
Quentin and Barbara Searles
Peter and Ellen Seibert
Marvin and Charlotte Shapiro
Kathryn Sharpe
Robert and Mary Anne Sitts
Jim and Sonja Staley
Doug and Lynette Strandness
Mary D. Strandness
Donal Sullivan
John and Nina Sullivan
Chris Taran
Ray and Betty Lee Taylor
David and Barbara Thomas
Michael and Spring Thomas
Robert B. Thompson
Jamie and Georgia Tongle
Mike and Kerry Travers
Hazel Tulecke
Gordon and Catharine
 Wagenet
John and Yvonne Wagenet
Donald and Gloria Wampler
Steve Ward and Casey Grant
Ralph and Virginia
 Wedgwood
Thelma Weeks
Phil and Jean Weinheimer
Jack and Shirley Weyandt
Sidney White and Pat
 Matheny
Rita Wieland
Margaret Wild
Keith Williams
Nan Wooldridge
Richard and Cheryl Wrangle
Frances J. Youatt
Barbara Zepeda

In addition to acknowledging the much welcomed contributions from the persons listed above, it is important to realize that Rich could not have completed his body of work without assistants. Rich's payrolled assistants are listed below. I especially want to thank Charles Beyer, Steve Love, and Don Carver for their perseverance, endurance, and skill. Rich's assistants ranged in number from one or two at a time, up to seven for the Columbus, Georgia, commission. Also, the efforts provided by volunteers and workers on a one- or two-day basis, particularly regarding the Tashkent sculpture, were greatly appreciated.

Jim Acord
Frank Almquist
Peter Bevis
Charles Beyer
Stan Burris
Don Carver
Peter Chesledon
Bruce Crowley
Megan Decker
Stuart Decker
Peter Donohue
Margaret Quinn Grant
Gary Headlee

John Hoge
Nawoki Ishino
David Jones
Steve Love
Rick Lucas
Ron McGaughey
Jim Miller
John Moilanen
Theo Ramey
Karl Rekovics
Mark Revis
John Wagenet

Dedication

To our grandchildren, Ian, Dane, Corinna, Dustin, Daniel, Jay, Kristofer.

Foreword

Richard Beyer is not just a fine sculptor, he is also an interpreter, ironist, fabulist, and philosopher who helps us understand the human condition. He takes account of guile and corruption in high places, where honor should prevail, but also notes integrity in low estate, where acts of honor are the norm in daily life.

What Beyer creates is universal. He speaks to all ages and levels of artistic appreciation except, perhaps, to those whose artistic knowledge comes from the monthly art press. A broad public appreciates his work, as do architects, who often enhance their buildings with it.

Rich's drawings and finished sculpture reveal an almost unique coupling of high artistic merit with penetrating, good-humored commentary on our fumbling attempts to cope. He illuminates, for all to see, facets of our being that we ourselves are often not aware of. He makes us laugh that we may not cry.

Of the many Beyer commissions I have seen, no single piece seems done solely for art's own sake. There is usually a message, but, unlike mere "story" art, inherent in this work are the qualities found in art that endures— relevance to time and place, appropriateness of content, freshness, and clarity of form.

Art and architecture critic Rae Tufts wrote about Beyer's work this way: "Rich Beyer's *Waiting for the Interurban* is probably Seattle's best-known public art work of figurative realism, although its realism is more intuited than actual (in fact, how many [oversized] people or dogs with curiously human faces are there?). It is also unquestionably, the most popular piece of public art in town. And for many good reasons, not the least of which is that the exceptional commingling of site and subject—content and context makes wonderful sense. The site has a valid historical relationship to the sculpture: this is where the interurban ran and these are the working class people who lived around the corner. The sculpture provides a cultural continuity both with the technology of the past and the socio-economic structure of the neighborhood. Further, Beyer's people convey with quiet dignity the resignation and the patterned inevitability of daily acts; and we understand, because we've all, at sometime or other, patiently waited for an interurban."

Rich's carvings, especially in materials such as wood or unfired brick, which accept decisive quick strokes, are bold and confident, but never *pretty*.

They remind me of the fine old statement: "I like a woman who is unafraid, a bit irreverent, audacious—it overcomes a crooked nose, and she is beautiful."

Richard Beyer is the Aesop of our time. No other artist that I know of has been more incisive in cutting to the quick, and illuminating the slant truths that hide from the rest of us.

Fred Bassetti, architect, AIA
1999

Introduction

Richard Beyer believes the public has good taste. This conviction sets Rich apart from the academic art schools and international fashion in the art world.

Form in art appeals to order and balance in the mind. *Content* appeals to the heart.

Rich quips: "Call community art, 'Art of the Heart.'"

He adds: "Much of the art today holds formality as its principal value." Rich's values, on the other hand, are in the stories and human situations we experience.

He gathers ideas for sculptures from many sources—personal feelings, from historical fact or legend, from poetry, folklore, myths, the Bible, and current events. Underlying all that he does are the dicta: Speak Truth to Power, and Question Authority, a slogan originating in the 1960s.

Rich makes sculptures for communities across the United States. Each is accepted affectionately by the community where it is located, just as the well-known *People Waiting for the Interurban* is loved in Seattle, Washington. Rich makes sculptures for neighborhoods—for the man and woman in the street—because he respects them. It is his acceptance of the public that brings him success in the art market.

As of late 1999, Rich has placed 76 large-scale public sculptures in communities in Washington, Oregon, Alaska, Georgia, California, Colorado, Minnesota, and Virginia, and in Tashkent, Uzbekistan. None of these sculptures are duplicated, nor are they even similar. Rich openly discussed each and every project with a community or corporate sponsor.

When Rich entered his career, several Seattle and Portland architects discovered his abilities and encouraged him. We are thankful and indebted to these friends.

Gradually in the 1970s, government art commissions began to intervene in the selection of artworks for placement in public areas. No longer could architects, builders, business owners, and communities deal directly with an artist as they were accustomed to doing. In Seattle, the Arts Commission claims jurisdiction over the selection of public art (except in the King County and Seattle library systems). The situation is similar in Tacoma, where the Tacoma Library still makes its own decisions concerning art acquisitions.

This intervention was meant to be an egalitarian change—to bring more artists into the market, and at the same time to provide standards for public art pieces and to protect the expenditure of public money. Well-meaning as this all might have been, the old system of architects having "stables" of artists came to an end. The old system could not function unless an artist's work could be sneaked into a project under "plumbing" budgets, or some other unlikely expense voucher. Architects designing public projects now were required to go through art commissions for art acquisitions.

"Protecting the public" assumes a premise that the public has bad taste.

Rich has been identifying the flaws in the arts commission system and presenting possible solutions. His wish is to make the art market more balanced—between the supply of visual art objects, and an awareness of their special value to us, which is market driven. In recent years, the supply of available art works has increased enormously, although an understanding of how these creations affect our lives in a positive way has increased only minimally. Professional artists provide a service. Their art can enrich our imaginations and souls in an enduring way. In rural communities, the demand for this service could be encouraged and fulfilled by local regional artists. In urban areas, neighborhoods should have final authority in selections.

Some of Rich's arguments regarding the present art market and the intervention by arts professionals are included in the text of this book as his story unfolds. Rich's arguments present an insider's point of view. Our colleague, Lyman Legters, has objectively summarized many thoughtful conversations with Rich on the subject of arts and public policy. His recent letter to Rich, included as a Postcript in this book, gives credibility to their shared values on this subject.

Thanks go to my family and all those friends who have helped us over the years in their own ways. They have made this book possible. As Rich's wife, I have walked beside him, lain beside him, fought him, and loved him for more than 51 years. Now it feels right to share the personal stories, and the stories of the sculptures, with a wider circle of friends.

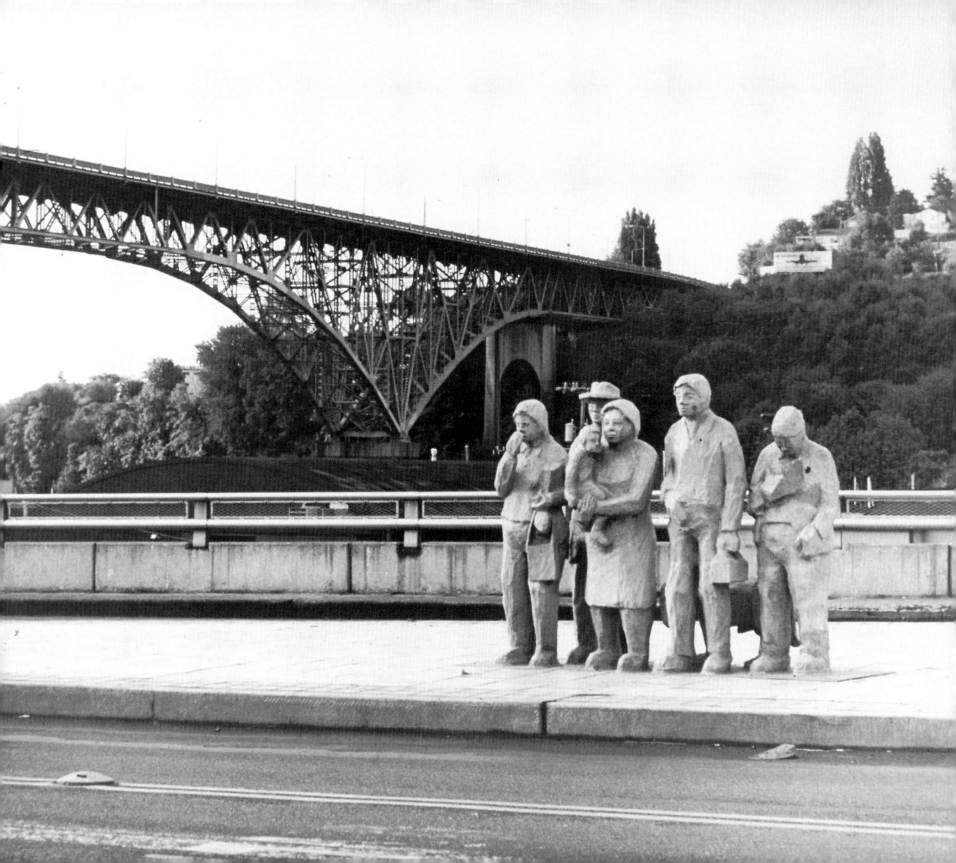

Part One / People Waiting for the Interurban

No one knows their names. They don't seem to have a lot of money. Where they work, what they believe in, how they vote—it's all a mystery.

These five anonymous adults, one small child and a dog—a dog with a human head!—compose a sculpture group by Richard S. Beyer titled *People Waiting for the Interurban*.

They're a patient group. Stolid. Faithful. For over two decades they've stood their ground at a congested intersection by the Fremont Bridge—one of the busiest drawbridges in the United States. For more than two decades they've been waiting, oblivious to the noise of traffic, the vibrations of trucks, the fumes of busses, the screech of brakes, the bleating horns, the occasional intrepid bicycle rider or pedestrian.

These figures are cast in aluminum and stand under a Victorian style pergola. They wait for a long-defunct trolley which is not likely to arrive. They stand, seemingly lost in their own world even as they enter the personal worlds of those who pass by, giving a precious gift to those who wish to receive.

"They make me smile." That's the comment we hear most often about *People Waiting for the Interurban*. Those seven, gray silent characters somehow move as if by magic into the hearts of people making a connection, easing tensions, teasing curiosities. Feelings engendered by the statues in the emotions of viewers are real, and that is what makes it Seattle's most beloved sculpture.

The five adults stand in a group. They do not touch or appear to interact. Perceived individually, we see on the left a trousered young woman, with hand to mouth, either eating or coughing. The gesture is a common one, but might not have been used in formal design before. Slightly in back of her is a man in a business suit, wearing a hat, and perhaps in a better financial situation than the other four. He does not push ahead to be first on the Interurban trolley. In front of the downtown man, and to the left of the young woman is a stocky middle-aged woman holding a child of three or four years. To me she is the most stoic of the five. She must hold the child who otherwise might be

■ *People Waiting for the Interurban* shortly after completion in May 1978, with the Aurora Avenue Bridge in the background.
Marie Hanak

■ "Flight of Birds."

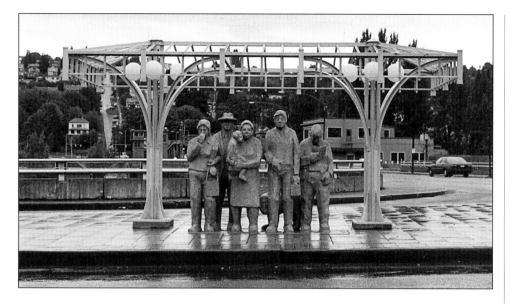

■ *People Waiting for the Interurban* in Seattle's Fremont district.

© *Photo by Mary Randlett*

endangered if left standing beside her when the electric trolley swings in. She does have the preferred place to get on first. She has undertaken a grandmother's responsibility.

A sturdy laborer stands to her left, and will politely let her step onto the trolley first. He carries his lunch pail, and we can assume the five o'clock whistle blew just a bit ago. Beside him is a shorter man somewhat older; his shape defines his fondness for beer and good food. He is reading a small book, deeply concentrating, with legs slightly apart to brace against the surprise of the arrival of the trolley.

Strangely a dog is with this group. And even more curiously it has a human face. It peers between the legs of the laborer and woman. The dog does not seem to belong to any of the characters.

Looking at each figure I find resemblances to Richard Beyer, be it in posture, hands, head or face—except of course the dog's face. (More on this creature as we move on.) This resemblance is found in some of

his other sculptures. He doesn't do it on purpose. It just happens.

Since its installation in May 1978 the cast aluminum group has been talked to, written about in poetry, drama and prose, photographed for personal occasions, used for advertisements, and daily dressed and decorated to reflect news events and all kinds of anniversaries. This is not vandalism of a destructive sort, but rather "creative vandalism," Rich says. He had no idea that the sculptures would become a stage for the ingenuity and creativity of so many people.

Many tell us that they take the Fremont route going to work in the morning to see "what's with" the Interurban on a regular basis.

People just can't keep their hands off those solid, full-size figures of cast aluminum. They've been protected from Seattle's ubiquitous rain with gaily colored umbrellas; they've been decked out with warm clothes when it snows, Santa Claus outfits at Christmas, party hats for New Year's, American flags for election day and a gamut of political signs and banners.

They're constantly photographed, appearing in tourists' scrapbooks, the pages of local newspapers, tourism publications and even *Playboy* magazine. The February 1985 "Playmate of the Month" posed with the Interurban characters. Thank goodness—for the sake of their 1930s' sensitivities—it wasn't the centerfold picture. The playmate was fully dressed in skin-tight jeans, knee-high boots and a baggy sweater. *People Waiting for the Interurban* brings a degree of commercial success to many people who photograph it for postcards, calendars, posters and advertisements promoting everything from bagels to ski equipment.

Despite the sculpture's phenomenal success it came about almost by accident. Certainly Rich, whose studio

was located in the run-down Fremont area, had not conceived of erecting a statue there. He was struggling to establish himself as a sculptor, having abandoned a career in academia—in economics. Community involvement is in his nature, so he was part of the Fremont Improvement Committee which served as a community sounding board whenever the City of Seattle wanted to make capital improvements in the neighborhood. In 1975 the committee was mulling a proposal from the Seattle Engineering Department to pave the triangle at N. 34th and Fremont with brick. If the community wanted to do something more with the site—perhaps install benches, signs, or art—city engineers were willing to install granite pavers to complement such an effort. Initially, there was no clear idea of what to put in the triangle. Suggestions included resurrecting some of the old equipment from the original Interurban—rumored to be buried under the triangle—which possibly was accessible from down the hill on the canal side. Rich investigated the site, but didn't find anything.

During a Fremont Improvement Committee meeting, Rich proposed a Fremont artists' contest. Artists could make suggestions for the triangle, be it machinery, sculpture or benches; any improvement which would assure the gift of pavers from the Seattle Engineering Department. The contestants' entries, in keeping with the general flavor of Fremont, would be "judged" in one of the bars and a $50 prize would be given. The idea was duly advertised in the neighborhood newspaper, but no one entered.

The aforementioned engineers, eager to get on with their project, pressed the community to come up with a proposal for the triangle or forget the offer. Feeling that something had to be done, Rich made a model of a ship rising out of the water. He called it a "ship of fools," with a rooster perched on the crow's nest and

passengers hugging each other, jumping over the side, or reacting with indifference. He also proposed a cougar, which would cost only $500 to $1,500 and could be made from melted-down beer cans collected at a local recycling station. He had reservations about the cougar. It seemed to have little meaning in relationship to the community itself.

Then the idea of the Interurban came to him. It would be more expensive, yet when models were presented at a meeting, there was no clear mandate. As the meeting broke up, a committee member offhandedly congratulated Rich on the Interurban. That settled it. Rich knew he wanted to build that sculpture and not the "ship of fools" nor the cougar. There was no $50 award, nor did they meet in a bar. The next day Rich

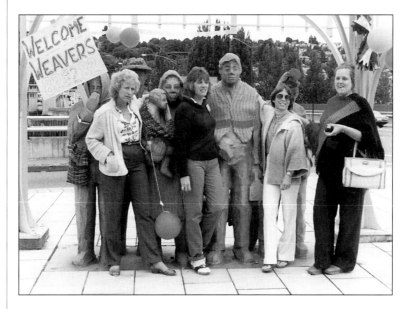

■ Handweavers from Bend, Oregon, attending a 1982 national conference in Seattle. They "spent the night spinning & weaving a shawl, purse, vest, hat, tie, hatband, & dog leash" for the statues. Left to right: Sally Foster, Dee Ford Potter, Carol Routh, and Barb Russell.

went to Fremont businessmen, individually, to ask for funds for the sculpture. His determination was compelling, and after he had pledges of $500 he went to work. He did not know then all the steps necessary to make the sculpture, but he always says "he who says A must say B." Over a year's period, construction and financial problems were all solved. And, the Seattle Engineering Department did pave the triangle.

People Waiting for the Interurban would not have been possible, Rich believes, without the friendship and council of Peter Larsen. At the time, Larsen was a young man trained as a landscape architect who focused on art in architecture; he also was a skilled carver and professional welder. Larsen was employed by the City of Seattle to lead a community architectural service called Environmental Works, which operated out of a remodeled vintage fire station in the city.

Pete Larson became interested in the Fremont community initiatives in which Rich played a role. He and Rich struck a deal: Larsen would help Rich with the politics and fund raising, if Pete could design and place a pergola over the finished sculpture. Pete was Rich's companion, tramping the streets of Fremont asking businesses for the funds to make the sculpture a reality.

When Rich became fully committed to the project, he had to figure out how it would be made. Up to this time, he really had only carved in stone, brick, and wood. His experience in casting had been limited to making small pieces on a jeweler's broken arm casting machine, which Rich and a partner at the shop had acquired for experimentation.

Bob Mortenson, of the Mortenson Foundry in Seattle, provided the know-how in casting aluminum.

Rich, along with another individual developing a casting program at the University of Washington, received invaluable information. Mortenson advised Rich on how to cut the life-sized model of wood into moulds for the casting parts. An assistant, Bruce Crowley, made the moulds, and finished and welded the cast pieces. Raising money for each casting was an ever present task for Rich and Pete because the foundry could not proceed until paid! When the figures were completed, they were hauled to Larry Lacock's South Center welding shop for assembly to the base plate.

For the first year after its installation, the sculpture's figures stood unframed in the roadway triangle. The environment was open and large—the figures appeared to be lonely and rootless. This changed with the addition of the iron pergola designed and fabricated by Pete Larson at his friend Larry Lacock's South Park welding shop. The pergola changed the feeling at the site, providing a visually protective and accommodating structure over the figures.

The sculpture is rooted in the history of the community. Fremont lands were homesteaded about 1875. It was originally a pioneer community on the shores of Lake Union, surrounded by virgin forest. There was no canal to Puget Sound at that time. By the 1930s it was a working class town of plain wooden buildings, sawmills and small factories. The corner of 34th and Fremont was a station for the electric trolley system, the Interurban, that linked Fremont with Tukwila beyond the south end of Seattle and Everett far to the north. Workers going in either direction rode the Interurban.

By the 1960s the Interurban was long abandoned. It fell victim to the automobile which became the preferred form of transportation. The Aurora Bridge was built by the 1950s further cutting off the community.

Where there had been a hotel, a drugstore, a post of-

fice, there were now bars, second-hand stores, and social service agencies. The Fremont Public Association was formed in the early 1970s, taking the place of the Improvement Committee to tackle all of the ugly problems of life in the stagnated area. The FPA worked with the federal Model Cities Program, and it was under the FPA's wing that the Fremont Arts Council was formed to give the community an identity.

A brochure—with a vintage photo of an old trolley car and a picture of Rich's model—promoted the sculpture as a way for Fremont to reestablish its vitality. The brochure description included these words: "In the quietly humorous style of the figures, in the use of ghostly aluminum to accord with an environment of concrete and aluminum the Art Board hopes to express the feeling Fremont residents have for their historic past and present condition, and to point to the neighborhood's patient expectations for a renewal of community values."

The sculpture has, in fact, been credited with sparking the beginning of a resurgence of Fremont from a blighted eyesore of a neighborhood to a thriving, bustling community, rich in commerce and the arts.

When news of the proposed *People Waiting for the Interurban* hit the press, we found the papers interested in any controversy about it that they could unearth.

"I think it is ugly as sin," one business owner told *Seattle Times* columnist John Hinterberger, who wrote about the proposal: "If nothing else is available, I'd rather see a welcome-to-Fremont sign and a bunch of flowers." An anonymous letter published in the *Ballard Outlook*, a community newspaper, complained that the characters looked like apes. (Rich, years later, made a small sculpture, *Monkeys Waiting for the Interurban.*)

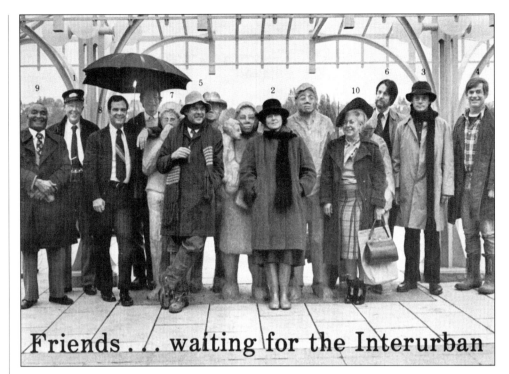

Friends . . . waiting for the Interurban

The idea of public art was relatively new for the raucous Fremont neighborhood with its biker hangouts and taverns. "Fremont, in the living memories of its present social set," wrote John Hinterberger, "has not had much respectable public art. Indeed, until recently, it has not had much respectable public."

Richard K. Untermann, acting chairman of the Department of Landscape Architecture at the University of Washington, wrote a letter to the Seattle Arts Commission in support of the proposed sculpture. "It will undoubtedly be the most popular sculpture in Seattle," he predicted.

The Seattle Arts Commission, however, was taken aback by the Fremont initiative—in their august councils, they had to discuss art that they weren't sure was "Art." The chairman of the Fremont Arts Council said

◼ Cover of invitation announcing the public benefit in recognition of Rich Beyer and the Interurban sculpture, December 4, 1979—
1. George E. Benson–Seattle City Council
2. Karen Gates–Seattle Arts Commission
3. Michael Hildt–Seattle City Council
4. Tim Hill–Seattle City Council
5. Paul Kraabel–Seattle City Council
6. Peter LeSourd–Seattle Arts Commission
7. John Miller–Seattle City Council
8. Randy Revelle–Seattle City Council
9. Sam Smith–Seattle City Council
10. Jeanette Williams–Seattle City Council

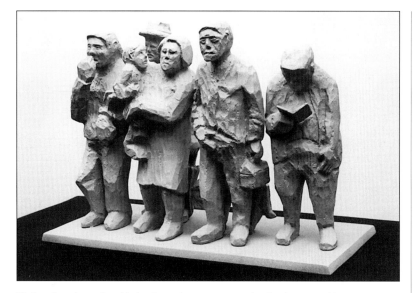

■ Small-scale replica. Limited numbers were cast in aluminum, and in 1992-93 three were done in bronze. All are in private collections.

■ *Monkeys Waiting for the Interurban.* Not reproduced.

munity, thus the Seattle Arts Commission understandably was not in a position to contribute to a piece it was to receive as a gift.

The Seattle Arts Commission, however, sponsored jobs for artists through the federal Comprehensive Employment and Training Act (CETA). Bruce Crowley was awarded one of the positions to work in Rich's studio and in the commercial foundry as an assistant on the project. He was paid about $9,000 as a CETA worker.

During the days when the project was being promoted and funds were collected, we heard comments for and against the human face on the dog. Myths arose—one initiated by a detractor who discouraged donations to the Fremont Arts Council. That person originally had *claimed* for himself the face on the dog, but soon had a change of heart and accused Rich of demeaning him. Characteristically, Rich then as now did little or nothing to dispel such a personal story or get involved in such controversies. Nevertheless, the nay sayer complained to the press, gaining coverage which is now legend. People still persist in learning the "real" story from me. I say you can choose the "credible witness" you prefer. From my perspective, as Rich's wife, I need to say that if there had been a significant objection to the dog with a human face, Rich would have taken the model back to the Fremont Arts Council and considered a change. As it was, folks contributed to the project as it was depicted.

The dog's face had come as an inspiration to Bruce Crowley one day as he was carving. That *flash* received instant approval from the studio group. Rich is magnanimous in letting assistants contribute to projects, so it was not unusual for Bruce to be carving that day.

In Rich's work there always are several threads of meaning coming together. At the same time, each

there was a turf war in progress, while another Fremont supporter challenged the commissioners' ability even to begin to understand community art: "Who's on an arts commission anyway? Except people who have the time and money to be on arts commission."

I thought at the time that this was all pretty messy business. I was working for the prosecutor's office then and believed it was inexpedient to be involved.

Though the Arts Commission ultimately gave the proposal reluctant approval, a week or so before the sculpture was scheduled to be installed, the chairperson, without warning, appeared in Rich's studio to judge whether the piece would do irreparable harm to the good reputation of "public art."

The Seattle Arts Commission couldn't give financial support although the Washington State Arts Commission granted $500. The sculpture was to be donated to the City of Seattle from the Fremont com-

thread suggests another image or story. In this case we see Northwest Native American influence in depicting animals as humans and humans as animals, or parts of one another put together. This leads us to animism and spirits of animals in humans. So, why is the dog waiting for the Interurban?

Rich has always said the dog in the sculpture personifies the person who wants a free ride. What is a free ride? Perhaps it is toadying for service from someone else. Maybe we all do it.

When the sculpture was finally unveiled and dedicated in May 1978, Rich admitted to being "scared."

"I thought, 'I could make an absolute fool of myself,'" he confessed. "It was relatively crude in comparison to the technically refined things you can see . . . That first day, some guys from the tavern came over and were having a wonderful time. They got this big yellow rope and tied it around the neck of the dog, and then to the telephone pole. That was so the dog catcher wouldn't take him away. People have done other neat things. When Mount St. Helens blew up, they put masks on the fellows. Another nice story is the guy from Ballard who got drunk and wanted to fight with the damn sculpture."

That event was reported in the *Ballard Outlook* in its police blotter: "A tipsy gentlemen approaches what appears to him to be four men and a woman carrying a child, standing on the 'triangle' at the southeast corner of N. 34th and Fremont at 1:30 a.m., September 7. He argues with them, though they say nary a word in reply. At 1:37 a.m. someone tells police, 'A man is beating the statues at 34th and Fremont with his fists.' Police arrive and find the 'boxer' out cold on the pavement, his knuckles bleeding. The group of old-time Fremont residents waiting for a street car, cast in aluminum by Rich Beyer, says nothing after being warned, 'You have

the right to remain silent. Anything you say can be used against you in a court of law.'"

The characters also have been subjects of whimsical compassion and concern. A staff member of King County Senior Services and Centers wrote a letter to the editor, published in the *Seattle Times,* soon after the sculpture was unveiled: "My job description requires that I notify the people 'Waiting for the Interurban' in Fremont: sorry, you're waiting at the wrong corner. Stand across the street on Fremont Avenue. The Interurban doesn't turn here, but continues north to 85th and Greenwood."

Interaction with the sculpture was not a passing fad. The decorations and activities it inspired became increasingly sophisticated over the years. One day in 1987, a man dressed in a dull gray suit, wearing gray makeup on all of his exposed flesh and carrying a gray briefcase and gray book, joined the line of figures standing motionless.

"It was hard to tell the real human from the stone figures," wrote *Seattle Times* reporter William Gough. "The scene caused a sensation—and small traffic jams—among passing motorists. Some honked horns, some shouted encouragement, all seemed to approve of the zany addition to the statues."

"I've seen a lot of interesting things, but this tops them all," a driver of a pickup shouted as he drove past the statues.

The human statue described himself as an artist and handed out blank, gray business cards. He told the reporter he intended to stand with his friends, "maybe until the bus comes."

On the first Halloween after installation a mime group in Seattle dressed up as the Interurban figures and stood together on various street corners in Seattle throughout the night.

The sculpture is consistently used for political commentary and demonstrations—even a dialogue. If a political commentary goes up, it may be changed two or three times in a day. One day in 1989, the sculpture had a large banner tied in front of it saying: "Still waiting for Contra aid to end." Within hours the banner was slashed and the words "to end" removed.

The Interurban sculpture was on the front page of the *Seattle Times* in 1985 when the city's teachers went on strike. The laborer with the lunch bucket held a picket sign, and the newspaper's headline writers captioned the photo, "Waiting for the Strike to End?"

A large-scale demonstration in 1989 prompted a fierce argument over whether or not to ban political use of the sculpture. Armed with a permit from the city to hold a public gathering, opponents of a proposed nearby development erected a 30-foot-tall scaffold from which immense view-blocking banners were hung. Fremont Works, which had taken on the responsibility for the statues' upkeep, long had unwritten rules that decorating should be on a personal scale. The informal rules, too, excluded politics, obscenity and business advertising. However, nothing came of the attempt to tighten restrictions. "That's our Hyde Park," a Fremont artist told a newspaper reporter. The demonstration proved successful and the proposed building, to be erected at canal level and which would have risen 30 feet above the sculpture, was rejected. Now, 10 years later, the building has been built.

An editorial in a neighborhood newspaper, the *Fremont Forum*, observed that the "public interacts with the sculpture but the members of the sculpture do not interact with themselves. Each is involved with their own concerns. After all, they are just waiting."

The waiting theme was aptly picked up by the press when, a year after the sculpture was installed, the Seattle City Council was alerted that Rich had not received an artist's fee and also had paid for materials and supplies personally from our own funds. Rich initially had estimated the costs at $10,000, but the final total was $18,000. A friend in Fremont brought the dilemma to the attention of the council. The council struggled with the problem while the *Seattle Times* blared a headline, "Waiting for Payment." This caused righteous indignation in the neighborhood. Members of the City Council solved the shortfall by throwing a star-studded fund-raising party in the unfinished, cavernous interior of Martin Selig's 4th Avenue building. Anyone could attend for $15. Martin Selig himself set off the donations with $2,500. The final tally was over $8,000. Rich was paid $2,643 for reimbursement of bills paid, and $2,500 for an artist's fee. The balance went to the Fremont Arts Council for other projects.

Invitations for this affair pictured the members of the City Council standing in front of the sculpture in 1930s attire. "Buddy, can you spare the time?" asked the invitation. It was a heartwarming validation for Rich.

The flap over finances prompted an outpouring from the general public expressing their love for the sculpture. Rich received many letters of support with checks enclosed. Common themes were regret that the contributions couldn't be larger and expressions of disenchantment with other public sculptures around the city.

"Oh, how I wish I were Mrs. Money Bags, for I would go round and buy up all that awful tortured metal," wrote one woman. "In their places, you could create lovely fantasies. As I've become that stupid word—senior citizen—and a recent operation took some cash, I can only donate two dollars, but I'm so glad others can help you more."

"How hungry we are for art that pleases and with which we can identify," wrote another. "'Waiting for

the Interurban' is not merely superficially amusing. Each of the sculpted figures is caught in a moment of life and one enjoys speculating on their individual stories. Does the beloved house pet, having been humanized by the owners, get to travel human style on the bus? Where is the lady taking her child? Day care? Grandparents? What is the book too fascinating to put down etc., etc. This is a work of which we will never tire."

Several writers confessed to feeling possessive about the Interurban sculpture and were appreciative that they could truly "own" a part of it.

"For your sake, I'm sorry about the payment hassle, but speaking personally, am inspired by the movement of the common citizen in your support and will feel just an extra measure of pleasure when passing Interurban for being able to participate in a small way," wrote a donor.

All of this harmonized perfectly with Rich's own philosophy of public art. In a thank-you letter to donors, he wrote: "I like to think it translates what is in our experience into an image of ourselves which, because it is recognizable and has some pleasant aspects we can share with each other in good fellowship as if we were going to an inexpensive but special restaurant where the cook cared about what was served."

Twenty sculptures later, Rich would tell a newspaper interviewer: "I hope my work represents my formula, 'Speak Truth to Power.'[1] Say what the realities are: the family, the human beings you live with and support, the things that make us laugh, the things we've got to endure. These are the things called community values, around which I build sculptures for community art."

People Waiting for the Interurban was the first of Rich's cast public sculptures.

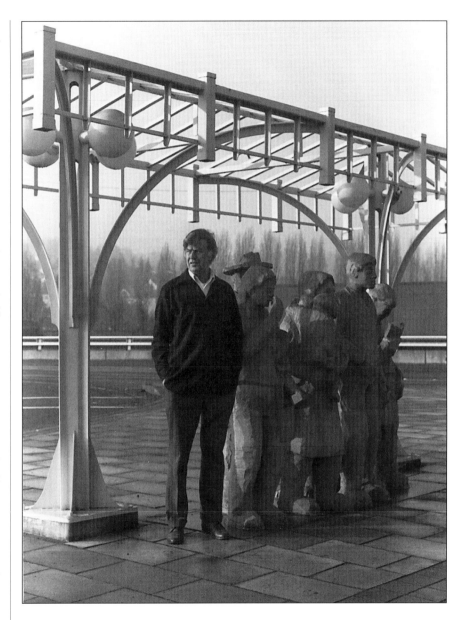

■ Richard S. Beyer standing in line for the trolley.
Marie Hanak

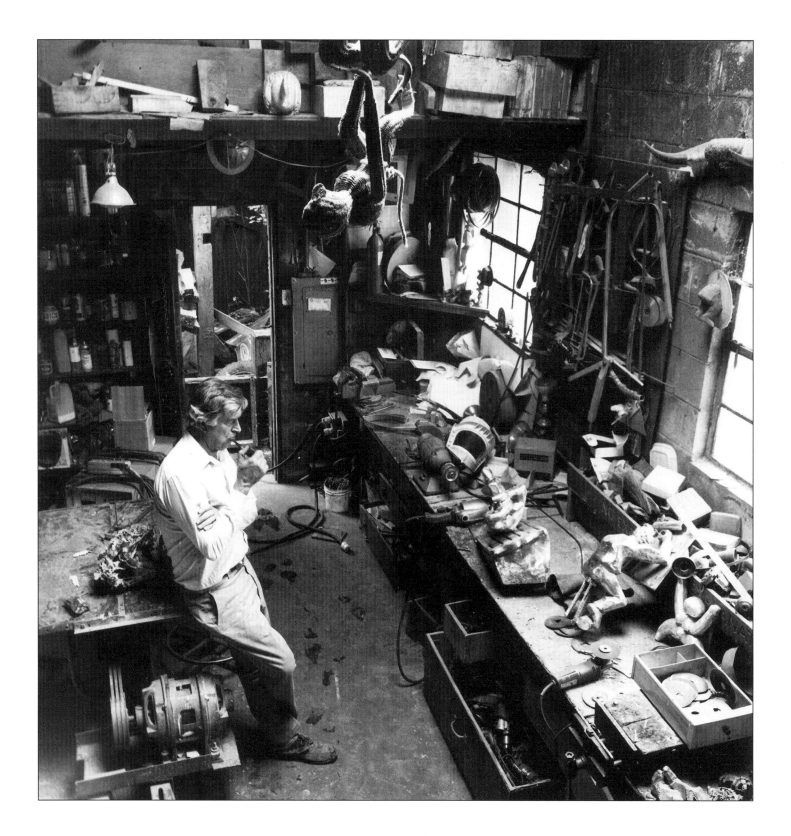

Part Two / From Cradle to Cocktails

Casual conversationalists ask me: "How did you meet Rich?" To which I can honestly reply: "In the cradle."

Rich's mother, Clara Mortenson, and my mother, Betsy Morrison, met as economics students at the University of California at a time when women were rare in that major. They became lifelong friends.

My mother, Betsy, was married to my father, Russell Gordon Wagenet, before both young women went to Washington, D.C. to work at the War Labor Policies Board during the First World War. My father went overseas to France, and mother chose to be on the East Coast to be closer to France!

Rich's mother, Clara, had finished a teaching term at Bryn Mawr College in Pennsylvania and joined Betsy, sharing an apartment in the District of Columbia. Clara and Otto Beyer were married in a Quaker Meeting at Bryn Mawr in 1920. Both young brides had their first sons in 1921—their friendship deepened through mutual respect and affection, and because of the many years of public service which all four spirited young people shared.

Richard Sternoff Beyer was born July 26, 1925. He was the Beyers' third son, but his mother mistook the first sign of labor as a little stomachache from eating a green apple. She was distracted by the assembled friends attending an afternoon party at the family farm in Virginia.

Suddenly she said to her husband: "It's the baby, we've got to go, quick!"

Otto Beyer, always fastidiously dressed, rushed to his room to put on a necktie, in order to be properly dressed to enter the hospital in Washington, D.C. The drive to town was fifteen miles, and a slow drive on the roads of the 1920s. I wouldn't be surprised if Clara Beyer drove herself, although this is omitted from the familiar family story. It seems to me that much of Rich's determination came from his mother's knack of "taking over" in any situation. There is hardly a physical obstacle that Rich cannot move by his own

■ Rich Beyer in the Fremont shop, circa 1975.
Ken Slusher

■ "The Miner Who Lost His Pants." Rich's wood models are on a small scale.

strength, or can figure out how to accomplish with basic engineering skills.

Clara Beyer returned to full-time employment when Rich was three years old. On the farm, he remembers that much of his early upbringing was in the hands of Julia and Henrietta, two intelligent Black women working in the household.

Spring Hill Farm, the Beyers' family home, had a fine antique house with two barns, one in the northern style and the other in the southern style. The house had been occupied by rebels during the Civil War, and the story has it that Colonel John Singleton Mosby (1833-1916), a Confederate partisan leader, rode through the downstairs on horseback. At any rate, Mosby's ghost is still an inhabitant. The house was located in a farm area where old houses and shanties were owned and lived in by Black families. Segregation existed in the 1920s, but the Beyer boys had no knowledge of it when they were small.

As Rich grew up, it was the servant Julia who advised him that he could no longer bring his friends into the house. "Because," she said, "these colored boys have got to know that they can't go into any white man's house."

It was an early lesson in inequity for Rich, and he knew it was contrary to what he was hearing from his parents. It was their ideals that marked Rich for life.

Some of my memories as a child were of visits to the Beyer farm for Sunday dinners. The guests were mostly associated with the Roosevelt administration, and their conversation centered around what part they played in an enlightened government. Young marrieds in the Beyer-Wagenet circle of friends were involved in the great changes which were then occurring in attitudes toward working people. They recognized the hardships that many Americans, both adults and children, suffered and endured in coal mines, the chemical, railroad, and garment industries, and in many other occupations. The growing awareness of problems in the nation's workplace helped give Franklin Roosevelt the presidency in the election of 1932.

It was the Roosevelt administration which inspired creativity, even risk, in the minds of the young and energetic. Clara Beyer worked in the Department of Labor in the Children's Bureau and the Division of Labor Standards. Otto Beyer developed a labor-management cooperative system in the railroad industry. Later, during World War II, he was a member of the National Manpower Commission, representing the government regarding labor problems in transportation, and at the major dams of the Bonneville and Tennessee Valley power administrations.

As the Beyer boys—Morten, Donald, and Richard—grew up, they were sent away to various boarding schools in the East.

Rich attended a Quaker school in Pennsylvania. It had a reputation for being progressive, and it was prescribed as a fit for Rich's intelligence, spirit, and creativity. The masters involved the students in projects of their own selection. The basics—the three R's—were extracted from these tasks. A master asked each student what he would like to make.

Coming to Rich in turn, the master said: "And Richard, what would thee like to make?"

To which Rich replied in a husky teenage voice, "I want to make a still."

The school aimed to please: Rich did his research and made a still. This he packed up carefully and brought home at Christmas vacation. It was a delicate instrument.

His father said: "What have you got there, Richie?"

Rich answered: "I made a still," then proceeded to fire it up and cook alcohol. In a couple of days the brew was ready—no more than a jigger full, I believe. It was poured out ceremoniously with Otto Beyer watching. The liquor smelled all right to Otto, but he declined to sip it. He took the small glass from Rich and threw the brew on the fire, causing an instant, memorable explosion.

"By God, it IS a still!" said Mr. Beyer. Rich moved on to another boarding school.

Rich's several dismissals from schools sometimes were due to disciplinary reasons. The fact was, teachers didn't know how to teach a bright child with a mind skipping through life, not paying attention to class work. A couple of years and a couple of boarding schools later the problem arose: How is he going to get a high school diploma?

His parents decided to try the local public high school in Fairfax, Virginia. The principal, Harold Weiler, happened to be an idealistic young engineering graduate who, by a piece of bad luck, lost his engineering job and quickly turned to the field of education out of expediency.

In a recent letter to Rich, Harold recalls: "Teaching was the one thing I said I would never do because I went through my high school period actually hating ignorant teachers. I was a trouble-maker at school and a hooky player."

He saw quickly that Rich had been educating himself and was well read. He also knew that Rich looked out the window most of the time.

According to Harold: "One afternoon the history teacher, Mr. B., charged into my office shouting, 'You've got to take this Beyer fellow out of my class, he sleeps all day—pays no attention and gives me surly replies.'

"'Calm down, boy, I'll take no one out of your class. What you don't, but should recognize, is that Beyer knows more history than you do. Take your students where they are and lead them forward.'

"And so the argument raged for an hour or so. Mr. B. capitulated following my direction to give the students an assignment of their choice with a paper due the end of the week.

"Friday after school, Mr. B. charged into my office, threw some papers on my desk and said, 'Damn, how did he do it? Beyer made the highest grade in the class!'

"My answer, 'Yep, because he knows more history than you and I combined. Go back and challenge him.'"

Harold Weiler took a great interest in Rich. He went in person with Rich and his father to the University of Virginia when Rich applied for admission after Rich's World War II military service. The Dean would not allow Harold and Otto to be present at Rich's interview.

■ "Feeding Time."

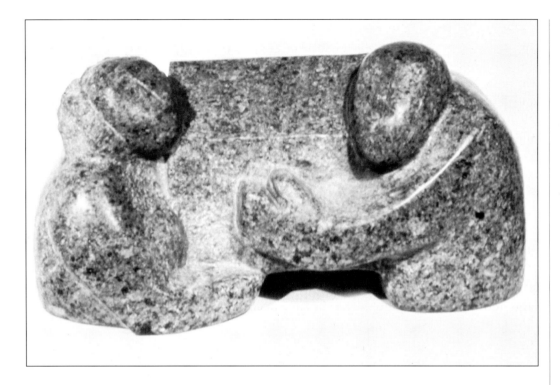

■ *People Holding onto Their House in Bellevue for Security.* Small mahogany granite sculpture, privately owned.

The Dean was silent for a moment and then said: "All right, Weiler, we will accept Beyer, but you are responsible for what happens."

After attending the University of Virginia, Rich transferred to Columbia University in New York and lost track of his mentor for forty-five years. Fortunately, Harold found Rich by contacting Donald Beyer in 1988. Harold was attempting to return books Rich had lent him in the 1940s; an important friendship was renewed.

During those intervening forty-five years, Harold had utilized his engineering skills in making developments in medical technology, and had married a Brazilian woman and lived in Rio de Janeiro. He had become a well-known painter in Brazil. Finding that Rich was a sculptor strengthened the original bond between them. He was proud that he had played a major part in saving Rich by giving him confidence. It was a seed, still to germinate, when Rich received his high school diploma from Fairfax High School.

Harold writes: "When the interview was completed Rich emerged distraught and uttered these words, 'I've never been so chagrined in all my life. He is unreasonable.'" Rich was denied admission.

The secretary to the Dean agreed to give Harold an audience two weeks later after Rich's interview. The Dean told Harold he eventually would have to expel Rich for the same reasons the prep schools had.

Harold replied, saying that "after those incidents" in prep school had occurred, Rich "entered Fairfax High and completed all requirements for college." He continued: "Dean, you have based your decision solely on a misplaced high school boy, but what I bring you today is a man who not only successfully completed high school but did survive three years of war in Europe."

The country was at war when Rich graduated from high school. Rich received a Congressional appointment to the United States Naval Academy at Annapolis, which was a coveted assignment, but it only served to add to Rich's confusion about going into the armed services. He had no one with whom to discuss this problem. The Quaker information about taking a stand as a conscientious objector was not available to him to help make a decision. His older brother, Donald, had been appointed to West Point and was a second year student. The oldest brother, Morten, was excused from serving because of asthma and his unusual height of 6 ft. 6 in.

Rich dropped the appointment to Annapolis and let himself be drafted. His parents were dismayed that he had turned down a chance for a few years of safety. In one sense I think he questioned the authority of his parents to arrange the Annapolis appointment. At the same time, the opinion of himself that he had gained at several private schools from which he had been dismissed gave him the feeling that he was an inferior student, not capable of the rigors of Annapolis. He felt no surge of patriotism, glory, or duty. He went to war because he saw no alternative.

Rich was a private assigned to Army Infantry. In the European theater, he was at the Rhone River during the Battle of the Bulge. He clearly remembers that he was overwhelmed by terror. Behind the front lines, the sky was lit up along the horizon with flashes of artillery fire. Rich and his squad clumped forward in the mud, forming a second offensive wave. Dead men were all around them. Seeing the first body was a visceral shock. The soldier appeared to be just lying in the grass and weeds by the road. A second glance told the reality; a rifle with bayonet had been jabbed in the earth beside the body as a signal for the Graves Registration team to retrieve and record it.

Rich remembers that after the war he moped around the house for months in the grip of survivor's guilt. Even though the shock dimmed with time, the dead soldier's image remains a haunting specter.

In June 1946, Rich and I each closed a chapter of our separate activities—Rich from the military and I from the University of California. Unbeknownst to me, Rich had received his discharge and was on his way to the West Coast with a friend just out of the Navy. They traveled in a rehabilitated taxi they had bought for the trip. Included in their duffel was a Spanish guitar which Rich had acquired with his mustering out pay. They drove day and night, reaching San Francisco in three days. His friend sold the cab and disappeared, while Rich stayed a few days in the city with a friend of his parents before visiting relatives.

By chance, we met at a cocktail party hosted by mutual friends of the Beyers and Wagenets. Neither of us imagined the other would be there as a guest. Each of us saw the sparkling eyes of the other and marveled. Of course, we compared notes from childhood and filled in all the blank years with our stories. We learned, too, that we would see each other more often in the future since I was accompanying my mother and father back to Washington, D.C. And, to add to that, Clara Beyer had invited my family to stay at the farm until we could find a residence in D.C. Such generosity was a "given" among friends.

The following summer of '47, Rich and I drove on many back roads of Virginia with the special mission of saving box turtles too slow to safely cross the road. We saw stock company plays when we could locate them, and rode the old merry-go-round at Great Falls, Virginia, catching the gold ring for free rides. On these dates, Rich decided that I was the girl for him. He wrote to a former girl friend saying that he was engaged to Margaret. I'm sure the letter was kind and honest, but he was concerned for her feelings long after it was sent.

I remember the hot humid day in July of '48 when we surprised Rich's father, Otto, at the farm.

Smart dresser that he usually was, Otto was clad only in shorts and sandals. He met us on the lawn under a great spreading oak tree. He was thrilled when he heard the news that we were engaged to be married. He ran back into the house, and reappeared carrying a large silver serving dish.

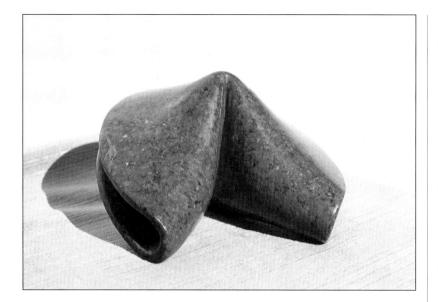

■ *Fortune Cookie.* Mahogany granite, privately owned, h. 5" × w. 10" × d. 8".

gown. Since I knew nothing of this, I had prepared a gift for her; pearl earrings to go with her necklace. All this was revealed when I sorrowfully showed the earrings to my father.

I wore the charmed set on my wedding day.

The death of Rich's father, Otto Beyer, two months later, further challenged our courage.

Rich and I settled in New York City in a Greenwich Village cold water flat. Greenwich Village was the section of the city with small "railroad" flats, in six-storey buildings of 1920s vintage.

We lived at the top; no elevator, and no hot water. A toilet in the hall, the antique type with a tank overhead and operated by a pull chord, was used by people in four apartments. In 1948, this section of old New York had not changed much in character from the tenements of the 1920s and 1930s, although it was soon to be a real estate find for the more affluent and with its development came "addresses of style." The apartment rented for $25 dollars a month, and was still under rent control authority; when an apartment changed hands, the new occupants paid the former tenant a negotiated fee. I think we paid $500.

The bedroom was a couple of feet wider than a double bed. Rich raised the frame to the height of a bunk so we could store a bureau and possessions under the bed. A double-hung window was located beside the bed—so close we used the sill for a step up to jump into the bed. One had to be aware of possible voyeurs on the nearby roof top. Also, we had to be careful that nothing fell out of the window by accident because it might land on pies cooling on the windowsills below. Our cat fell out of the window once—the whole six

"Here," he said, gallantly handing it to me. "This belonged to the German side of my family; now you won't be able to get out of this engagement!"

Both families had watched as we fell in love, and both sets of parents had cautioned each other not to "say anything" lest the spell be broken.

Amid all the joy there was tragedy. Four days before our wedding, set for October 9, 1948, my mother unexpectedly died. My brother, his wife Catharine, and their firstborn, Hal, arrived from California the day after her death. It was sad that Mother never saw her first grandchild.

The wedding was at St. Alban's, the parish church of the Washington Cathedral. The fatherly bishop advised us that nothing should change. We put aside grief and continued the wedding week, just as Mother also would have advised.

Mother had planned a gift for me; it was her treasured, double strand of pearls that my father had given her. She thought they would look just right with my

floors. We know about the pies, because we were scolded by the haus frau below. The cat survived, to live on in our next adventures.

In the spring of 1950, we moved from our cold water flat to Levittown, Long Island. The new home seemed so spacious. The air was fresh and the house stood on ground level, built on former potato fields. Our first child, Elizabeth, was born July 19, 1950. Our second, Otto, was born May 14, 1952. He did not survive thirty-six hours.

When we were able, we took the canister of his ashes to the beach on the south shore of Long Island, near Levittown. There, while Liz played in the sand, I watched Rich wade far out into the surf. With his hand, he cast the ashes into the ocean. I fantasized that wherever I would meet the ocean again in life, there I would find this baby's spirit.

Rich returned to me on the beach and said: "The ashes were soft, and there were tiny bones also in the container."

In June 1953, Rich graduated from Columbia University. We were proud, but there was no celebration. In July, Liz had a marvelous third birthday; though I was waddly pregnant, I was determined to have a bang-up party for her. The next day, July 20, son Charles was born a week early.

The children have always been a source of wonder to us. They inspired Rich to contrive stories for them, which, as they grew up, they illustrated themselves. He has never been at a loss to invent a toy or game for his satisfaction and theirs. Now, as a grandfather for more than twenty years, the creative process goes on. I expect that as a great-grandfather he will exceed all that has gone before and perhaps repeat all the good and favorite stories.

In the fall of 1954, we enrolled in the Putney-Antioch Graduate School of Teacher Education in Putney, Vermont. Of course, the children came along. Rich took a general teacher's course and I specialized in early childhood development. We both received Master's degrees in education from the University of Vermont. When we returned to Levittown, Rich worked for the Bureau of Economic Research in New York for two years, and I worked in a local nursery school. It was largely due to Douglass North, who was preparing a book at the Bureau of Economic Research, that Rich decided to study for a Ph.D. in economics at the University of Washington, where North was on the faculty.

It seemed then that the future was taking shape.

■ "Women Playing with Child in the Surf."

17

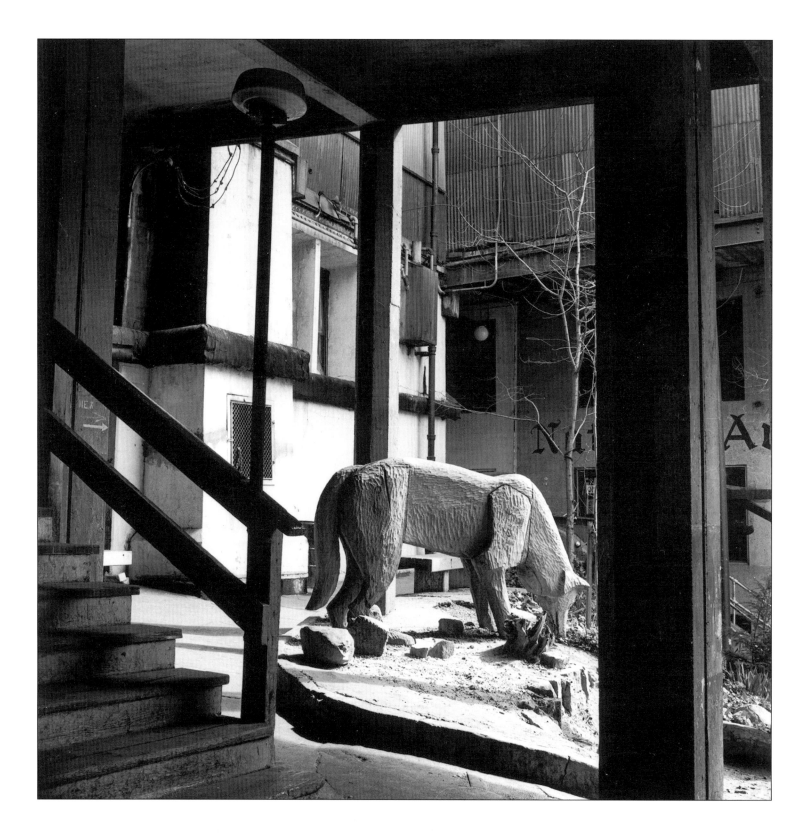

Part Three / Skeletons in Our Closet

We moved our family from the East Coast to the Pacific Northwest during the hot summer of 1957. Our second-hand Ford dragged a U-Haul trailer, loaded with bed, table, and other necessities. We believed our children—Liz, seven years old, and Charlie, four years—were ostensibly on an extended educational trip, and not an important relocation. We camped and traveled slowly.

Ahead of us awaited wolves and coyotes, bear and Sasquatch, but we didn't know that then. As a graduate student in economics at the University of Washington, Rich would be working his way up the academic ladder. I thought I was going to be a professor's wife at a university somewhere. That was in my unwritten contract. Neither of us had a clue that sculpting would become Rich's career.

That career, which now encompasses more than seventy-five commissioned pieces spread throughout the U. S. and as far away as Tashkent, Uzbekistan, began with a simple toy shaped from coat hangers. Rich was preparing for his Ph.D.—orals and a dissertation—and as a relief from his studies he created a toy for our son, twisting black coat hangers into a flexible skeleton. It was lovingly named "Skelly." The wire toy lasted through many baths until the paint wore off in the water and rust set in. Rich bought a stone hammer, chisels, and woodcarving tools at the University Book Store in Seattle to create small sculptures in stone and wood.

Ultimately he left economics behind him, turning to art as his medium for truth. Ideas came from many sources: personal feelings, history, poetry, folklore, myths, the Bible, and current events. Among his first projects was a collection of small cedar pieces depicting one of the state of Washington's most tragic events: the massacre of Industrial Workers of the World (IWW) members in 1916.

■ The original *Peace Wolf* in the old Seattle Public Market, March 1967.

© *Photo by Mary Randlett*

■ Ball game sketch for carved brick.

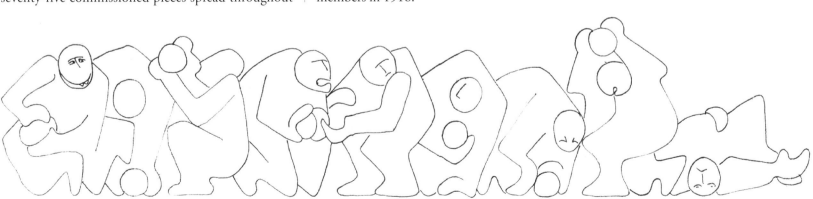

Two-hundred and fifty IWW men, or "Wobblies," from Seattle arrived by steamer at the Everett waterfront to organize loggers and laborers. They were met at the dock by the sheriff and local citizens. A shoot-out ensued, and five Wobblies were killed. The mob tied the dead bodies in gunnysacks and threw them into the water. Later, the bodies were washed up on nearby beaches. In contrast to the massive works that were to come later, Rich began with a wooden block just five inches square to depict a body tied in a gunnysack.

Rich's miniature sculptures were shown in a gallery on University Way, Seattle, and all were sold. Two of the pieces caught the eye of a young Seattle architect, Fred Bassetti, who became a supporter of Rich's work and a lasting friend. One of the pieces Fred bought followed the IWW theme—it depicted a line of unem-

■ "Couple Fleeing the City with Their Bed and Table."

ployed men. Rich was speaking for the underdog—the unemployed, or the worker caught up in the struggle for labor rights.

Fred's other purchase represented a telling expression of Rich's personal unhappiness while at the university. Rich had shaped a block of cedar to look like a Gothic university building. All four sides were covered in patterns of faces, people, and animals looking out of windows. Rich titled it, *Lux Sit*, or *Let There Be Light*.

Rich continued to develop his skill at direct carving in several media while providing small sculptures for galleries. Those self-taught carving techniques eventually would become the basis for his large-scale sculpting. Rich was evolving toward his ultimate goal of being a full-time sculptor—even if we didn't know it.

He enjoys describing the period from 1960 to 1967 as, "When I was 'canned' from the university, went to work for Boeing Aircraft, carved totem poles on pencils at my desk, and hoped to be riffed."

But he was not riffed. He finally quit his job because of Boeing's military connection. In the early 1960s, we had joined the University Friends Meeting (Quakers) and the group's testimony to peace was to be taken seriously.

At Boeing, he had been kept on the payroll as an engineer with nothing to do. It was a time when hundreds of workers waited in boredom for Boeing to get yet another government contract. It proved to be a good time for Rich to leave. But as Rich drifted into full-time sculpting, the uncertainty of our income was hard for me to take. In 1958, I had secured a teaching position at the Helen Bush School, a private school in Seattle's Madrona district. I was a nursery school teacher, and director of the nursery and kindergarten programs. We could live on my salary—along with substantial birthday checks from home.

Rich kept carving and looking for a job. He landed one with the Washington State Department of Employment, and it seemed to be what he was looking for. We bought a lovely house, co-signed for by Rich's mother. However, the job was not the right match for Rich, who grinds against structure and institutions. Within six months he was asked to leave.

It proved something, says Rich: "I found that what I could do best was carve."

There had, in fact, been compliments many years earlier regarding small sculptures he had created while in elementary school and in an art class during his high school years. Then, while at graduate school in Vermont, Rich sculpted an eight-foot "fallen angel" in the deep snow. The director of the school commented that Rich had talent as a sculptor. This was not taken seriously, as the angel, which had fallen on her head in the snow drift, stared at us upside down causing laughter amongst us all. Art was not considered a serious occupation in the early 1950s; the "establishment" influenced us in attempting to pursue "real" professions.

By 1963, Rich's small sculptures were selling at Jakk's gallery in the Seattle Public Market. If they didn't sell, we took them home and gave them away. Rich was producing a large number of pieces which we didn't want to store at home. In the summertime, we sold cedar sculptures at the Edmonds Art Fair; later, at any fair we could enter. Our children came along—sometimes with a large grocery carton of kittens for sale. During winter weekends, we set up small displays at the fishing piers on the waterfront, where it often rained and was biting cold. Rich sold a few pieces. However, it was during these soggy days that we made

enduring friends, and they were worth every bit of that effort.

Rich acquired a palette of black granite pavers left over from paving at the Seattle Center for the 1961 World's Fair. He used these for small granite carvings. Larger pieces of mahogany, pearl, or white granite were bought from stone yards, quarries, and grave monument suppliers. Some titles of these pieces reflected his political opinions: *Man Holding His Nose over the War in Vietnam; The Draft*, because Rich was against it; *The World Breaking Up; A Vietcong Prisoner*, expressing sympathy for the hated ones; *The Pilot*, a black granite head imprisoned in a helmet, but none-the-less a hero to someone; and *Hippopotamus Sitting on a Man*, i.e., the huge oppressive government squashing the citizen (the story is derived from Menes, an Egyptian pharaoh who died in the Nile River when a Hippopotamus rolled on him).

Another granite piece, *City Running Away from the Bomb*, was Rich's reaction to the endless planning for supposed escape routes away from cities in the event of a nuclear attack. This sculpture is an abstract form in black granite. From an eighteen inch cube, running leg forms are sculpted as three perpendicular swastikas in the block. The legs run in all directions. Rich viewed plans for evacuation as futile because roads would be clogged with stalled cars, few people would get out, communications would be destroyed, and nuclear fallout would contaminate the area for miles around. The consensus of our neighbors was that dying in the first hit was preferable to the imagined struggle for life that would follow an attack.

Rich's goal of wanting to create large-scale sculptures was first achieved with *The Peace Wolf*, carved in wood in 1963. (Although it is one of his early works, he would return to it three decades later. And now,

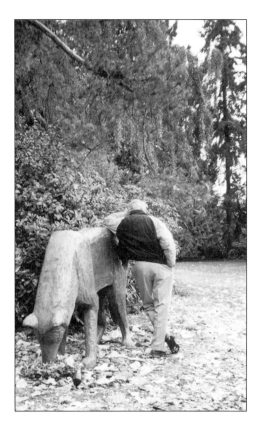

■ Rich in contemplation (1994) while leaning against the bronze sculpture cast from the original cedar *Peace Wolf* dating from 1963.

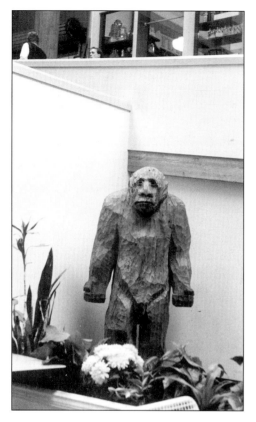

■ Sasquatch in the Seattle Public Market.

cast in bronze, it commemorates an important milestone in his career. More will be said about this bronze sculpture shortly.)

Rich fabricated the wolf in our backyard at Madrona Place East in Seattle. The head, neck, legs, trunk, and tail were carved from large blocks of western red cedar hauled from a standing timber sale on the Taylor River in the Cascade Range. In the years to come, cedar would be the material used in creating sculptures of bears, wolves, dogs, pigs, rhinos, birds, and ultimately even the mould for *People Waiting for the Interurban*.

Many of the animals would be large pieces. *The Peace Wolf* was an oversized beast, in a posture of holding its head down in a peaceful looking way. It suggested that we should be reconciled with wolves, contradicting the perception that they are always snarling, ugly creatures. The message was one of peace and respect for a misjudged adversary.

Some residents of the Madrona area made a proposal to the Seattle Park Department that the wolf be placed on a pedestal in a pond in nearby Denny Blaine Park. The plan was accepted on January 16, 1964, but never carried out. Other residents, by petition, negated the idea. A real live wolf—a pet—lived in a house across the street from the pond. The neighbors were apprehensive; they didn't like the wolf's monthly moonlight serenades and didn't want the pet to be validated by the sculpture.

The Peace Wolf was loaned to the Pike Place Market for about a year, where it was warmly received—and also anonymously initialed by someone with a pocket knife. After that sojourn, it was loaned to the Central Area YMCA. Eventually it went to the University Street Fair where it stood among other carvings of domesticated and mountain animals. It was sold, from the street, to a young family with a large house and land-

scaped grounds on Lake Washington. For three decades, *The Peace Wolf* stood there, symbolizing their concerns for peace. Over the years, the sculpture underwent a few repairs.

Finally in 1994, this generous family—the Peter Wolf Eisings, now with their children grown—decided to have *The Peace Wolf* cast in bronze for permanence. Rich was able to do this using the original wood sections for moulds, even preserving the anonymously carved initials in the process. Rich and the Eisings did not view the initials as damaging. Rather, the initials showed the touch of another person, perhaps an appreciative one, and it had become part of the sculpture.

Other large cedar sculptures done by Rich were inspired by the public's fascination with the legendary Northwest creature, Sasquatch. One or two eight-feet-high Sasquatches were sold, and one remains today in the Seattle Public Market. Rich's understanding of Sasquatch was put forth in his article, "The Natural History of the Sasquatch," published in the *Fremont Forum*. He wrote the article in an effort to establish some reality regarding the legendary figure, other than presenting mere sentimentality and false hype.

Rich noted: "Sasquatch was a motif in the Indian culture, apparently suggesting the accepting dependence of the Indian on the generosity in, and the terrifying power of the thick forests in the mountains and along the sea. It was an ambivalent creature; a great female, and a child thief, an omen of death, but also its blessing brought well-being to the tribes. In our popular culture, Sasquatch is some kind of friendly hairy clown, another approval symbol used by beer companies and banks, appealing to the last-friend syndrome. Thus the figure is well-known in the Northwest. But in our use of it in the Pike Place Public Market, we had more in mind."

According to Rich: "The sculpture is placed now [in 1997], on a lower level of the market lurking to take by surprise the giddy explorer through the maze of the market. Sometime in the 1970s the proprietors of a small leather business sold their wares at the craft stands in the market. They wanted an indoor shop and I approached the market's administration for them, and got a shop location. That night, celebrating this luck, we chose Sasquatch as the shop's name.

"When the market was renovated, the Sasquatch Shop was displaced for several years to a less desirable location. Business and profits fell off; the shop needed a device to get attention and restore income. The Sasquatch figure was then commissioned, and interprets those times in our lives when, as things change, and we are dislocated, we suddenly see through the structures of our everyday lives and comprehend the great threatening but promising forms outside of us, through which we live, but which we also forget."

 Carving brick in the "mud stage" at the Mutual Materials brickyard.

 Beginning in the 1960s, Rich received commissions for creating story panels in brick. Here he is at work with assistant Bruce Crowley.

Marie Hanak photos

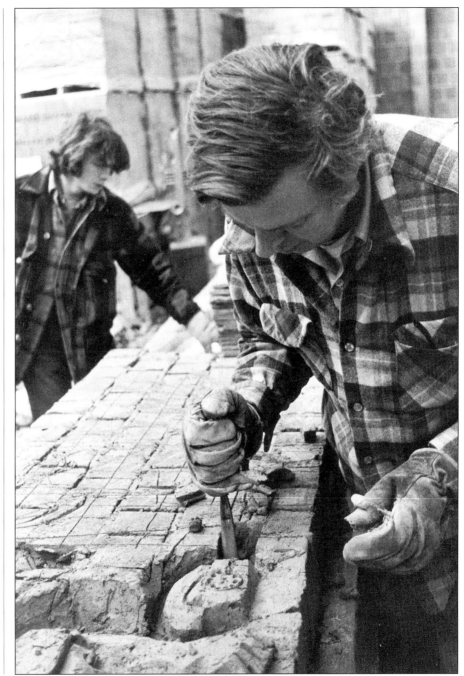

23

Interest in Sasquatch hit a peak in the 1960s. Newspapers printed a variety of articles, and pictures were published documenting Sasquatch footprints—and a film strip supposedly showed an actual Sasquatch fleeing into thick timber. Coastal Native American legends about the creature were recalled and published.

By the early 1960s, Rich had recognized his muse and his skill, and had made it work for him. When an artist takes on the risk of showing his or her work to others, and sees it successfully displayed in galleries, then the question arises of selling it to another person for them to enjoy. For achieving that goal the artist may seek a larger audience—and real commissions—and hopefully an income to justify all of the expended labor and creativity. Those are steps that Rich took. We were excited about the early commissions.

"Direct carving" is the technique of removing hard material to reveal a subject, as opposed to "modeling" in a soft material, like clay, by starting with a bare armature and building the subject around it. There is some taking away and re-dabbing in the latter technique, but hard materials such as wood and stone are unforgiving. However, green brick— the mud stage of brick—can be used in a combination of direct and modeling techniques. It was this medium that Rich utilized in several of his early commissions.

Carved brick decorations at Central Washington University in Ellensburg, and the *Stations of the Cross* at St. Joseph's Church in Roseburg, Oregon, are examples of brickwork commissions done by Rich. Other carvings at Bellevue's Newport Library and at the Kent City Hall also were early commissions.

To see and work in "large scale" requires a different vision for the artist. It is not a question of simply enlarging a small piece to a large size by a proportional mathematical increase, but rather understanding that we see differently from a distance and need to select and emphasize important elements in the design. Rich has often said that the model on a small scale shown to a client is going to change on a large scale because relationships are different. It is evident to me that figures increased by a simple mathematical enlargement lose their essence or "life."

In order to gain further experience in working on large-scale projects and in moving and handling big materials, we set out for the Washington coast each summer between 1968 and 1975. Trips to Ozette and the Cape Alava beaches and to Shi Shi beach near Neah Bay became regular weekend or week-long excursions. Cedar logs washed up on the sand by tumultuous winter seas were selected for totem poles and other large designs Rich carved with a chain saw. Hauling the enormous logs into position honed our engineering skills. We used the simplest sort of methods—bar and fulcrum, small trees for rollers, and block and tackle for pulling. All tools were carried in on our backs by trail; the end of the road at Ozette Lake was three miles from the beach.

Even our Samoyed Husky, named Klayuk, carried his dog food in his own pack. We discovered that camping provided a common ground for us to behave more like animals and for our dog to behave more like a human. We translated Klayuk's name to "Many Hairs." We returned home wearing our share of white dog hairs acquired while sleeping side by side with him.

We invited friends to camp with us, but when it came to erecting a sculpture, any person on the beach was fair game for providing labor. We acquired several special friends who wandered onto Rich's projects.

Rich sketched the carvings on mesiricords in medieval English churches. A misericord is a small projection on the underside of a hinged choir seat in a catherdral. When thrown back it gives support to a person standing in the choir stall.

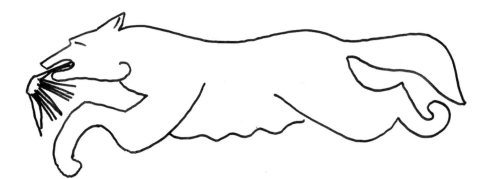

■ "Wolf Running with a Book."
Drawing for a sculpture at the
Kirkland Library.

A totem pole Rich carved at Shi Shi beach depicted two gold miners, who long ago had camped at the outlet of Petroleum Creek. They too had carried in all of their equipment, which yet lay there rusty and covered with weeds. Rich carved the two miners one atop the other, and holding their gold pans tipped out toward the sea.

The first carving at Shi Shi beach was of a Sasquatch jumping out of the brush. There also was the *Hywaco*, a dog-like creature, whose long tail was a curved cedar branch. The Hywaco was a mythical Indian beast. It took visual shape when a Chinese logger, in circa 1880, imagined its form in a wood carving. In Rich's mind's eye, he carved it as a wolf-dog at Shi Shi beach, and as a lion with a growling expression at Doe Bay on Orcas Island in the San Juan Islands. At Doe Bay, the *Hywaco* sits on a concrete foundation from an old hotel. It too had a curved cedar bough tail.

Also at Shi Shi beach, Rich created *The Codfish Head*, *Dog Bringing a New Dispensation from Heaven*, and the *Ghost Dance Platform*. There seemed to be no end to the experiments, and in meeting campers of kindred spirit.

In the 1980s, after this strip of coast had been declared a Wilderness Area, Rich was asked by the National Park Service to remove his sculptures because, being man-made, they were no longer welcome there. By this time, *Hywaco* and *Dog Bringing a New Dispensation from Heaven* had been stolen. The *Ghost Dance Platform* also had been removed, board by board, but relocated up the beach as the back wall in a handmade cabin. The Park Service flew the remaining sculptures by helicopter to the road at Lake Ozette, which proved very helpful to us. Hands-on, large-scale carving on these beaches provided our family with many memorable experiences and gave Rich a familiarity in working in large-scale cedar.

In the fall of 1974, friends who visited at the beach and who also were former high school classmates of mine organized a Swan's Tour to Egypt, which included four Seattle couples. They asked us to join them and we jumped at the chance. This was an opportunity for Rich to see how immense granite sculptures were cut out of blocks, i.e., cut from the "living rock." It also was a chance to see a formal style of figures—streamlined and polished, but sometimes soft, graceful, and expressive. Rich's mother, generous and wise as always, provided us with mature war bonds so that we could take the trip. She was pleased that we chose to use the money for a great adventure! All that was observed and learned on the trip to Egypt gave Rich greater insight into stone carving.

Rich has noted: "The dignity and formality of stone contrasts with the business of life. The difficulty of handling stone forces us to think of important uses. Stone accords with our sense of the dominant and hierarchical; our use exaggerates its coldness. It was a more patient and reflective people than ourselves who used stone for artistic expression. They gave its quality to animals and man as well as to their institutions. The thought and force required to work stone is not equaled in other arts. Stone requires a confident grip on ideas and an insight into structure that refers all

work to the center of the mass. Stone has a depth of surface, a sweep of line, a solidity of form peculiar to itself alone. The qualities of carved stone point to that which endures in the life of man."

On our way back to the U.S., we spent some time in England sketching carvings on miserichords in medieval cathedrals. The carvings were a surprise and delight to Rich. The small carvings are in hardwood on choir stalls, and are, in a sense, three dimensional cartoons. Many of Rich's small sculptures have the same cartoon-like function, depicting an outlandish or humorous slice of life to delight viewers, much as the miserichords must have kept choir members amused and awake during repetitious church rituals. The subjects of the little carvings are not of a religious nature, but are of people or animals who often are the butt of jokes. The carvings were intended only for the eyes of choir members. In-house jokes appeal to Rich.

Interviewers ask Rich: "What has influenced you the most?"

He replies that two books are indispensable to him: *Best Loved Poems of the American People*, and Edward Steichen's exhibition of photographs, *The Family of Man*, published by The Museum of Modern Art in 1955. A favored motif used by Rich is the human skeleton; it crept into Rich's repertoire from a childhood reading of A.E. Housman's poem "Immortal Part."

Rich has been misquoting it for a lifetime. It seems that as a child he mistook the word "travails" for "travels." A child would be unfamiliar with painful labor, but quite entranced with the picture of a playful skeleton accompanying him everywhere. The quote is as follows:

"Wanderers eastward, wanderers west,
 Know you why you cannot rest?
 'Tis that every mother's son
 Travails with a skeleton."

In Rich's cartoons, the human skeleton represents the structure that we, with our enthusiasms and vitality, depend on. Flesh and bone work together, but we cannot see them do so. We see only the exterior body and imagine the skeleton from scientific knowledge. Rich says this is a fourth dimension problem. Bones are with us, but not verified directly by our vision. Also this structure, if it could lie down beside us, has no senses. It is our flesh which has the guts, feelings, and a mind with dreams. The skeleton is the mirror, or juxtaposed image, to our vitality and enthusiasm.

■ "Travels" with a skeleton.

Part Four / Studios and Invitees

Rich's studios are almost like public places, drawing many people who are pursuing their particular interests in creativity. Artists come to see how their own work corresponds to Rich's. Also, an active studio's chaotic and creative atmosphere seems to be therapeutic to many. A number of the "drop-in" visitors are artistically conscious young men who are looking for direction—and a way of making a living in the "establishment" world.

Over the years, each of Rich's studios also has been his office for meeting prospective clients. Neighbors, too, stop in out of curiosity. Some days see no accomplishments!

In the early 1960s, at the first studio in our house in the Madronna district, a man came to attend a sculpture class that Rich had advertised in the Free University catalog. He was the only student to appear. He and Rich found they had common interests in working stone, metal, and wood, and they have been friends ever since. For awhile, he paid the $75 per month mortgage for Rich's Fremont studio. He now is retired, living in Idaho, and stops by our Pateros studio on trips to and from Western Washington to visit relatives.

Rich's first commercial studio was located on the eastside of Lake Union—on a dock over the water in a space that formerly was used as a warehouse. The weak electrical connection was barely adequate for operating a few power tools and an overhead light at the same time. In the mid 1960s, a frequent visitor to the studio was a young man who resisted the draft during the Vietnam War.

In a recent conversation, this man recalled the support he had found in being in Rich's company. This friendship gave him strength during his subsequent imprisonment, and even gave him life-long direction. He recalls also that there were spaces between the planks in the floor through which lapping water could

■ The Pateros foundry on the Columbia River in central Washington.
Marie Hanak

■ "A Days Work."

■ "Cliff" came to the Fremont studio to do a day job and stayed for 3 1/2 years.

Bronwen Miller

A neighbor, a professor at the University of Washington, also had a studio nearby and he became a close friend. For "good" company, he bought Rich lunches during our starving years before Rich succeeded in the Public Art scene. The professor's talents were in science, Rich's were imaginative. They had a lot in common. He believed the world could be perfected through pharmacology. Rich made him a small carving of a three armed man holding in each hand a pill—a cure for venereal disease, a contraceptive, and an aphrodisiac.

Rich was grateful for the friendships and the lunches. These visitors at the shop joined our larger circle of family, friends, and neighbors in Seattle.

The Fremont studio, with its three-phase electrical connection, allowed for the acquisition of more tools and equipment. An air compressor provided the power for Rich to carve small granite sculptures for gallery sales, and air-driven wood chisels facilitated wood carving. Later in the 1970s, Rich added centrifugal casting equipment for small brass or silver pieces. And, in the summer of 1978, he built a foundry for aluminum and bronze casting. In 1980, a stone cutting torch was added to expedite the carving of granite for *McGilvra's Farm* at Madison Park.

One day, the Casual Labor office in Pioneer Square sent a man to our Fremont studio to help Rich with an odd job at the studio. He was homeless, only recently having been evicted from his dwelling. He took a fancy to Rich's studio and asked to stay there overnight. Like the proverbial "Man Who Came To Dinner," he did not stay the night, but for 3 1/2 years.

His former place of residence had been located where the Myrtle Edwards Park was developed. Previ-

be constantly heard, and which allowed for the disappearance of many small tools to the watery depths. In this studio, cedar sit-upon animals were created as Rich regularly got commissions for his rugged chainsaw pieces. This increased our confidence in Rich's carving skills and trust in him pursuing it as a business venture.

We bought the next studio, in the Fremont district, in 1968. It was an abandoned, cement-block paint shop, standing on dry land but within sight of the ship canal. The price was right—a $16,500 contract, paid for with the aforementioned $75 monthly payments. A bonus to us was an old garden in the yard. Volunteer potatoes, a raspberry patch, and a bounteous cherry tree provided free food. Fred Basetti came often to pick the cherries when in season, or to go out with Rich to lunch.

ously, this area had been a large landfill where rubbish was dumped, including materials from demolished buildings, such as Seattle's old Orpheum Theater. Cliff, a transient, lived there in a shack made from slabs of concrete and other cast-off building materials. With a sledge hammer, he busted up concrete to remove the rebar, dragging it away to sell as scrap metal.

Cliff was a small wiry man—a World War II veteran, tough, pugnacious, and marked liberally with facial scars. Suspected of having homicidal tendencies when in the Navy, he was discharged, and taken to a Veteran's Hospital in the late 1940s and given nine shock treatments. He had no family or other social support, and lived a solitary life, damaged, but not dangerous. His conversation was about himself. Looking back, it is still difficult for me to understand how Rich could be so accommodating to him.

But, Rich said, "Cliff is a human being too, and needs to be treated civilly."

The physical demands of completing a large project require help from assistants. Usually, only one helper at a time is needed, but sometimes two or three, or as many as seven, are required. Over the years, twenty-six different paid assistants serving from a few months to six years have worked with Rich. Many more volunteered for a short time, just to be part of a project. Rich has encouraged several assistants to further their own artistic development and careers, and he allows assistants to complete parts of a sculpture so they can have a real sense of involvement in the process.

It took us a long time to realize that not all of the assistants prized the opportunity at hand. When some assistants watched the clock, instead of the quality of their work, it made us sad; angry too sometimes. Rich was exhaustingly patient until they went away.

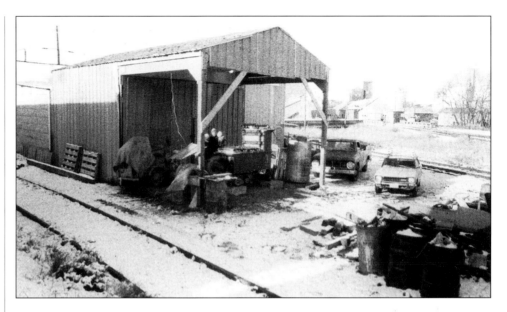

■ In the 1980s, Charlie cast twenty-six of Rich's sculptures at the Moscow Foundry.

■ Rich and Charlie on a sunny, winter day in Moscow, Idaho.

Rich's comment: "Suffer fools graciously."

Even so, Rich enjoyed having a variety of people around to talk with—and to share stories and artistic ideas at tea-breaks during a day of struggling with tools and unforgiving metal. We both are grateful for the enthusiasm and energy of the assistants.

By 1982, Rich's projects outgrew the facilities at the Fremont foundry. Rich arranged with our son, Charlie Beyer, who was living in Moscow, Idaho, with his wife Bronwen and their young children, to set up a foundry. Charlie was enrolled in the mining engineering program

"Wagon Driver."

at the University of Idaho. He and his wife, Bronnie, had bought a fine piece of property in the hills north of Moscow. The plan was that Charlie would do Rich's foundry work for a salary and continue his education at the same time. It was a workable arrangement (or just barely they might comment).

Charlie built his shop in the south part of Moscow and named it the Moscow Foundry. It was an extension on the back end of a former railroad building, which was used at that time as a forge. This proved to be a compatible arrangement. Rich and I had bought a secondhand Reda tilt furnace from a Bellingham foundry that was converting from oil to electricity. We planned to transport it on a utility trailer to Moscow, where Rich would help install it in Charlie's shop.

After crossing the Cascades via Interstate 90, it was my turn to drive the truck and trailer burdened with the furnace as we began the ten mile downgrade from Rye Grass summit to Vantage on the Columbia River. That was a daunting task for me. I remember reaching across the truck seat to squeeze Rich's hand, calling out, as is our custom, "We're on an adventure!"

During the time Charlie was in charge of the Moscow Foundry, he cast twenty-six of Rich's public sculptures. He not only cast these pieces by himself in aluminum or bronze, but returned them to the Seattle studio and welded them up.

At the studio in Fremont, no sooner had the foundry pit been vacated, than another homeless man, a stone carver, asked for permission to build a hut in the pit. This idea seemed to have been suggested by the foundry pit's simple shed roof. This educated, unemployed scholar gave instruction in the art of stone carving to anyone who would listen. He moved on in a year.

The process of creating a cast aluminum sculpture is called the "lost styrofoam" process and is comparable to, but more direct, than the "lost wax" process of bronze casting. The designing of a sculpture begins with a small wood model. It next is enlarged onto plywood cutouts, and then carved from solid blocks of styrofoam, which ultimately become the moulds for the finished pieces. Rich carves the styrofoam with a band saw, sanding disks, or wire wheels, and a butcher knife. Details can be articulated with rotary files and a die grinder. Figures can be pieced together with styrofoam glue or carved as one piece.

The finished figure is then cut apart and hollowed out to a surface thickness of about a half-inch. These cored-out pieces are then buried in boxes of chemically charged sand in manageable parts for moving them about (i.e., the shells of the heads, arms, torso, legs, etc.). Each piece is sprued by a neck of styrofoam which rises above the sand, into which molten metal will be poured.

These cored-out styrofoam pieces were picked up in Seattle by Charlie and brought back to Moscow for the pouring stage. The sand in which the pieces are buried is mixed with sodium silicate. This mixture hardens providing a shell; it rigidly holds the dimensions of the piece in place when hot metal poured in the sprues burns away the styrofoam, filling the channels and design in the mould with metal. The mould box can weigh as much as a thousand pounds.

We had our share of disasters, such as the time when Rich and his assistant, Don, were crossing the mountain pass. The wind from a passing semi-trailer blew a box of styrofoam off our truck, snatching the moulds of five pigs. Rich and Don did not notice this until several miles later, then retraced their route to find white flakes and pieces all over the shoulder of the highway. I made these trips to Moscow, too, with the added pleasure of visiting Charlie, Bronnie, and their two young children.

The Reda furnace can melt 300 pounds of aluminum at a time. Electric power then tilts the furnace, pouring molting metal into a large ladle. Next, an overhead crane transfers the ladle to the mould box. Metal is poured down the center sprue until the mould is filled and all of the styrofoam parts buried in the sand are replaced by metal. The styrofoam flames and smokes as it is burned out. Often, the wood of the mould box catches fire. Not to worry, however; within 30 minutes the metal is solidified and the mould box is broken, revealing a big, sandy lump. After smashing the sand from the metal with a sledge hammer, the bare casting looks much like a tree—the central sprue has fruited hands, feet, faces, and legs, or small animals, men, and women, or automobiles or buildings, or whatever of the image that was originally made in styrofoam.

Then, the metal parts and designs are cut from the sprue and runners of the casting. They are cleaned up by sandblasting, and then are reassembled and welded together into the intended design. Life sized figures are assembled with the help of a crane.

A sculpture's shape is finished by grinding the welds smooth and hammering them with a needle gun. A piece is finally cleaned with another sandblasting and is made shiny with a wire wheel. The finished sculpture is ready for exhibition. The process also is used in industrial work, but it is modified by Rich in his art castings. Aluminum is less formal than bronze; it is somewhat lighter and less expensive, which has made public sculptures more accessible to many communities.

Charlie asked to be relieved from the foundry tasks during his senior year at the University of Idaho. We understood his needs in this regard, and this was one of the reasons we moved the furnace and foundry equipment to Pateros, Washington, in the fall of 1988.

This comfortable, small town in Okanogan County offered real estate at bargain prices. We were able to buy a large metal building on the Columbia River to use as a studio and foundry, and also a small house in town. Our daughter and son-in-law had moved their family to a wooded hill above the Methow River just ten miles away. Being close to her family was important. We rejoiced in being grandparents involved in the day-to-day lives and growing-up of five fine grandsons. Of course, leaving Seattle after thirty years did cause some emotional stress. But solving our foundry problems reestablished our equilibrium, and we have never regretted the move. Friends and acquaintances visit us out of affection and curiosity. In 1995, counting breakfast, lunch, dinners, and overnight visits, we hosted 210 new and old friends.

May the enrichment continue!

■ Rich working on *The Story of Reynard the Fox* at the Pateros foundry. These bas-relief, aluminum panels were mounted at the Bellevue Regional Library in 1993.

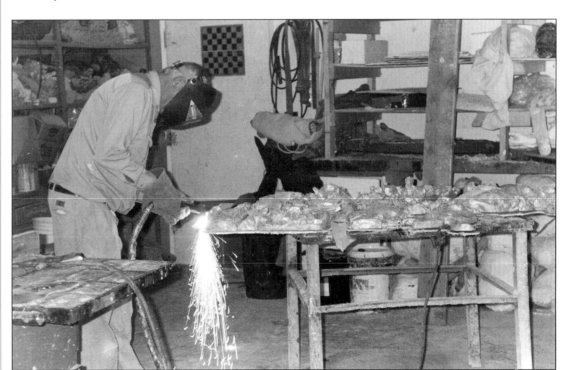

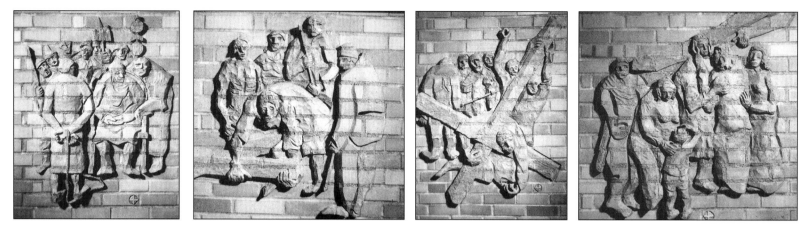

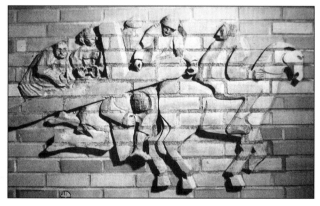

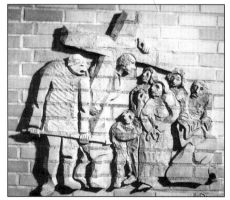

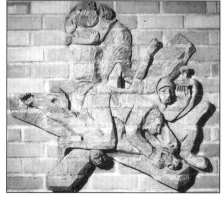

■ *Stations of the Cross*, 1-11

Photos by Peter Pan Studio, Roseburg, OR

Part Five / Large-scale Commissions Prior to *People Waiting for the Interurban*

■ *Stations of the Cross*, 1967
St. Joseph's Church
Roseburg, OR
carved brick

Beginning in the 1960s, Rich received several commissions from architects for storypanels carved in brick. This was a medium well suited to his direct carving ability. Rich was asked to articulate the fourteen Stations of the Cross on the interior brick walls of Roseburg's St. Joseph's Church, in southwest Oregon. The designs—including an added fifteenth station, the Resurrection—were laid up as the walls were finished. The story is of a lynching. The accused and condemned man, Jesus, must endure what persecutors, by common practice, have been trained to do.

The architect ordered the brick from a small brickyard in McMinnville, outside of Portland, where Rich did the carving. Here, a large worktable was set up in an open shed on which Rich placed flat 3' x 3' squares of bricks in the manner they would appear on the church wall. Pieces of wood separated the bricks indicating where the mortar would go. The bricks were in the soft mud stage known as "green brick" and were carved with a kitchen knife.

Our children and I would visit Rich at lunchtime, bringing a bag lunch from our motel room. A two-storey kiln was located in another part of the brickyard. The man at the kiln controlled the temperature of the furnace by directing wood chips with his feet into holes in the floor, feeding the furnace first with one foot and then the other. We watched as he gracefully and delicately danced the chips into the pattern of holes in the floor. We could see the fire flare-up orange through the holes as he moved around. By long experience, he knew just the right amounts of fuel needed for getting the required heat. There were no gauges, thermometers, or mechanical instruments. He was a master.

Rich, at his table, matched the kiln keeper's concentration. I wondered later at the speed and direction of his work. Was there a guiding hand? Or was there magic in the solitude, the ambience of the little factory, the heat, the excitement of being honored with an important job, the pleasure of coming home at night to an ocean-side motel room?

Rich's description of the Stations of the Cross, written for the church pamphlet, is as follows:

"Station number one: *Jesus is Condemned to Death.* Jesus, with his hands tied behind his back, appears before Pilate. Pilate is talking with the chief priest who is leaning on Pilate's chair. The soldiers hold the symbols of authority, the symbols of the Roman legions. Carved on the legs of Pilate's chair are snakes and a lion.

"Station number two: *Jesus Receives the Cross.* The soldiers stand by threateningly as Jesus receives the cross. In the background are the type of men who make gallows and crosses.

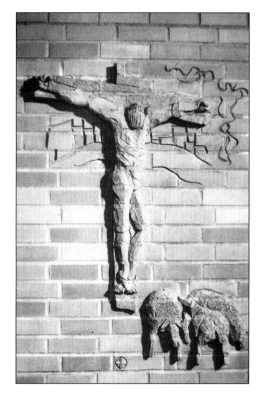

■ *Stations of the Cross*, 12

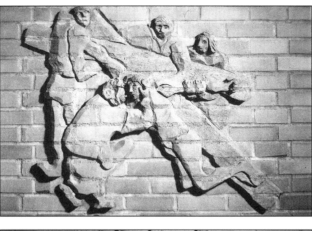

■ Stations of the Cross, 13-15

"Station number three: *Jesus Falls the First Time.* The unsympathetic mob is yelling at the man stumbling under the cross. One man, who is sympathetic, reached to hold the cross from falling on Christ's back. Though the guard is contemptuous of his prisoner, he shows his power and protects him from the unruly mob.

"Station number four: *Jesus Encounters His Mother.* Mary has stepped from the crowd to say good-bye to him and takes his face in her hands. A companion stands with her, placing her hand on Mary's back in sympathy. Another woman, looking down at her own little boy, wonders what life has in store for him. The guard, standing before Christ is non-plussed and somewhat embarrassed by the show of emotion.

"Station number five: *Simon of Cyrene Helps Jesus Carry the Cross.* Simon is being urged by a soldier to help Jesus carry the cross. The soldier, prodding him with a spear, seems to be saying, 'Get on there, and do what you are told!'

"Station number six: *Veronica Wipes the Face of Jesus.* Veronica steps from the crowd to wipe the sweat from Jesus' face. The soldier behind urges Christ on, while the other soldier moves in to push Veronica away.

"Station number seven: *Jesus Falls the Second Time.* Jesus tries to break his fall by putting out his hand. The guard behind yells orders for him to hold up. The lieutenant of the guard, on his horse, turns to see what has happened. The people in the back gasp with the suddenness of Christ going over on his face.

"Station number eight: *The Women of Jerusalem.* The soldier urges Jesus forward and orders the women out of his path. But Jesus stops to speak with them. The women are overwhelmed by what is happening. Jesus tells them not to weep for him, but for themselves. One woman weeps, while her husband behind her, peers forward to catch Jesus' words.

A child stares up, open-mouthed, into the face of the condemned man.

"Station number nine: *Jesus Falls the Third Time.* Totally exhausted, Jesus falls under the cross. Two soldiers try to lift the weight from his back. A man who has brought a dipper of water for Jesus gives it instead to a soldier and he smiles in satisfaction as he drinks. Another soldier holds their two spears.

"Station number ten: *Jesus is Stripped of His Garments.* Jesus' face shows complete submission, accepting even the indignity of being stripped of his garments. The soldiers know that he will not try to pick up the spear they have left on the ground.

"Station number eleven: *Jesus is Nailed to the Cross.* With senseless brutality the soldier who holds the nail that is being driven into Christ's hand, has his knee on Christ's throat. The other soldier, driving the nail, is mesmerized with his sense of what he is doing. Behind, weeping in each other's embrace, are His mother and her companion.

"Station number twelve: *Jesus Dies on the Cross.* The sheep near the foot of the cross are symbolic of Christ's flock. In the background are the outlines of the City of God. The storm of the passing of Christ's spirit is indicated in the swirl on the right of the cross.

"Station number thirteen: *Jesus is Taken Down From the Cross.* Mary holds up Christ's head and looks into his face as the cross is lowered. The rich man who has received permission from Pilate to bury Jesus stands by with two companions.

"Station number fourteen. *Jesus is Laid in the Tomb.* His mother is washing Jesus' face as he lies in the tomb. One of the holy women and the rich man draw the cover over him. The carved lines above are intended to show the narrowness and depth of the crypt.

"Station number fifteen: *The Resurrection.* On the evening of the third day Christ appears where the apostles are taking the evening meal. Jesus comes in on the right. Mary goes to him and takes His arm. The women who are serving the meal show peace and joy in realizing the fulfillment of their hopes in Jesus. One apostle embraces Jesus' knee. Another stands by filled with joy. A third seems to be saying, 'If this is really Christ, then what will it mean for me?' The partially eaten fish on the table he will eat to quell the apostles' doubt that he is, indeed, a man like them still. The apostles are charged by the event, and realize they must now preach the new covenant. On the ceiling in the form of a cross, are the symbols of the four evangelists whose gospels will carry Christ's teaching down through time. Those who follow them will be safe within the room, whereas, outside is the world of darkness where an army of grotesque horsemen represent various forms of evil. In Christ's right hand is the sun which symbolized light and the new life and order of things accomplished by Christ in his death and resurrection. The mouse under the table is a grace note to involve children who may not understand these things at first, but will come to understand them later."

■ Sasquatch bench in Woodland Park Children's Zoo.

Marie Hanak

■ *Woodland Park Children's Zoo (Carved Benches),* 1968
5500 Phinney Ave. N., Seattle, WA
wood (cedar)

The six carved benches are located in a section designated as the Children's Zoo. Each bench is a 6' x 2' x 1' block of cedar, and each depicts a reclining animal—horse, lion, wolf, mountain goat, alligator, and bull.

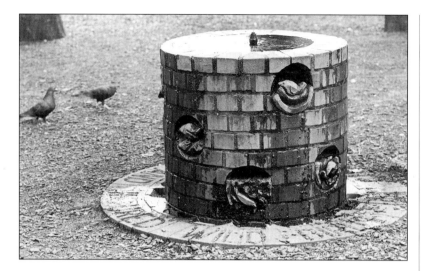

■ *Poncho Theatre (Panel)*, 1969
Woodland Park Zoo
5500 Phinney Ave. N., Seattle, WA
carved brick

Two bears meet and pass each other in the wall on the front of the building.

■ "Bears Taking Down a Wall."
■ *Poncho Theatre*

■ Detail of *Audubon Fountain*

Marie Hanak photos

■ *Audubon Fountain*, 1968
Woodland Park Zoo
5500 Phinney Ave. N., Seattle, WA
carved brick

This design is a cylindrical form approximately 4' high. The top has a rounded depression for a birdbath, and carved brick water ouzels rest in several niches on the sides. The fountain, sponsored by the Seattle Audubon Society, is a memorial to Mrs. Hall Schumacher, who cared for sick and wounded birds.

Rich suggested adding a carved brick cat sitting on the fountain, to conveniently cover the water inlet. However, an Audubon member said: "Cats and birds are not compatible. The quicker we eliminate the cat the better."

Rich liked the irony and complexity of putting a cat with the birds—to pay respect to the order of things, he said. "My responsibility as an artist is to give whatever leadership I can to preservation of things as they are, or as I see them."

The president of the Audubon Society countered: "It will be the subject of ridicule. No cats please."

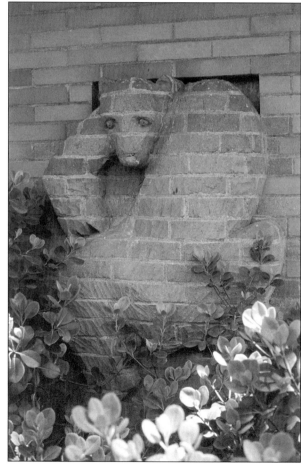

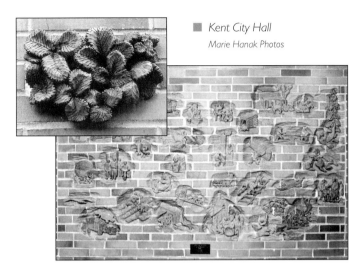

■ *Kent City Hall*
Marie Hanak Photos

■ *Kent City Hall (Panels)*, 1970
South 4th Ave. and G, Kent, WA
carved brick

Panels of carved brick are located throughout this building. A number of them depict the farms and agricultural life that once dotted the valley where the City of Kent now is located. Through Rich's interpretation, the changes—the coming of trucks, bulldozers, a thriving commercial land boom—also are illustrated.

In the jail cells, the ceiling-high panels could be seen only by jailers and inmates. These bricks picture Jonah in the whale and other trapped individuals in the stomachs of a variety of animals. In recent years, these cells have been converted to a storage area for criminal and trial evidence. The accused and convicted have been moved to a building with a larger detention capacity, where there are no carved brick decorations.

Lush strawberry plants in carved brick are located on an exterior wall near the entrance to the city hall. A close look will reveal various hidden objects in among the leaves. In one plant, a hand reaches out from its interior, as if to pick a berry.

■ *Newport Library (Panels)*, 1971
14250 S.E. Newport Way, Bellevue, WA
carved brick

The interior walls of this Bellevue library are decorated with Rich's brick carvings. Also, the children's corner has a large reclining dog in brick, which is used as a seat. The stories depicted on the walls are modest in scale, but intricate in meaning.

According to Rich, they illustrate "man's discovery of figures on rock, and his decision to worship them. The man instructs the women to sew the signs on blankets and paint them on their clay pots. Other men discover figures on dead trees, in bones, in ashes, birds, water, and even in the palms of their hands. Men fight unsuccessfully over the meanings of figures and conclude that 'we live in a world of clouded meanings.'"

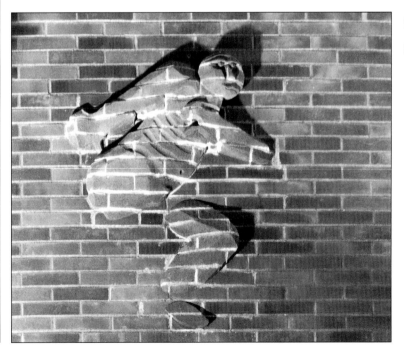

■ *Newport Library*

■ A man enters the library through the wall.

Marie Hanak photos

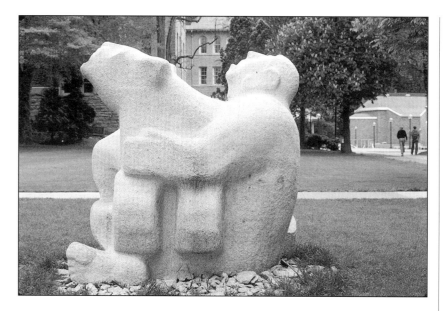

■ *The Old Man and the Cougar*, 1971
Adjacent to the Western Washington University Library
Bellingham, WA
granite

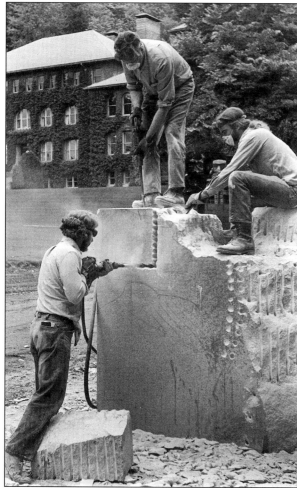

In 1971, when buildings on the Western Washington University campus were remodeled, new landscaping with artwork was planned. Rich was asked to provide a granite sculpture near the front of the library. For a subject, he chose a legendary story from the local area, "The Old Man and the Cougar." This is the tale:

"In the days before the campus was established, there was a man living in a cabin nearby. He used to hunt cougar for bounty, roaming the hills with his dogs. He prospered on the bounty, but the cougars became scarce. His dogs wore out, his knees gave out, and he could no longer hunt. He took to drink. So, now, with a cougar sitting on his lap, they both become drunk and sing 'America.' It is the reconciliation of the bounty hunter and the cougar; in its way, an ecological instruction."

For the sculpture, a 5' cube of Sierra granite was shipped from a California quarry and off-loaded at its designated location on campus. The placement was crucial as it was unlikely the huge stone would ever be moved again. Rich, son Charles, and our son-in-law at the time, Peter Donohue, and an occasional student carved the block with power and hand tools in about eight weeks time. A silk-screened design, *Einstein and the Crows*, also was done on a brick walk on campus.

The new Kah Nee Ta Lodge was built in 1971-72. It has a fine outlook across the valley to the hot springs and the Warm Springs River. Rich was asked to decorate the inside of the complex, as well as the exterior.

He routed designs in the cedar siding and painted them. They illustrate themes from this locale, such as mocking birds in flight, or a coyote sneaking under barbed wire. Legends told by Native Americans of the Warm Springs Reservation are also illustrated in fifteen locations. These include "The At!at!a'lia, and the Rabbit," "The Girl Guarded by a Coyote," and "The Boy Who Finds Fire in a Clam Shell."

The latter story goes as follows: A boy in the village is always fighting. The chief tells the other boys to take him up the river and lose him. They do so. *Itcixyan* (the River Monster) knows what they have done. The boy calls and calls, but the others have run back to the village. The chief orders the village to be abandoned and everyone takes to their boats and crosses the river. The boy returning finds that his grandmother has left coals in a clam shell under the cold hearth. At night, *Itcixyan's* daughter brings blankets for him to sleep under. She stays with him. They build a shelter. She bears his children. They prosper. But across the river the village is very poor. At night the grandmother comes over and *Itcixyan's* daughter gives her fish and meat. Then all the village wants to come back. As they cross the river, *Itcixyan* sinks the chief's boat. The boy who was always fighting now is the village chief.

When the excavation was made for the swimming pool at the lodge, a mass of volcanic tuff as large as a Volkswagen bug was removed. When Rich saw it he asked if he could fashion a sculpture from the stone to be placed on a knoll on the grounds. This became a reclining mother coyote and her pups. One of the pups has a human head and was dubbed "Son of a Bitch." While Rich was carving with a small jackhammer he almost created a union labor problem:

"I was at work when one of the workmen on the pool came up and said jackhammers came under their jurisdiction. I think that he believed at first we were just splitting the rock. After watching for a time, and seeing the sculpture take shape he figured it was more than just jackhammer work, and he backed off apologetically."

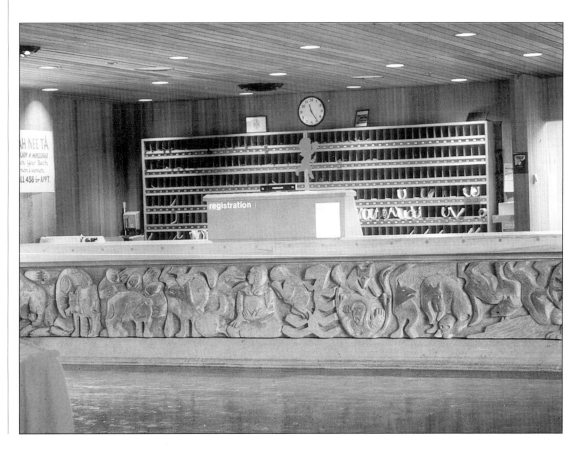

■ *Kah Nee Ta Lodge*
Marie Hanak

In the lodge, the front of the registration desk consists of a carved 25' long cedar log. Rich carved the log in deep bas-relief depicting many facets of Coyote's life, which is interwoven in myths of the Warm Springs people. Rich's source for the stories was *Wishram Texts* by Edward Sapir.

The door pulls of the lodge's main entrance are also Rich's work. Two horizontal blocks of carved oak depict, on the left, "How the Wildcat got the Tips of His Ears Blackened," and the one on the right, "How Bears Became Boulders."

When a new section of the lodge was constructed, Rich was asked to decorate the exterior in routed and painted designs similar to the ones on the original walls. The first one that visitors see is a story that Rich made up to decorate the end wall of the building, titled "The Story of the Eagle and the Coyote." In Rich's tale, the Eagle pounces on Coyote when he is "itching" fleas on the desert. Coyote then zaps the Eagle with his magic, knocking all his feathers off. Eagle grabs a gun and jumps on a horse to run Coyote down, but Coyote puts on the Eagle's feathers and hides in an Indian dance.

■ Kah Nee Ta front desk, bas-relief detail.

■ At Kah Nee Ta Lodge, Liz Beyer, Peter Donohue, and *Coyote and Her Pups*.

■ *Cedar Stump*, 1974
King County Park #10
4700 6th Ave S.W., Burien, WA
wood (cedar)

King County has built neighborhood parks to clear away and control brush and blackberry undergrowth, and to provide public access from one street to another, as well as recreational and playground facilities and drinking faucets. Park #10 is comprised of several wooded lots next to a branch library.

The landscape architect planning the park called upon Rich to design playground equipment and a sculpture. The focus piece is a large cedar "old growth" stump. In the early 1970s, an awareness of our laying waste to the landscape was just beginning to enter our consciousness; most people felt sad to see so many areas around Seattle cleared of evergreen trees. Rich procured this stump from Snohomish County, cleaned it up, and, with additional cedar pieces, carved life-sized ordinary folks, children, and other figures. These sculptures, some appearing much like the people in the Fremont figures, are affixed to the stump and circling it—they are dancing to bring it back to life.

An unusual drinking fountain was made by putting plumbing in a huge granite boulder and a frog was sculpted sitting by the spigot. Nearby were small buffaloes mounted on pipes, similar to carousel animals, for children to ride on. They were made of laminated hardwood. There was a game also—a mathematical game using pebbles in carved cups in a horizontal cedar log. All of these latter pieces now are deteriorated or need refurbishing. The cedar stump, however, is yet intact and "polished" from being climbed on by children for more than a quarter-century.

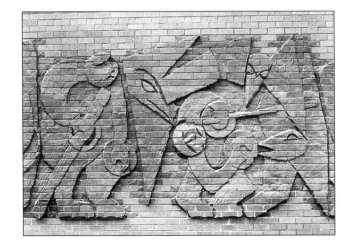

Rainier Beach Metro Station detail.

■ *Rainier Beach Metro Station (Panel)*, 1974
Seward Park Ave. S. at Henderson, Seattle, WA
carved brick

Marie Hanak Photos

The carvings in brick covering the east exterior wall of the pumping station illustrate Rich's story: "A man has dirty hands. Wash them as he may, they will not become clean. He sets out to find clean water. Terrible birds obstruct his way. Alligators threaten his life, but at last he finds a spring of clear, clean water. Plunging his hands in to wash them, his hands fall off. The mitts seen as auras around his hands are the clinging dirt and grunge."

Three Dogs Chasing a Rat, 1978
Regrade Park
3rd Ave. at Bell, Seattle, WA
sandstone

This park is a small open space established as an amenity for nearby apartment residents. The Seattle Parks Department had a program of acquiring small areas to make into "pocket" parks. Money was budgeted for a sculpture at this site. It was granted to a designer from California to make an oversized cement snail. Park planners also wanted a piece by Rich and decided it could be paid for under the budget item "playground equipment."

These sandstone pieces depict three dogs in a row on a bank of steps. Each dog leans forward from a step, looking down under the step he is lying on. Looking for what? The bottom dog has found it—a rat! This park improvement helped upgrade what was a run-down section of apartment complexes built before the 1940s.

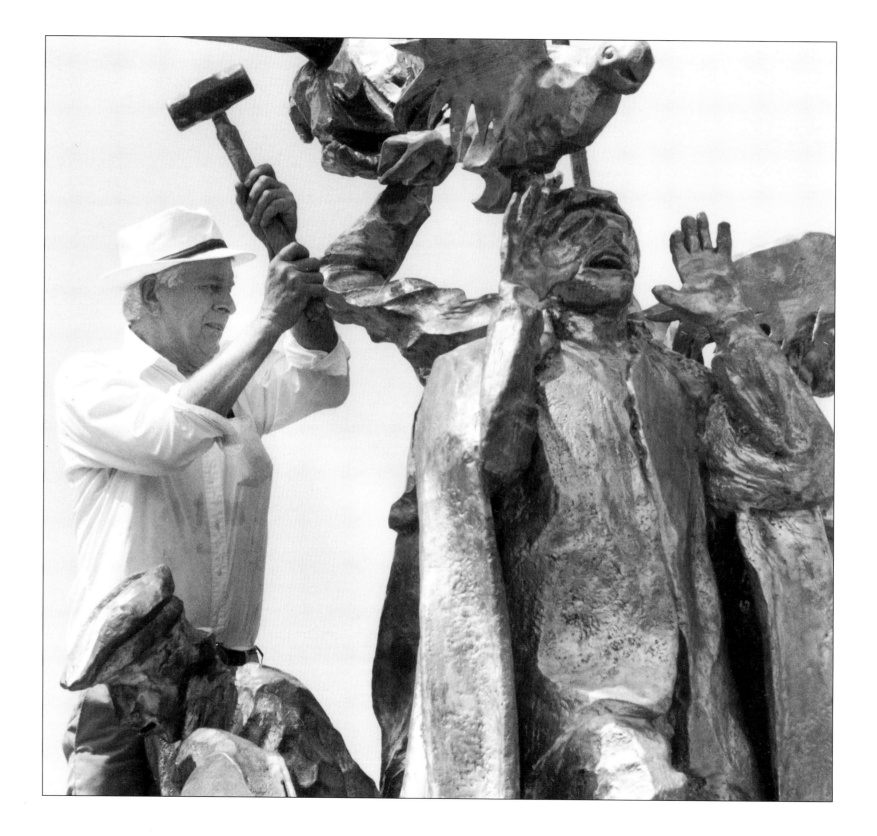

Part Six / Rich Disputes Government Intervention in the Art Market

It is a meeting of the arts commission. One "gentleman" is picking his nose, another stretches his arms skyward in an enormous yawn, a third—a plump and prosperous businessman—smiles complacently. The commission includes two architects. The elder is rumpled, battle worn, and weary, while the junior architect is resplendent and smug in his three-piece suit. Among the women at the table is a scholar with a craggy face, scarce hint of her sex. Another woman is the commission's executive director. She wears a supercilious sneer and has exaggerated, pointed breasts. Her bosoms appear aimed and ready to fire at any hapless artist who might contradict these high and holy Patrons of Art.

These twelve cast aluminum heads display Rich's biting satire. Although Rich is highly critical, he tries to stop short of being cruel because, says Rich, he feels sorry for these people. He views them as prisoners in a system that dictates art policy from above—a system that assumes the public has no taste and should have no particular say in the selection of public art.

Guests viewing the twelve busts at the opening of Rich's exhibition at the Larson Gallery in Yakima, Washington, interpreted them as being members of a generic committee. A professor said they were in a faculty meeting; a school board member saw the school board; and a CEO despaired that she could get any action out of such characters. Wherever they seem to be located, they are bureaucracy at its worst.

We had moved to Pateros in north central Washington prior to when Norm Rice was elected Mayor of Seattle. Rich, however, wrote to the mayor elect on behalf of the artists he had known in Seattle. Rich stated that the city's administration of the arts amounted to a "patronizing intervention."

Rich continued: "Art is approached as a resource to be developed, like fish and game or open space.

■ Rich adds a finishing touch to *Columbus (Four Images of the Man)* at Riverwalk Park in Columbus, Georgia.
Columbus Ledger-Enquirer

■ Kah Nee Ta front desk.

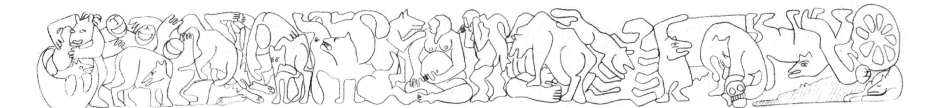

■ Sasquatch shoving a truck, before the sculpture's placement in Seattle's University Playground as *Sasquatch Pushing Over a House.*

Larry Lacock

"Great art does not come from afar," Rich argued. "It comes from the recognition of the artist in his own time in his own community. It comes from the cooperation of artists to meet the community's aesthetic needs. If it can do this now, it will continue to bring pleasure and not fall into the refuse of fad."

In the early 1970s, the Seattle Arts Commission (SAC) was a gleam in the eyes of a number of arts advocates who had been buying art to donate to the City of Seattle. They did so out of civic pride, and as a useful IRS deduction on personal tax returns. With the establishment of the National Endowment for the Arts, states and localities throughout the United States had a new model which they could follow to create their own art commissions. One percent of the total budget for constructing government buildings and other projects was to be set aside for artwork to decorate a structure or facility. Personal tax deductions for gifts now were no longer a common option. At first, the founders of local art commissions were often the same individuals who had made tax deductible gifts. As it turned out, they now could expend public money on their own personal tastes in art.

In Seattle, a public meeting was held in true egalitarian spirit to explain the art commission plan. One person in the small audience attending the meeting was Rich.

Two main points are remembered from his prepared comments. The first was that an architect designing a public building could no longer select an artist of his choice with specific capabilities for a specific project. Instead, an appointed commission now would select all of the artwork to be done from a pool of submissions competitively presented by artists.

Therefore it becomes the subject of a governmental bureaucracy. The bureaucracy holds that art is objects to collect, and not a process of expression—that the artist is expendable and the public has no taste. It intervenes between the public and the artist, attenuating the confidence of each in the other. It sets artist against artist in wasteful competition. It co-opts artists to pass judgment on others. Behind a claim of expertise in quality, it fawns to fashion from elsewhere and diminishes the status of the contribution of the local artist."

On the other hand, an arts commission could strengthen public demand for art by encouraging the public to find, and work with, artists in its midst.

Rich's second point was that local artists should be given the local funds, rather than granting local money to celebrity artists from afar. At that time, there was no talk of developing regional talent. And still today, artists from outside of the Northwest region are preferred (presumably because of their recognized stature in the national media) over regional artists. The new art commission's public meeting in the 1970s turned out to be perfunctory.

In 1980, at the dedication of *McGilvra's Farm* in Seattle's Madison Park, Rich had his chance to speak to a large audience about community art. He rejoiced in the process that had led to the creation of this group of five granite sculptures—a process of the "community" working with the "artist."

"We have a monument here, I feel, to a real will in the American community to value its history, to create opportunity for enjoyment, to use technology affirmatively, to cooperate with government and encourage talent," Rich told the audience.

Perhaps the project was feasible because Madison Park is relatively more affluent than many other neighborhoods and could afford such efforts. Yet, Rich asked if the project couldn't be a model for other districts in the city.

"What stands in the way of other groups finding their own artist, of working with that artist to create support in the community to raise monuments we can all be pleased with?" he asked. "I believe that standing in their way is the politics of art."

Rich is not opposed to politics per se. He has staunchly defended the use of *People Waiting for the Interurban* for political expression. "Politics is a positive human activity," he wrote in a letter to the "Friends of the Interurban."

"If we see only the selfish interests at work in our politics, I can understand our separation of it from our lives. But to see only the selfish interests is to encourage them. Then we put our lives in boxes, and I think this is the root of troubles, locally, domestically and universally. Art, too, gets put in a box, and we have the idea that art and politics should be kept separate."

It is that box, that barrier against the public being involved in the politics of art, that makes Rich chafe.

"Art has been low on the list of American priorities," he acknowledged in his *McGilvra's Farm* dedication speech. "In recent years, to try to change this, we centralized decision processes in the arts market into a governmental bureaucracy. We asked good people to oversee the process, but something was wrong.

"Experts were deciding what was Public Art. When this occurred, there wasn't that face-to-face relationship between the artist and the people who would live with the artwork. The arts professionals intervened between the relevant parties, not trusting a grassroots decision. The arts professional believes that, being charged with spending the public's money, the Arts Commission has the only authority of taste. The result of this is Art in Public Places which is an art certified by experts technically proficient, but limited in meaning.

"Art in Public Places and Public Art are not the same thing. Quality and creativity are two sides of the same coin. Great art is both creative and qualitative. The two sides of the coin are miraculously one. But an art that is creative is more consistent with our traditions than an art that isn't. The idea of Art in Public Places sacrifices creativity to technicality. Public Art, on the other hand, expresses the creativity of the community, risks being technically erratic; and that is the bureaucratic fear."

Rich's philosophy of public art gained even more exposure in 1989 when the Seattle Arts Commission rejected an anonymous donor's proposal to commis-

sion five Beyer sculptures. At the donor's request, Rich had developed a model for the first piece, which would be placed at Green Lake, a popular and heavily used park in Seattle's north end. The proposed eight-foot sculpture, entitled "Going Fishing," depicted a collection of children and a dog. Two boys whispered to each other, a little girl danced, and a toddler imitated her. Rich said it was a remembrance of a simpler, saner time.

SAC's Art in Public Places Committee turned the proposal down flat, giving a variety of reasons. One opinion setter on the committee did not perceive the model presented to be as good as other Beyer pieces which were already in place. Besides, members said, there were already too many Beyer sculptures in Seattle's public places—although none of these, interestingly, had been commissioned by SAC. Once again, we were in the midst of controversy, with the Seattle media happily fanning the fires. Despite irate letters to the editor and even a Seattle *Post-Intelligencer* editorial endorsing the proposal, SAC held firm. The proposal died, but not before Rich had his say in the media and in person before the SAC committee.

The argument, as he presented it to the committee, was less about Richard Beyer and more about the concept of public art, the art market, and the politics of art.

"Public art arises as an expression of people in their communities," he told the SAC committee. In contrast, "Art in Public Places is a matter of museums getting too crowded and taking over the public space for display. The Art in Public Places Committee has set itself up as if it were the board of a museum, albeit without walls."

"Public art is not collected," Rich noted. "It occurs when the community has some value to express."

He scoffed at SAC's argument that there were too many Beyer sculptures and a limited number of sites for art within the city.

"The city is growing and changing," he countered. "The community and the artist create their own sites."

Rich also questioned a tendency to put all of the art in the downtown area, apparently to generate tourism.

"Public art does not have to be all downtown in locations out of a bureaucrat's catalogue," he said. "The city cannot be made a museum; it is a complex society. The city already has an expensive museum system; it doesn't need another."

The heart of the problem, he continued, is that SAC "patronizes the artist and the public. It has created a bureaucracy, the life of which depends upon your standing between the artist and the public, setting artist against artist, and alienating the confidence of the public in their artists and the artists in their public."

With his sharpness of perception, we see Rich's characterizations in his sculpture "The Art Commission." Rich commented that he found the spirit of SAC "ungenerous and ingenuous."

"The bureaucracy is really the beneficiary of government patronage, not the artist wasting his time on SAC competitions, not the public that is diminished by SAC's condescension. Why is this? It is because the artist and the public are not organized. This is a serious problem of rights not answered by co-opting artists to your practice."

Rich was particularly unimpressed by SAC's claim to have had 400 artists compete for a single commission. He considers this "social waste" in which artists are pitted against each other in a struggle for available money. He believes artists need to unite to work for each other on several issues. He put his energy into organizing a Seattle chapter of Artists Equity about 1986, but it has not continued and the wide ranging political, economic, and so-

cial issues confronting artists—income tax provisions, copyrights, material safety, competition standards, museum policies, insurance, sales taxes applied to public art, art in the school systems, studio space, censorship, rural arts, and other concerns—have had to be taken up by organizations such as the Artists Trust and the League of Local Arts Agencies. Unfortunately, these local spin-offs of the Arts Commision movement are, in Rich's view, company unions. The benefits these groups can provide cannot substitute for artists taking into their own hands matters that affect their professional lives.

An especially big issue for Rich are the arts commission budgets. Rich wrote to a fellow artist shortly before the Green Lake incident: "If we exist by patronage, art is something less than it might be. I think the budgets should be reshaped to provide educational services in the community, to not so much indulge patrons' tastes but to interest the public in buying the artists' works." Pubic money should be programmed to enhance demand, not manage supply, he says.

Among Rich's proposals were to make commissioners' positions elective and to get a voting response from artists themselves. In Seattle, members of the arts commission are appointed by the mayor.

Also vexing to Rich is his belief that the struggle over government funding of the arts—particularly the debate in Congress over the National Endowment for the Arts—gets misinterpreted as a censorship issue. Actually, the NEA is a prime example of the government intruding in the market place, he says.

Over the years, Rich has frequently discussed these issues with artists, friends, scholars, and numerous others.*

*For more insights on the topic of arts commissions, artists, and the public, please see the Postscript for a comprehensive letter on this subject from Lyman Legters, Professor Emeritus of the University of Washington.

© Photo by Trisha Hines, 1979

Part Seven / Selected List of Public Sculptures

The Root Digger, 1978
Tribal Headquarters
Warm Springs Indian Reservation
Warm Springs, OR
cast aluminum

Another opportunity for Rich arose at Warm Springs, Oregon, located eight miles south of the Kah Nee Ta hot springs resort. The architects who designed Kah Nee Ta Lodge also designed the new tribal headquarters in the town of Warm Springs. Again, they asked Rich to work with them. An appropriate outdoor sculpture was requested. Rich chose springtime root digging as a theme to emphasize tribal heritage.

To learn about root digging firsthand, we went to Warm Springs and were introduced to Bernice Mitchell, who in the late 1970s still led annual outings to the high desert meadows to dig roots. The three of us drove to a location distant from town. Bernice, the mother of 13 children and a teacher in the Warm Springs Head Start program, knew the best locations to find roots.

She took along a *cup'n* (digging tool) and wore her ceremonial dress and hat. At her home, we all had been chatty, getting acquainted, seeking ease. On the prairie we were all quiet—respectful of the age-old custom of gathering roots. The earth was providing the Mitchell family with food for the following winter. She dug the *cup'n* into the ground and twisted it to loosen the root. After partially filling her *wapas* (root bag), she indicated we should go. It was not yet time for gathering roots because the prairie sod needed to be softer, but she felt pleased to be the model for the sculpture, and gladly performed the demonstration for Rich to sketch and me to photograph. She was a matriarch who taught school children the traditional way of digging, peeling, and drying roots. We were honored to be Bernice's guests.

The cast aluminum sculpture of *The Root Digger* is located in front of the tribal headquarters on a traffic island in the parking lot. It serves as a reminder to present-day Native Americans of their dependence on the land.

The Root Digger

Bernice Mitchell.

■ *McGilvra's Farm*
© *Photo by Mary Randlett*

"I made him out to be an old-time farmer in whose barn, and amongst whose animals, the children could play. It was a farm that was here in dangerous wilderness times, so the old bear is scheming with the young bear how they are going to grab one of the sheep. McGilvra's horse is unaware that a great cougar is sneaking up behind him to drag him away into the forest and make a meal of him. The beavers have inadvertently dropped a tree into the barnyard. Rats dance on the top of a tree that has been topped by lightening. Pig, goat, bull and alligator heads end the beams of the barn roof. Frogs' faces are carved in the cross beams of the floor. Snake, crow, rabbit and chicken sit on fence posts. McGilvra himself with his pitchfork is in the clouds as a weather vane on top of the barn. I felt he would want to be remembered this way.

"The architect, Art Skolnik, who wants to be mentioned in any publication on Madison Park, put the project together for me. We used cedar from the mountains for the barn fence and purchased the great blocks of granite from Vancouver, British Columbia, where they had been piled in storage under the Burrard Bridge. We constructed a kerosene-oxygen watershield torch to carve the granite into animals. We had to move them with cranes, the largest weighing about ten tons."

■ *McGilvra's Farm*, 1980
Madison Park
East end of Madison St., Seattle, WA
granite

Rich relates the story of *McGilvra's Farm*, and I cannot improve upon it. Here it is:

"In 1979 the community of Madison Park, Seattle, decided on a play area for its children in the large park on Madison Avenue close to the beach front on Lake Washington. This had been under discussion for about ten years when it was discovered the City of Seattle had unprogrammed Capital Improvement money. The Madison community submitted my name to do the work in the park.

"McGilvra, an early resident of Seattle, brought the railroad to Seattle in the 1880s. As a subsidiary interest he developed the lakefront property that is now Madison Park.

Marie Hanak

■ *Renton Wolves*, 1980
Cedar River Park
End of Burnett Ave. at S. Tobin, Renton, WA
brass

The *Renton Wolves* were cast in brass from old plumbing fixtures. The moulds were of wood. Sometimes Rich's wooden moulds have been sold or given away after a sculpture has been cast; however, he only casts a single sculpture from each mould. Renton Allied Arts, Inc., sponsored the *Renton Wolves* and it was paid for by the Rotary Club.

In his search for a suitable subject for Renton, Rich delved into Renton's history and American Indian legends. Finally, in *The History of King County* by Clarence Bagley, he found a tale to his liking, which Rich retells as follows:

"According to local legend, Indian women used to go out and gather large baskets of berries from the river bank in late summer. One day, a group of them were picking, and one woman insisted she had bad feelings about the place they chose to pick berries.

"That night when the other women bedded down around a campfire, the troubled woman went away and slept behind some boulders. In the middle of the night she heard wolves come to the camp. They devoured the sleeping women. Only she survived to relate the tale.

"My moral to that story is telling people not to let the City of Renton be eaten up by wolves—big business, industry, or government."

The wolves stand next to a boulder, eating berries from the baskets. Rich often uses boulders in his public sculptures. Boulders provide a natural look and a good contrast to the bronze or aluminum elements of a sculpture. We have been good at spotting huge rocks uncovered in street reconstruction or sewer repair projects. City workers are always delighted to use their equipment to move and place a rock for Rich. They have to get rid of the boulders anyway and are always willing to help Rich out in a project—free for the amusement.

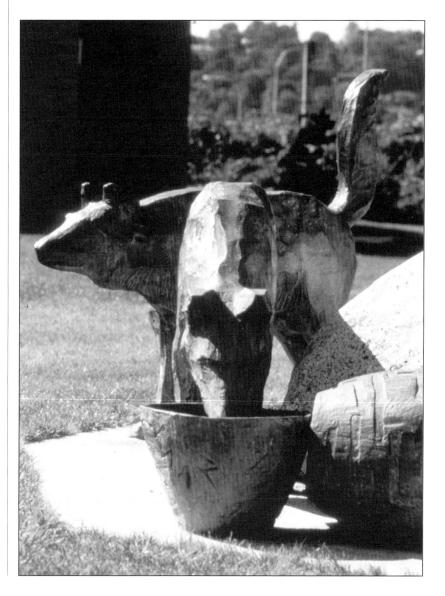

■ *The Ecologist and His Dog*, 1981
Spectrum Building
1580 Lincoln St., Denver, CO
cast aluminum

The Spectrum Building in Denver was built by a consortium of oil magnates. One of the gentlemen had seen *People Waiting for the Interurban* in Seattle and was determined to commission a suitable piece for the new structure. Rich was delighted with the challenge. We negotiated a contract about 100% advantageous to the client. In fact "negotiated" is a misnomer; we were just told what the price would be. However, so great was the compulsion to make the "right" piece, the matter of covering costs was not a high priority.

The client had some ideas for a sculpture, such as a man sitting on oil barrels, something about derricks, and so on. Rich turned the subject away from oil fields by creating a hippie character sitting on a bench in the lobby playing a banjo and singing with his dog. Laying by the man's foot is his hat, a receptacle for tossed coins

which the architect office's staff now collects for a local charity. The contented figure had instant appeal and was dubbed "The geologist who didn't make it."

We hauled the sculpture in an open truck from Seattle to Denver. Before arriving at the appointed time, we parked the truck and decorated it. We then drove up to the entrance of the building with colored ribbons flying from the hippie and his dog. Rich's unpretentious piece was placed on the ground floor of the 14-storey atrium, a gleaming and formal interior column of space. Above the 14th floor hang 8 gigantic prisms, fabricated by an innovative artist in New York. In the course of the day, the prisms catch sunlight coming through a huge skylight and cast rainbow colors on the interior walls, and on the failed geologist. The prisms are not glass, but consist of plastic three-dimensional frames filled with mineral oil. This magnificent scene, however, is relieved on the ground level by brick pavers and tree plantings making for a more informal, human scaled interaction around the sculpture.

The happy hippie has been named Roy G. Biv, for the colors of the spectrum—red, orange, yellow, green, blue indigo, and violet. It is conjectured his song is "Red, yellow, blue, green, prettiest colors I've ever seen."

Rich's subjects tend to be drawn from the kinds of human personalities that Rich has come to know and understand. They often are in a staged setting; the viewer observes the figures as if in a fleeting moment. In many of the sculptures, the figures appear real enough to bring on an expectation they will move. This is not to say that the style is representational to the point of depicting a subject in complete detail, but seen through Rich's lens of creativity, an essence is achieved.

This also holds true for his sculptured animals, which cause passing dogs to circle and bark, and can spook cats coming unexpectedly upon a newly placed sculpture. In this regard, Rich achieves better realism than in sculptures cast from moulds directly taken from living people and animals. This abstraction—achieved by Rich's feelings, and his concentration while designing and thinking of a subject as "real"—is a key element of his creativity. The gift is evident in *The Ecologist and His Dog*.

■ *Cedar Garden Apartments (Murals and Sculptures)*, 1981
2220 S.W. 337th Pl., Federal Way, WA
wood and bronze

In addition to other murals done at this location, Rich routed and painted a long expanse of exterior fence. Also located here are the bronze sculptures *A Raven Who Has Pilfered a Lady's Watch* and *Fox with a Stolen Cabbage*. It is gratifying to us that the owners have maintained these features over the years.

■ *The Itinerant*, 1981
Opposite 324 Broadway E., Seattle, WA
cast aluminum

Cliff posed for *The Itinerant*, which is on Broadway at Harrison, in Seattle. This aluminum figure of a man lying on a bench with a newspaper over his head is located in a "pocket" park, across from a Baskin Robbins ice cream shop. *The Itinerant* clearly is a bum. The sculpture was placed by Environmental Works, a group of architecture students promoting community improvements. They also designed the pergola for *People Waiting for the Interurban*.

A friend wrote Rich relating: "I drove by the man under the newspaper and noted a woman, perhaps 60 years of age, standing imperiously over the poor fellow, shaking her finger, berating him, jabbering away at a great rate, oblivious to his efforts to feign sleep."

Then, an article appeared in the *Capitol Hill Times*' Police Beat, September 21, 1994, which I quote as follows:

"Flaming memorial: Police saw a small fire burning on the sidewalk at East Harrison Street and Broadway at 1:30 a.m. A [retirement-aged] woman was dancing around it. The fire had been set with some papers and drinking cups underneath a bench with a stone sculpture of a sleeping man. On the sculpture there were soda cans and bottles, a beer bottle, a potted plant and several cigarettes arranged all over it. The woman told police that she was making a memorial to her dead husband. The woman was taken to Harborview Medical Center for an involuntary mental evaluation."

■ *Cedar Garden Apartments*

■ *The Itinerant*

■ *The Construction Workers*
© *Photo by Mary Randlett*

■ *The Construction Workers*, 1982
Wright Schuchart Building
Pontius Ave. N. at Republican, Seattle, WA
cast aluminum

In contrast to the less fortunate folks who have entered our sphere, there are the more economically secure corporate players. Two corporate officers, Howard S. Wright and George Schuchart, were constructing their headquarters in Seattle in 1981 and they asked Rich to create a public sculpture. They wanted it to reflect the purpose of the building. There were some suggestions that Rich dismissed, but which set his imagination in high gear. "Construction" was the industry to be illus-

trated. The Wright Schuchart Corporation had helped build the Hanford Atomic Reservation, numerous Seattle buildings, and naval facilities in Vietnam to mention only a few projects.

The admittance of women into the construction workforce at that time inspired Rich to sketch a buxom female superintendent bending over a male crew in a hand dug hole, pointing her authoritative finger at them. I told him that his motive of making fun in this way would not work, and the management also let Rich know the idea was politically incorrect.

The final design that was chosen, however, allowed the owners to laugh about the stresses of the construction occupation. It depicts four men in the process of solving the problem of where to put a wheelbarrow of wet cement. To the right, the contractor has a waist belt with tools and stands with his back to the front window of the building, scratching the back of his head in confusion. The architect stands near him looking through the window at the pretty receptionists. The owner stands next, pointing to the opposite wall as if to say, "The wall needs to be patched there," and a patient worker with his wheelbarrow loaded with "hot" cement waits to do what he's told.

■ *The Whale's Tail*, 1982
Alki Playground
One block off Alki Ave. S.W. at 59th Pl. S.W., Seattle, WA
cast aluminum, partially painted

In 1982, the Seattle Parks Department, through the auspices of Art Skolnik, developed three parks. A Beyer sculpture was commissioned for each location. At Alki Playground in West Seattle, Skolnik envisioned a whale disappearing into the lawn, which Rich produced in aluminum. The graceful flukes rise about six feet above a painted blue base depicting swirling water.

■ *Wyvern*, 1982
Bobby Morris Park, Capitol Hill
11ᵗʰ Ave. at Olive, Seattle, WA
cast aluminum, painted

At the Seattle Parks Department's Bobby Morris playground, a fanciful beast known as a Wyvern clings to a great fallen log. The cast aluminum sculpture is painted dark brown, and is splattered with colorful spots. When new, the sculpture's vivid spots attracted honey bees from all over the area. They regularly buzzed over the sculpture in the midday heat, inspecting what they perceived to be a bank of flowers.

The Wyvern is said to be the last known species of dragon. It roamed the low hills of England as late as the 17ᵗʰ century. As population increased, so too did the number of farms. The Wyverns—winged dragons with heavy tails, hooked bird-like beaks, and raptor claws—were thought to carry off piglets, cats, and full grown fowl. They struck terror in the hearts of farmers. The last one seen was shot when livestock were being defended, an event recorded in a rural history of the region.

One day, when we were taking an out-of-town guest on a tour to see Rich's sculptures, we stopped at the *Wyvern*. There was one child there, a girl of about 10 years crouched between the wings on the back of the Wyvern.

Rich asked, in a grandfatherly way, "How do you like your dragon?"

To which she replied in a low husky voice, "This ain't no dragon, mister; this is my motorcycle."

■ *The Whale's Tail*
© *Photo by Mary Randlett*

■ *Wyvern*
© *Photo by Mary Randlett*

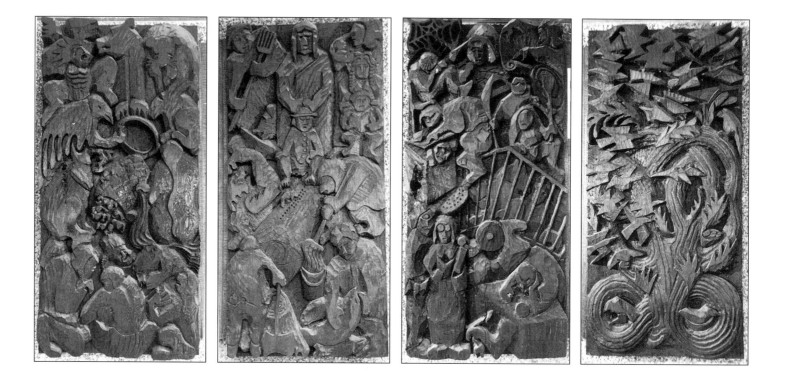

■ *Des Moines City Hall (Four Bas-relief Panels),* 1982
21630 11ᵗʰ Ave. S., Des Moines, WA
wood (cedar)

Long Ago—The Indians and animals are playing the stick and hoop game. In the center is the basket from which people were scattered over the countryside. A woman had a basket of children; Coyote told her to let some out in one place and some in another. This was how the tribes took up their localities in this country. In the upper left corner, a shaman predicts that nothing will remain the same.

Not So Long Ago—Settlers have come from the East to raise families around the Sound, to harvest timber, and to fish and farm. When Chief Seattle gave his speech ceding the lands and shores to the whites, Governor Stevens sat before him. Seattle put his hands on Stevens' head while he spoke, as was the custom amongst chiefs announcing great mutual decisions. To Stevens' left is the Puyallup religious prophet of this time of transition.

Within Our Time—We look back and forward. At lower left is a local historian and futurologist; he has the bird of time in his hand. The animals are in cages and people in boxes. We row our ship of state into the future. While we puzzle over the organs of the computer, our planners spend long hours discussing appropriate community design.

Forever More—This is the Nordic tree of life, with its roots in the earth and branches in the sky; all of its branches and roots grow into themselves in a great knot. We are the birds that find food and shelter in the tree. We crowd the sky seeking where to nest, to raise our families, and to share in the life of the community—receiving what we need and giving what we can.

■ *The Traveler*, 1982
Downtown intersection
Bend, OR
cast aluminum

A park bench is an ideal place for a sculpture. People can sit down beside a figure and their imaginations about it can blossom. *The Traveler* in Bend, Oregon, has that kind of charisma. In 1981, we visited the town at the invitation of Bend's Art in Public Places, Inc. The committee was anxious to revitalize the downtown area, which had become neglected, even deserted, because of the growth of a highway strip and malls. Bend's downtown, which includes the city and other government offices, has a historic ambience due to its small brick buildings, and it has the additional charm of its Mirror Pond—residents enjoy the fearless ducks coming right up onto the sidewalks and making themselves quite at home; they are fed and protected.

The success of Fremont's *People Waiting for the Interurban*, which helped awaken a new vision for businesses in a blighted urban area, was appealing to the people in Bend. The committee asked Rich to design a similarly appropriate piece for their downtown area.

The Traveler is a man who has come to Bend, likes it there, and does not want to leave. He is looking in his wallet, either for money, or perhaps the address of an acquaintance. The wallet is empty, and he is contemplative. The ducks from Mirror Pond share the bench with him.

Rich had a young man from the Quaker Meeting in Seattle pose for him. Stan was in his late twenties in 1982 and unemployed (and was still unemployed in the late 1990s). Homeless, before the "homeless subculture" gained media recognition, the Quaker Meeting had provided friendship and gave him encouragement. He was very agreeable to posing for

Rich, even though the chainsaw came too close for comfort a few times while Rich carved a cedar model. Stan endured. After the casting, Rich gave Stan the model in recognition of his courage, but Stan sold it the following week to a Fremont businessman for $500. In fairness to Stan, I must report that he did acquire a job as a private security officer, resplendent with a uniform. The day that Senator Henry Jackson passed away he was asked in the morning to raise the American flag at half-mast. This he did, not noticing the flag was upside down. He was speedily terminated.

In 1988, *The Traveler* was recipient of the Governor's Arts Award presented by Neil Goldschmidt, Governor of Oregon.

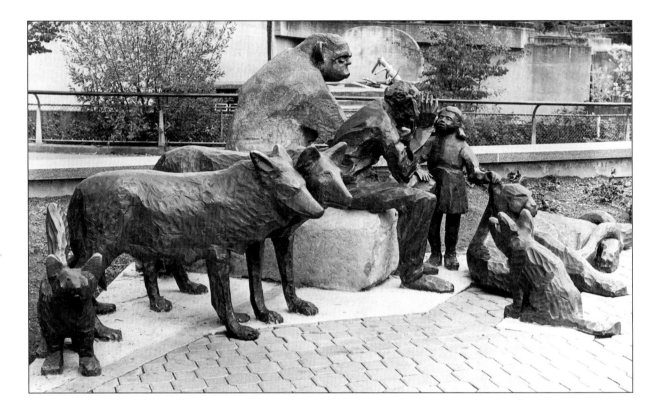

The Storyteller
Marie Hanak

■ *The Storyteller*, 1983
Washington Park Zoo
Portland, OR
bronze

Time wise, this was one of Rich's longest projects, taking three years from the beginning interview to its dedication in 1983.

The zoo director was instituting new educational programs, and, at first, he wanted a Beyer piece added to the zoo's sculpture garden, which he discussed with Rich. But later, he asked Rich to produce a focal piece for the plaza at the new penguin house.

The theme of the sculpture, of course, is story telling. An elderly man surrounded by forest animals tells a little girl how the forests used to be—there were cougars, wolves and their pups, and even sasquatch. The sasquatch sits behind the old man on a bench of columnar basalt and hoots as if to say, "You don't know what it was really like."

The sasquatch's face is similar to that seen on Northwest Coast Indian ceremonial masks, which depict her hooting with an o-rounded mouth. When worn by a chief at a Potlatch ceremony, such masks were considered to be a blessing on those assembled.

The little girl portrays no fear of the animals and even holds the ear of the reclining cougar. She listens intently to the old man; their interaction is the focal point of this large piece.

The bronze sculpture was cast from wood moulds at Charlie Beyer's foundry in Moscow, Idaho.

■ *Sasquatch Pushing Over a House*, 1983
University Playground
50ᵗʰ St. N. at 9ᵗʰ Ave. N.E., Seattle, WA
cast aluminum and wood beams

The third aluminum sculpture of the Seattle Parks Department's 1982 commissions was scheduled for the University Playground on 50ᵗʰ Street, two blocks west of Roosevelt Way. In 1956-57, a wide corridor of small, one-family houses had been condemned by the government to construct the I-5 freeway. Hundreds of simple dwellings that numerous families called home were vacated and mowed down by bulldozers. Rich was appalled to see this happen in the name of progress.

His sculpture at the University Playground memorializes this destruction by showing a female sasquatch pushing over a house. The "house" consists of framing made of eight-inch beams. It was an engineering puzzle to construct a wracked structure that would not fall over and which would be safe for children to scramble on. The Parks Department approved Rich's plans and took the risk. The sasquatch is female because that is the way Northwest Indian legends usually describe the creature.

■ *Kah Nee Ta Village (Pool Sculpture)*, 1983
Warm Springs Indian Reservation
Kahneeta, OR
bronze

In 1983, the pool at the popular Kah Nee Ta resort on the Warm Springs River was being renovated. Three cement bears on a low, dividing wall between the deep and shallow ends of the pool were all but dissolved by minerals in the hot springs water. Alarmingly, chunks of cement had cracked off and fallen into the pool. Rich replaced the concrete sculptures with three bears cast in bronze. The bears, however, now hold salmon from which spout fountains of water.

■ *Sasquatch Pushing Over a House*
© *Photo by Mary Randlett*

■ *Kah Nee Ta Village (Pool Sculpture)*

■ *The Peaceable Kingdom*
Marie Hanak

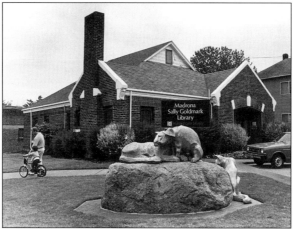

© Photo by Mary Randlett

■ *The Peaceable Kingdom*, 1984
Sally Goldmark Library
Union St. at 33rd, Seattle, WA
cast aluminum

A good example of a community initiated sculpture is *The Peaceable Kingdom* in Seattle's Madrona District. The Madrona Community Council had access to block grant funds for a public sculpture at the Madrona library, which was housed in an old brick fire station (formerly called the Stationhouse Library). The neighborhood had become increasingly interracial between about 1965 and the end of the 1970s, and residents also represented a mixture of economic backgrounds ranging from the wealthy to the unemployed. Three interracial public schools served the area, as did an interracial parochial school and a white independent school which became interracial in the 1970s. The Black Panther organization had an office in Madrona, and provided free school breakfasts.

Regrettably, a few hassling Black youths began frightening store keepers, stealing from property owners, and robbing the unsuspecting elderly of their wallets or purses. The Seattle Police did their part to answer calls, but they also stopped cars and interrogated people without apparent cause. Interracial tension was high. However, in another five or six years, by 1984, successful intercommunity action helped resolve much of these problems and fears abated. The Madrona Community Council asked Rich to create a sculpture which would acknowledge the success of the interracial community in handling its differences.

The Peaceable Kingdom is located on the grounds of the Sally Goldmark Library across the street from the Madrona School, an interracial elementary school. Cast in aluminum, a panther sprawls on top of a large boulder, while a pig shares the space, closely snuggling the panther with its snout. Rich's symbolism here regarding the community's recent history was not missed. Alongside the aluminum boulder stand two more animal figures— a wolf and a sheep, as if in idle communication. These two symbolize the street youth and the little old lady in tennis shoes. The theme is recognizably from the Bible, Isaiah 11: 6-9, although different kinds of animals are appropriately used here. It is a study in reconciliation.

■ *Donkey Run Away from the Mines*, 1984
Tonkin Park, opposite of the Whistle Stop Ale House
340 Burnett Ave. S., Renton, WA
cast aluminum

In a Renton Municipal Art Commission competition for a sculpture for proposed new maintenance shops in Renton, Rich was chosen for the "1%" award (i.e., 1% of the project's construction budget was designated for artwork). The commission, however, decided the sculpture should be made available to public viewing and changed its location to Tonkin Park in the downtown area. This park sits alongside a railroad, which occasionally still is used. In the early 1900s, it carried coal from the mines in Renton's hills to the booming city of Seattle. Across the tracks is the Whistle Stop, a working man's tavern which has been there for as long as anyone alive now can remember.

Donkey Run Away from the Mines stands in the park directly across from the Whistle Stop. The donkey appears to be peacefully grazing on the lawn, with the strap of his harness dragging on the ground. In the early days of western mining, donkeys worked alongside the miners pulling "ore" cars containing coal, minerals, waste rock, timbering, and other materials. In mines across the West, donkeys often spent weeks or even months working and living constantly in the gloomy underground, with feed and water hauled down to their stalls. The faithful animals eventually were replaced by motorized equipment. This donkey has run away to find fresh air, light, and green grass.

On the eve of its dedication, the donkey was rudely attacked. In a *Daily Record Chronicle* article, October 7, 1984, Mike Brennan reported:

"Just hours after Renton's newest artifact was erected in downtown Tonkin Park, vandals toppled the $5,000 sculptured donkey by ramming it with a truck.

The replica, titled 'Donkey Run Away from the Mines,' paid tribute to Renton's coal mining history. It was to be formally dedicated at 1:00 p.m. Friday by city officials.

"A 23-year-old Renton man and a 29-year-old Seattle man were arrested Thursday night for investigation of malicious mischief. Renton police said a witness reported that after two suspects tried unsuccessfully to pull the donkey to its knees with a truck, they took a running start and rammed the sculpture. The 600 pound cast aluminum donkey broke cleanly at all four legs, below the knees."

The next morning phone lines were hot; the first call I received was from one of the young men—in jail. He had sobered up and was very contrite. He said he loved the sculpture so much that he attempted to steal

it. He vowed he would pay for its repair, and, of course, we let him do that.

Rich had no phone at his studio, so I drove across town to Fremont with the bad news. Rich's immediate agitation was not about the aborted larceny, but rather he feared that a practical joke would be revealed. It seems that he had taken a notion to fill the cavity of the cast animal with horse manure and worried that it had spilled out! Then he would have to go to jail.

Rich arrived at the scene of the disaster and found the inside-joke still secure. Repair was fairly speedy.

After the main offender was released from jail, he declared himself "keeper" of the donkey and posted signs around the tavern. He also invented a game for the tavern regulars: Pin the Donkey on the Legs. When the authorities' anger and the mayor's and art commission's dismay subsided, Rich met the young man, who became a steady guard of the sculpture. Rich forgave him, and affirmed his honesty.

■ *Man Slopping Pigs*

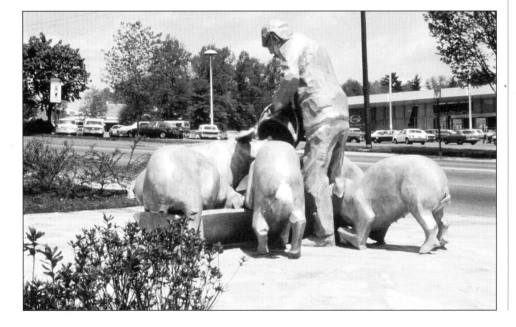

■ *Man Slopping Pigs*, 1984
Don Beyer Motors, Inc.
1231 West Broad St., Falls Church, VA
cast aluminum

Rich was born in Washington, D.C., and brought up on Spring Hill Farm in McLean, Virginia. Many of his images are drawn from sympathetic observations of people and animals in rural settings. *Man Slopping Pigs* is a study in pig energy and of a stalwart human form, the farmer.

In 1984, Rich's brother Donald operated a car dealership in Falls Church, Virginia, a town near McLean (today, his sons operate the business). Don Beyer, Sr. commissioned Rich to make a landmark sculpture for the town. The Beyer brothers claim that Falls Church was the hog capital of northern Virginia many years ago, and no one has proved otherwise.

Rich has his own agenda for the social commentary exhibited in his artwork. It is a wry statement to those who take themselves too seriously, or who would be pompous in the Washington, D.C., bureaucracy. Rich likes incongruity—the formal against the informal; the elegant against the gross. He describes his art as Urban Folk Art. It is for the average taxpayer and stands for what he or she finds significant in life. Each sculpture translates an idea, a story, or a bit of history for the community which the piece will serve.

Rich does not sign his artwork; when a piece is finished it belongs to others from then on. He adheres to the philosophy, "Gifts given should be freely given in return." He takes an aspect of humanness, an essence, or truth, and depicts it in sculptural form. This becomes the reality of a piece, which often cannot be expressed in photographs of a sculpture, but must be experienced firsthand.

Man Slopping Pigs could be from Rich's experience on the farm, or is it historical, or allegorical? Does it represent five bureaucrats at the government trough?

Don Sr. says, "The story is in the eye of the beholder."

■ *The Story of Bricklaying*, 1984
Mutual Materials Corporation
605 119th N.E., Bellevue, WA
carved brick

The Mutual Materials brick company of Bellevue, Washington, launched a nationwide promotion of carved brick sculpturing. A new addition was planned for their main office building and Rich was asked to decorate it with bricklaying scenes. This was a good opportunity to demonstrate the techniques of deep relief sculpturing while, at the same time, showing how the strength and integrity of the brick walls can be maintained.

On the building's interior walls, there are three life sized brick workers—a man mixing mortar, a hod carrier, and a mason. In modern bricklaying, the mixer and hod carrier have been replaced by a muller and hoist, but the mason is still a necessary laborer with special hand skills. Rich's mason is having a spiritual experience slopping mortar on a brick.

■ *The Horse*, 1985
White Horse Crossing Subdivision
12718 S.E. 252nd Pl., Kent, WA
cast aluminum, painted

Vandalism and graffiti have rarely been problems for Rich's sculptures. Thefts have outnumbered the instances of graffiti. But at the White Horse Crossing subdivision in Kent, *The Horse* fell victim to nocturnal paintings. In 1988, three years after its installation as a mascot piece for the housing development, the local *Val-*

ley Daily News reported numerous paint jobs applied to the aluminum sculpture. It was painted like a zebra (which Rich thought rather clever), and other times had orange and blue stripes, too. Sometimes, obscenities or satanic symbols were painted on it. And one time it was wrapped in toilet paper—which must have required about a case of tissue. People scolded the vandals in the newspaper.

I have not heard of the horse's fate in recent years. The development's management has painted the sculpture white, and always has taken good care of it.

■ *The Story of Bricklaying*

■ *The Horse*

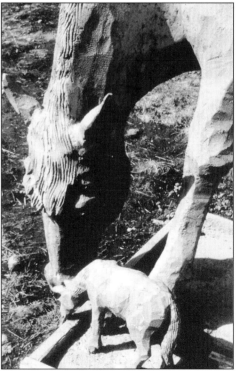

67

■ *The Children*, 1985
Rainier Beach Library
9125 Rainier Ave. S., Seattle, WA
cast aluminum

This commission was community financed. One or two primary donors were involved, but the bulk of contributions came from alumni of the local

■ *The Children*
© *Photo by Mary Randlett*

Emerson Elementary School in Seattle's Rainier Beach section. The sculpture is a memorial to Victor H. Dickinson, who was the principal at Emerson for thirty years during a period of racial integration in the Rainier Valley. African Americans and Vietnamese moved there in large numbers, swelling the population of what had been primarily a Caucasian and a more traditional Asian American community. The sculpture is a tribute to Dickinson and his accomplishments.

Principal Dickinson united students of all races in a common cause: Getting a good education. The sculpture is designed to show Dickinson's love for children, art, and learning. Through his efforts, the Rainier Beach neighborhood became racially interactive and balanced.

The sculpture depicts three children. On the left, an African American youngster reads to himself. In the center, a Caucasian girl looks up from a book she has been reading to another child.

Rich said, "She is holding her book face down, staring off into space, wondering what adults are doing for the children of the world. I was trying to express concern for children as persons. I think this is consistent with the feelings the community has for Victor Dickinson."

A librarian reported that during the installation ceremony, a little boy and his father were walking past the library. The youngster saw the sculpture and spontaneously ran up to hug one of the children in it. The sculpture evokes the love and caring taught by Victor Dickinson.

A remark I have treasured came from an African American longshoreman we had known for many years. He said, "Rich, you sure do know how to make a little Black boy!"

■ Margaret Quinn Grant and Rich
at the Pateros studio, circa 1995.
John Grant

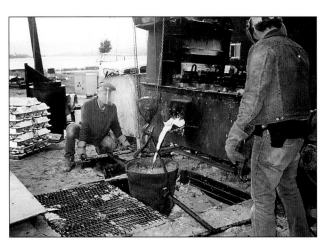

■ "Lost styrofoam" casting—molten aluminum being poured from the furnace into a ladle.

■ As the metal is poured into the sprue of the sand-encased mould, the styrofoam burns and flames up as it is replaced by hot aluminum.

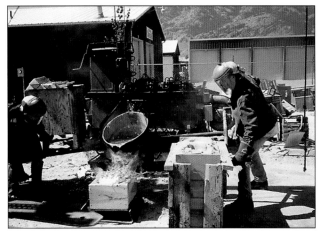

■ After the pour, Rich breaks sand loose from the sculpture.

■ *Hywaco*, Shi Shi Beach.

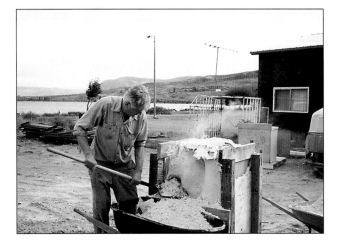

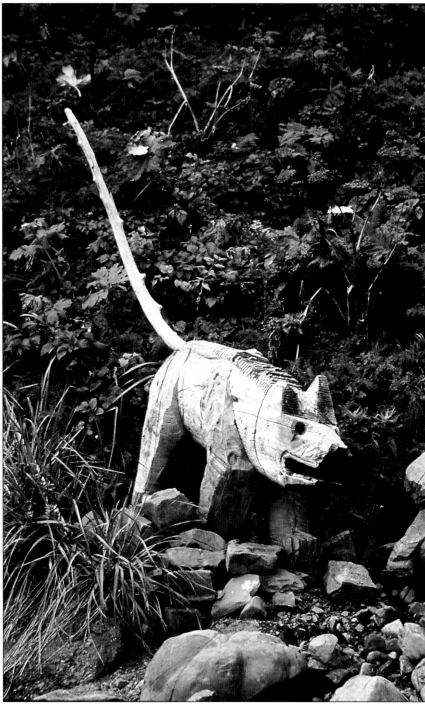

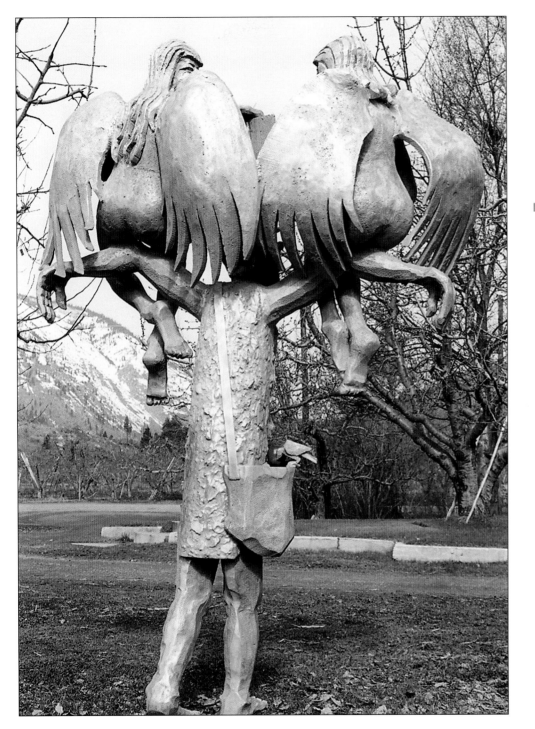

■ *Johnnie Appleseed* is located in a private orchard near Manson, Washington (rear view).

Marie Hanak

Kah Nee Ta Lodge on the Warm Springs Indian Reservation, Oregon—

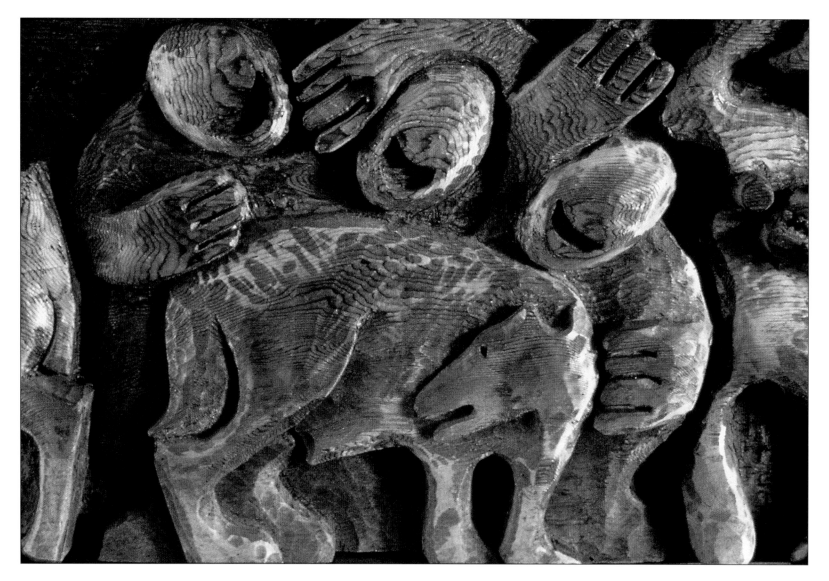

■ Coyote figures prominently in Warm
Springs Indian legends.

■ Detail of a wood carving.

■ Women displaying horsehide.

■ Boy finds fire in a clamshell.

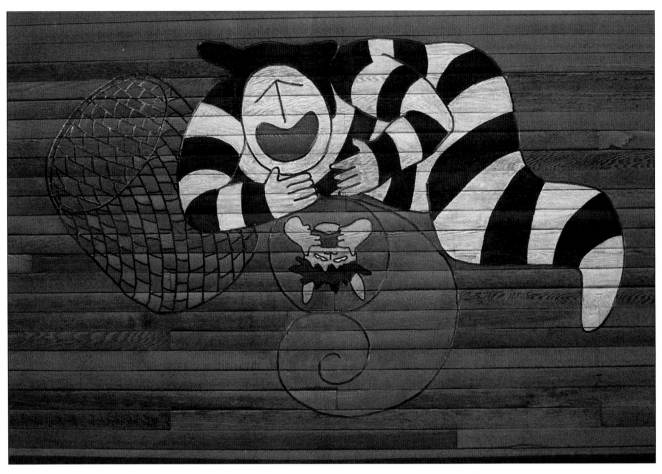

■ At!at!a'lia.

■ Door pull.

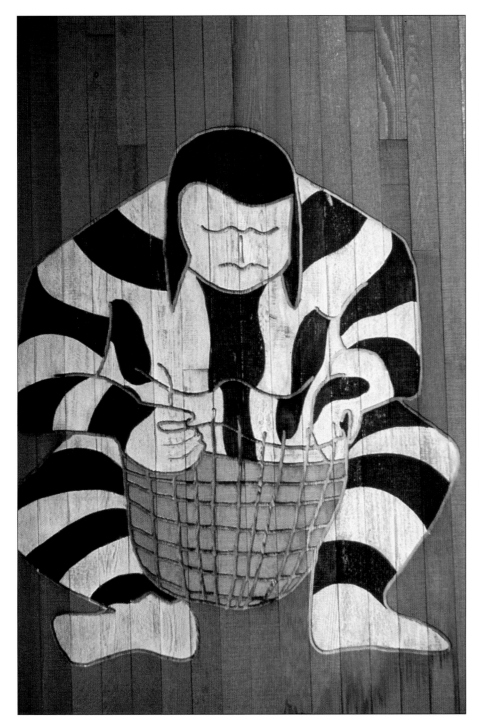

Basket weaver.

Bear and salmon.

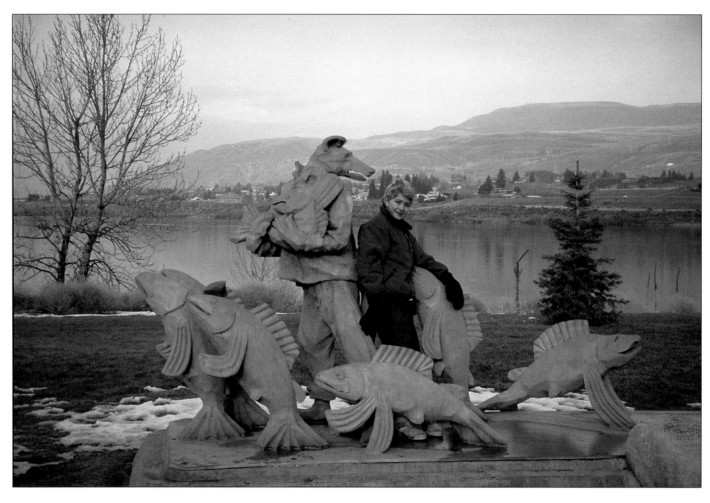

■ *Coyote Leads the Salmon up the River* (1990) at Walla Walla Point Park, Wenatchee.

■ *Codfish Head* (1969) at Shi Shi Beach on the Olympic Peninsula.

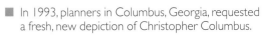 In 1993, planners in Columbus, Georgia, requested a fresh, new depiction of Christopher Columbus.

■ *A Raven Who Has Pilfered a Lady's Watch* (1981) at Federal Way's Cedar Garden Apartments.

■ Four of the Beyers' grandsons "cutting up" by *Sasquatch Jumping*, relocated from the Olympic Peninsula.

■ The cubs in *Dancing Bears* (1987) at Bellevue's Sherwood School represent children playing together.

■ The boy's coonskin hat in *Growing Up* (1987) caused controversy on Mercer Island.

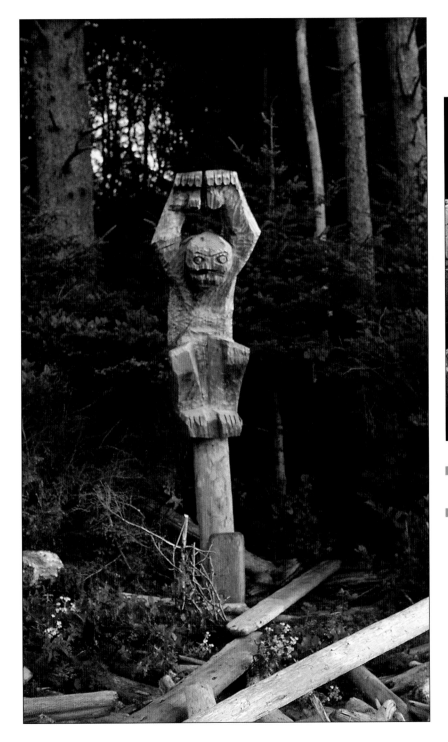

■ *Sasquatch Jumping* on the Olympic Peninsula's wilderness coast.

■ A wooden mould for the *Renton Wolves* (1980).

■ Styrofoam casting model for *Man Slopping Pigs* (1984).

■ Solar Boat panel at the Anna Wheelock Lemon Library, Tacoma.

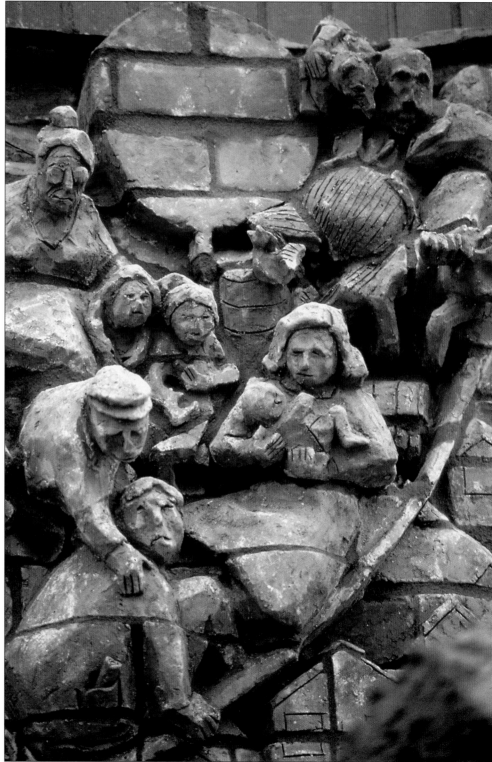

McGilvra's Farm (1980) at Seattle's Madison Park.

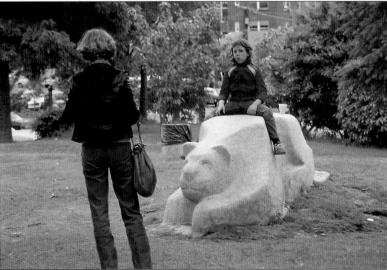

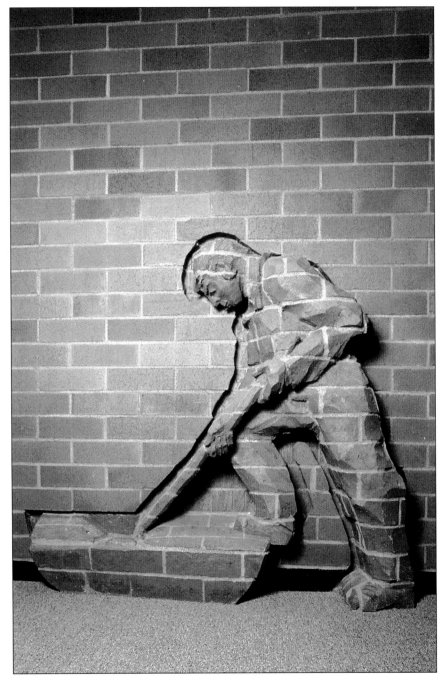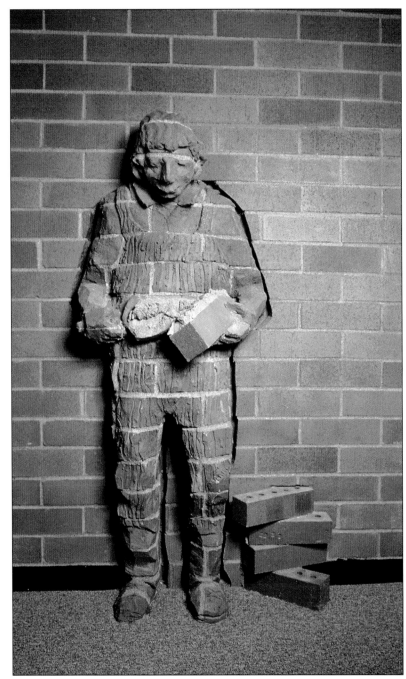

■ *The Story of Bricklaying* (1984) at the Mutual Materials Corporation, Bellevue.

■ *The Bull* (1986) in Ellensburg's Rotary Pavilion.

■ Diminutive, bronze construction workers adorn the Merrill Court condominiums in Seattle.

■ *Captain Alexander Griggs Walks to Work* (1997) in Wenatchee's Sternwheeler Park carrying a model of the *Selkirk*.

■ *Wyvern* (1982) in Seattle's Bobby Morris Park, Capitol Hill.

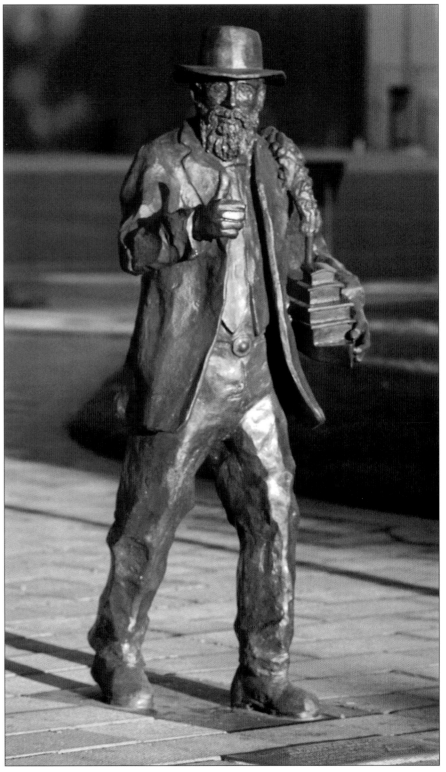

The Little Girl Who Grew Up with Chickens, 1985
Radisson Arrowwood Hotel
Alexandria, MN
wood (ash)

Ten carvings in laminated ash decorate posts in the restaurant's banquet room. They tell a country story, as follows:

- The little girl and her chicken friends.
- She remembers her mother standing at the wood-fired stove.
- Her papa at leisure, reading the newspaper in his rocking chair.
- The young girl holds a photograph of her brother lost in the war.
- She grows up and marries her sweetheart. We see them in their wedding clothes standing before the minister.
- Then her first child is born. She is up at night with the baby while the father confidently sleeps.
- Now we see her as a pregnant woman pushing a shopping cart with the first child riding in it.
- Her husband goes fishing.
- She is middle-aged; the children are grown and have left home. She sweeps the dog out of the back door with her broom.
- The last carving shows her seated, as a grandmother, knitting while grandchildren play around the bench.

Merrill Court (Decorative Features), 1986
Seattle, WA
bronze

Small bronze decorative features adorn the outside of this condominium complex in Seattle. Represented here are images of squirrels, as well as diminutive-sized construction workers, including a bricklayer, a taper, a man with lunchbox, and so forth. On the court signage two squirrels have dropped a pine cone.

The Little Girl Who Grew Up with Chickens

Merrill Court

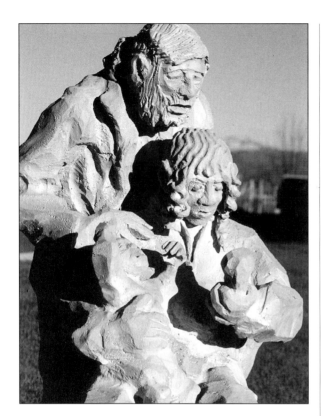

■ *A Call from America*, 1986
North Wire Center
1309 E St., Anchorage, AK
cast aluminum

In 1985, the Arts Commission of Anchorage, Alaska, commissioned Rich to create two public sculptures. The first one, depicted here, was installed in 1986 at the North Wire Center, a large building located in a residential section of town. It is not an office building, but rather a warehouse for a vast array of electronic wiring—the telephone exchange for the City of Anchorage.

Rich's sculpture stands in front of the building and depicts a young woman sitting in a chair holding a baby in her lap with one arm, and a telephone receiver in her other hand. The baby is bawling. Behind the mother stands a bearded young man, typifying a "back to nature" type of twenty years prior.

Rich tells their story this way: "The young lady from Bellevue has her mother on the phone and tells her of the wondrous grandchild she holds.

"The grandmother in the lower forty-eight says, 'But are you married?'"

■ *Lunch Break*, 1986
Metropolitan Transit Administration Building
Anchorage, AK
cast aluminum

The second sculpture commissioned in Anchorage is located at the edge of the Metropolitan Transit Administration Building parking lot. The parking lot adjoins an in-town wilderness area of short conifers and brushy terrain, which is used for training sled dogs.

Here sits a bus driver on a large boulder, eating a sandwich. A grizzly bear, with front paws on the rock, stretches its neck toward the food. The design at first caused consternation among committee members because they feared it would induce small children to feed bears. Rich changed the posture of the bus driver's arm and hand, to indicate he was not going to share the sandwich with the nice bear.

In the following year, a call for artists' proposals went out for sculptures to be placed in several locations at Anchorage's new Performing Arts Center. Rich applied, sending three drawings and models.

For the center's lobby, he proposed a smooth and graceful non-objective piece of granite which, he felt, would satisfy the Anchorage elite's expectation for a modern "art in the eye of the beholder" type of sculpture. It was a large rubber ball, squashed, as found in a gutter. It would consist of rigid material, but would appear soft and pliable.

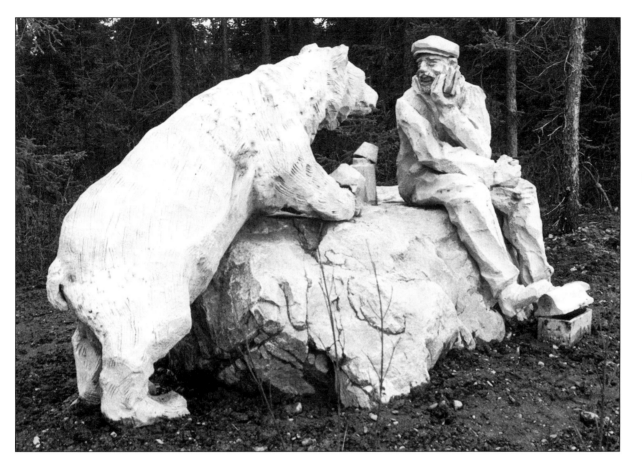

■ *Lunch Break*

At the entrance to the parking garage, he suggested a large scale aluminum sculpture depicting a team of husky dogs in a fierce fight. This not infrequent Alaskan scene would symbolize the well-known competition for parking spaces before cultural performances and shows, along with the tension often experienced when hoping to arrive on time at an event after a member of a party is, rightly or wrongly, blamed for tardiness. Such tensions arise especially where cultural events require expensive tickets.

For the lobby of the balcony seating section, Rich proposed a bronze sculpture, titled "The Miner Who Lost His Pants." The debut of this model has its own story. The art commission had been expecting to receive Rich's model, and several commission members were in an office with the press in attendance (I believe TV for the evening news). With expectations running high, the wrappings of the package were carefully removed, the box was opened, and the assembled faces peered in. The small wooden model was lifted out, briefly inspected, and dropped back in. A hush of dismay settled over the group—there were scowls, and a wry smile or two, but no evening news clip.

The number of Rich's Anchorage sculptures remained two!

■ *The Bull*
Brownen Miller

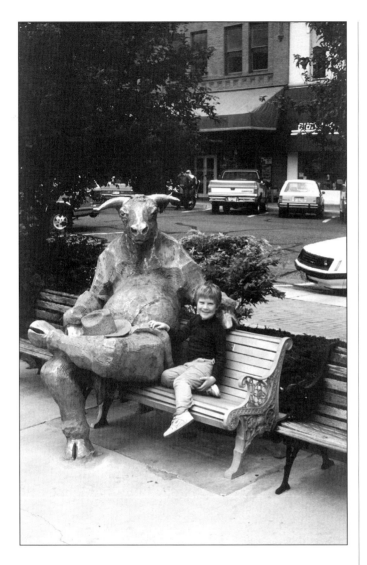

■ *The Bull*, 1986
Rotary Pavilion
Pearl St., Ellensburg, WA
cast aluminum

The idea of a public sculpture for downtown Ellensburg was initiated by Dick Elliott and Jane Orelman of Ellensburg's downtown task force. Rich presented a small cedar model of the sculpture to the Ellensburg Art Commission on September 25, 1984, and it was approved. It was decided funding was to be by $50 subscriptions from private sources. On October 15, 1984, the model was presented to the city council with a request for its installation at Ellensburg's Rotary Pavilion.

The model, named "Cowboy," was a bull sitting on a bench with a cowboy hat on his lap. Rich said it was to honor the cattle industry in the area. But some cattle ranchers were offended by the title, and felt put down by the use of the word "Cowboy." The ensuing controversy over the benign model and its name seemed to disrupt the town.

Rich said, "I really meant it to be fun, and I was certainly shocked that so many people seemed so offended by it."

He was glad to change the title to *The Bull* and see if the offense could be cured. The uproar from ranchers seemed to stem from the name, not the artistic merit. It was said Ellensburg had not been so responsive to an event in years—not since taking sides over the dog leash issue. The *Ellensburg Daily Record* printed full pages of pro and con letters sent to the editor. At the same time, the committee continued raising money for the purchase of *The Bull* by hosting many events—"fun raisers" they called them. Little by little, they were being successful in raising the $15,000 needed for expenses. This was a quiet, steady validation of *The Bull*.

When the name was changed, the underlying reason why people were personally offended by *The Bull* finally broke out into the open. The bull's private parts, which are not "private" in a real bull's life on the open range, were suddenly disturbing to ranchers, cowboys, and The Cowbelles, an organization of ranch wives. Grandmothers, too, protested that they

could not take their grandchildren near the bull for fear of rude anatomical indoctrination. We wondered how they kept their wee ones clear of all the pastures in the Kittitas Valley.

In January 1985, Rich brought the styrofoam model of *The Bull* to Ellensburg and placed it in the Rotary Pavilion, so the city council could view it on site. The result was overwhelmingly positive. The council approved the Rotary Pavilion location. Again, in April 1985, the styrofoam model was returned for a public viewing. It was met with delight. Several ladies of over-50s vintage were seen to bend over to surreptitiously check the bull's anatomy.

The Bull was installed permanently on a snowy day in December 1986. Now it is a common sight to see a grandmother having the grandkids pose around the bull for a candid snapshot.

■ *The Storyteller*, 1987
Lake Washington Park
Lake Washington Blvd. at N.E. 59th, Kirkland, WA
cast aluminum

The composition of *The Storyteller* is like a stage setting. It consists of three figures on an L-shaped bench; a natural arbor extending over the group suggests an architectural enclosure. This is a corporate sculpture— a public amenity for a large modern office building located on the site where a hotel stood a century ago. The historic old hotel at Houghton Beach was directly across Lake Washington from Seattle's Madison Park.

In the days when the nearby wilderness was being logged, a ferry ran from Madison Park to approximately Houghton Beach. Holiday gatherings were held at the hotel, but for loggers it also was the last stop in civilization when leaving for the woods and the first sign of civilization when coming out. The history of

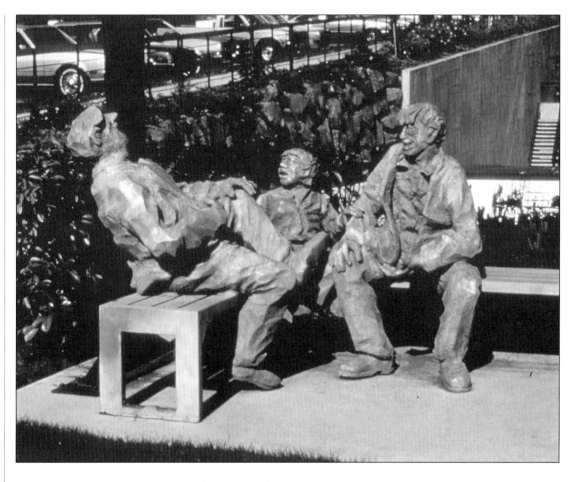

■ *The Storyteller*

the area is well documented in displays located behind the sculpture. Rich imagined that the porch of the old hotel was a meeting place for travelers and workers, both coming and going.

To the left is a man laughing contagiously with his head thrown back and slapping his knee for emphasis. Across from him is the man telling the delightful story. A small boy sits between the men; his expression shows that he is confused and does not understand the story. Rich has cast the three of them in a manner making them seem very much alive.

■ *Dancing Bears, A Memorial to Cecil Lowe*

Marie Hanak

■ *Dancing Bears, A Memorial to Cecil Lowe,* 1987
Sherwood School
16411 N.E. 24th St., Bellevue, WA
cast aluminum

Another anthropomorphic sculpture is *Dancing Bears, A Memorial to Cecil Lowe,* located at Bellevue's Sherwood School and dedicated in October 1987. The Sherwood School is for disadvantaged children and the playground is designed for their specific needs. Cecil Lowe was director of special education for the Bellevue School District for nineteen years, until his untimely death in 1984. At the dedication, his grown son said he was gruff, but loveable, and was firm in his beliefs.

Lowe, of Scottish descent, was known for playing the bagpipes for students. The sculpture shows him as a very large bear—bespeckled, and wearing a tam-o'-shanter and playing bagpipes.

His wife said of the metaphorical irreverence, "Oh, he would be beaming. He'd be grinning from ear to ear."

Alongside the large bear, who is both dancing and making music, run two bear cubs hand in hand, in obvious enjoyment. One cub's gestures are those of a Down's Syndrome child.

The establishment of the park was instigated by a Bellevue resident, Christie Heaton, who understood the needs of handicapped children—particularly those using wheelchairs who required a barrier free playground. She said: "The more I found out about the lack of that opportunity, the more compelled I was to do something about the inequity."

Christie Heaton and other citizens worked for two years to raise $220,000 for designing and building the park, including acquiring the sculpture. It was truly a community project.

■ *Growing Up*, 1987
Near 2780 78th Ave. S.E., Mercer Island, WA
cast aluminum

In March 1987, members of the Mercer Island Design Council decided to ask Rich to look at the Mercer Island business district with the idea of placing a sculpture on city property. Some local residents felt that Mercer Islanders took themselves "too seriously," so they looked to Rich to provide a sculpture with some comic relief.

The day before his visit, *The Storyteller* had been dedicated in Kirkland and there was considerable anticipation about what Rich could do for Mercer Island. City officials suggested children be included in the sculpture and possibly the local animal icon, the raccoon.

"This business of raccoons," Rich thought aloud, "might be great fun."

A month or so later, Rich returned with a model of two teenagers—a boy and a girl—"hanging out" on a brick wall in front of the Caldwell Banker building. The male youth wore a coonskin hat. However, it immediately became evident that there were two distinct schools of thought, so to speak, on Mercer Island—those who loved the little animals, and those who would be glad to get rid of the pesky varmints. The pro-raccoon party also objected strenuously to the coonskin cap. The controversy aroused emotions, and a debate was on.

Before the argument became deadlocked, Rich thought of a solution: The young man had discovered a road-kill raccoon on a wooded street. He did not want to throw it in the garbage, so he properly skinned it and made a hat. Thus the theme shifted to a positive recycling tale, and the youth kept his hat on.

■ *Growing Up*

■ *The Cougar, Holding a Hazelnut Branch*

■ *The Cougar, Holding a Hazelnut Branch*, 1988
Hazelnut Park and Library
14475 59th Ave. S., Tukwila, WA
cast aluminum

This larger-than-life cast aluminum cougar lounges on a boulder sunning itself—when there is sun in Tukwila. It seems to me that the cougar is Rich's way of reminding us of the original forest before the intrusion of paved streets and family home plots.

The cougar raises its head to view a little hazelnut twig, which it holds in the claws of a paw. The hazelnut tree is Tukwila's town emblem. The peaceful animal is inoffensive and has no human characteristics, except for holding a hazelnut twig. The sculpture is situated on the grounds of the Tukwila Library, which is housed in a remodeled fire station.

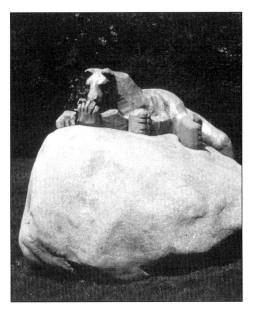

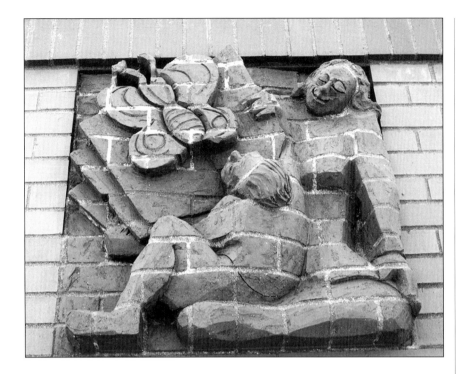

■ *Anna Wheelock Lemon Library (Panels)*, 1988
3722 N. 26th St., Tacoma, WA
carved brick

Even though five of the panels located here are mounted high on the library's front wall near the top of the windows, they are easy to view. The panels are 4' x 4' and spaced evenly along the wall. In addition, a low, outside wall is inscribed with a long panel spelling out the library's name.

In this type of sculpturing, bricks are carved when in the mud stage, then each is numbered and lettered on the back in a grid system. The bricks are dried and fired, and, in the handling, the bricks get completely mixed up. Brick masons, not having seen the complete sculpture when it was set up in the "green" stage, are naturally at a loss to figure out the design. Since bricklayers are ex-

pensive to hire, and reassembling the puzzle is time consuming, one of us has to organize the hundreds of brick pieces and hand each one, in proper order, to a mason.

I have been pleased to do this job for Rich, making new friends and directly being part of a project. In this instance, it had to be done in a cold Tacoma drizzle over the course of four days, which led to time-outs for hot coffee and our bashing the "jolly weather." We have always found that masons and other skilled workmen are energized by working on Rich's projects. Often, it is their first opportunity to do so, and it is a source of pride for them. Backhoe and crane operator, too, are generous to a man. They are pleased to move huge rocks, logs, and finished sculptures with precision, and for the sake of art. I hope all of these helpful people have good memories of our projects.

Of the five library panels, the farthest to the left depicts the Solar Boat over Tacoma, with Mount Rainier in the background. Every day as it rises, the sun boat carries the people of Tacoma into the city to their places of work. People from all walks of life are recognizable in the panel.

In the second panel, an author is seen penning words with a quill pen.

The third panel concerns opinion. Included are four faces depicted as if shouting, "This is what I see."

The fourth panel shows animals dancing around a bonfire of burning books. Rich felt that while the burning of books is unthinkable, the violence with which we sometimes confront opinions other than our own is very real. A library committee member was concerned that children might think burning books would be a good prank and try it. Rich, however, softened the act by depicting animals burning books, rather than people.

The last panel nearest the entrance is of a kindly librarian reading a butterfly pop-up book to a child.

■ *Ivar Feeding the Gulls*, 1988
Ivar's Acres of Clams Restaurant
On the waterfront
Seattle, WA
bronze and aluminum

Ivar Haglund was a legend in his own time; he established a restaurant chain called Ivar's Acres of Clams, beginning in 1936. He also had a radio program of commentary and songs, the latter of which he made up and sang himself. He was good natured, fun loving, and known to be a maverick.

His friends, restaurateurs, and others decided to raise money for a memorial to Ivar after his death in 1985. Neighboring merchants on the Seattle waterfront joined in to form a committee called Friends of Ivar Haglund. The group included Morrie Alhadeff, Gordon Bass, Edward E. Carlson, John Franco, Ken Hatch, Chuck Peterson, and Victor Rosellini. The committee asked Rich to present a proposal. They also asked the public to donate to the sculpture fund. The names of the contributors are listed on the back of the captain's chair.

The memorial shows Ivar dressed in his captain's jacket and hat, with three very large gulls reaching for a shoestring potato in his hand.

"Why," Rich was asked, "are these gulls so outsized?"

Rich said: "Because Ivar was part of the seagulls and the waterfront. Seagulls were big in his life. Besides, when the statue is finished and put in place this winter, small children can sit on the seagulls. Ivar would have liked that."

The story is told that customers in the restaurant were regularly feeding the ever-present gulls, which swooped down and rested along the railings. The Seattle City Council felt this was causing unlimited amounts of guano to be deposited on the waterfront railings and sidewalks. They passed an ordinance prohibiting the feeding of seagulls. Ivar took immediate offense and put up a sign: Feed My Gulls, They Like My Shoe String Potatoes. No one stopped feeding the gulls, and the ordinance was unenforceable.

Ivar's slogan at Acres of Clams was, and still is, Keep Clam. So, under the captain's chair, Rich has placed two little mollusks running on their legs to escape the hungry gulls.

■ *Ivar Feeding the Gulls*
© *Photo by Mary Randlett*

■ *Family Watching TV*, 1988
King Broadcasting
333 Dexter Ave. N., Seattle, WA
cast aluminum

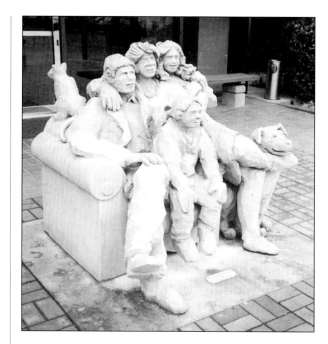

■ *Family Watching TV*

The owners of King Broadcasting commissioned this sculpture in 1988 to solve an acute problem at their building. The structure has large glass doors and windows across the front, and, earlier in the year, a daring youth in a sports car purposely drove his car through the doorway and into the lobby. This was not only dangerous for him, but also for visitors and bystanders, and it terrified the receptionists seated at desks in direct line of the entrance.

No one was hurt in the incident, but the management realized a barrier was needed in front of the building. However, they did not want to install unfriendly bollards or any barrier that might cause undue attention or provoke an attack. Rich was called upon to provide human interest and humor in a sculpture that also could serve as a barricade.

The *Family Watching TV* faces the street, in relaxed postures, forever watching the screen with engaged expressions, while effectively serving as protectors of the building's entrance. The cat ignores the TV.

■ *Life, Love, Time, Game*, 1988
Seattle/Tashkent Peace Park
Tashkent, Uzbekistan
cast aluminum

The challenge of this commission in what was then the U.S.S.R. had both intellectual and heartfelt goals for Rich. It was an opportunity to bring Soviets and Americans together for the sake of mutual understanding, and for the valuable experience of working together to build the Seattle-Tashkent Sister City Peace Park in Tashkent, Uzbekistan. In 1986-87, plans were finalized for the park. In the Soviet Union, Premier Mikhail Gorbachev was head of the Communist Party and had begun to make changes in the lives of ordinary people; they felt some relief from the KGB eye, though they could not yet speak freely. Suspicion and paranoia were lessening, and hate propaganda toward the U.S. cooled.

We traveled to the Soviet Union in June 1987 with a team of people from the Ploughshares organization, which was promoting the park. The purpose of the trip was to see the location selected for the park, and to meet various persons in Moscow and Tashkent who would set up the citizens and crafts groups needed to join with the Americans to accomplish the work. It was a time when most Americans did not truly trust Russian intentions of establishing peaceful relations. Within a year, however, there was a positive change of attitude; we felt welcome and our own suspicions no longer caused fear.

We could all believe that peace was possible.

One of the most important contacts for us was Yakov Shapiro, a well-known sculptor who was supported by the Soviet government. His workshop, tools, and employees all had been provided by the authorities. During our first trip in 1987, Yakov and his wife, Lucie, entertained our team at dinner with their family, friends, and several people from the city government.

One of their guests was a friend from Moscow, Vladamir Genibekov, a cosmonaut and a general in the Army. The general had come to see Yakov, and to rest and paint in his studio. It was his favorite vacationing place. Fortunately for us, our visits overlapped. We were awed to be in the presence of a Soviet cosmonaut of high rank and one who was well known for his painting. General Genibekov spoke perfect English and had polished manners. With his fine translating skills, it was easy to convey complicated thoughts. The general had been to America many times, in particular to the NASA complex in Houston. There, he had joined in the planning for cooperation between the two countries in space. We learned later, through an article in *National Geographic* magazine, that Genibekov was one of the cosmonauts sent up to the Mir Space Station to fix faulty equipment and to relieve its resident crew in about 1985.

It was clear that he had a genuine respect for all humans. He urged us to believe that the Soviet people desired peace. Rich asked about the love that could be shared between Soviet and American citizens, and the General replied that love was too unpredictable. He said that true friendship, dependable and enduring, was the goal. Vladamir Genibekov was an impressive person; we were glad he had an influential position in Russia.

When we had the opportunity to exchange gifts, I chose to give him stones from Washington state, one of

■ *Life, Love, Time, Game*

which was a polished agate pin for his wife. We both knew that the same rock specimens are found in the Soviet Union—just as human values can be found to be the same. Vladamir accepted the gifts for his family and then gave me a big hug. We never saw him again.

The following year, we arrived in Tashkent before the sculpture *Life, Love, Time, Game* had arrived. It had been shipped gratis by United Airlines Air Freight to Moscow. There it languished, until Aeroflot represen-

tatives could understand the situation, check many numbers on slips of paper, and ship the sculpture to Tashkent. The process used up a week. Ian Miller, our grandson, age 11 at the time, came with us as the youngest member of the Ploughshares park building team. Yakov and Lucie Shapiro hosted the three of us in their home. During the week that the sculpture was "lost" en route, Yakov and Lucie took us to the Fergana Valley, Samarkand, and Bukhara. Their generosity was unlimited.

Rich reported to his mother after the trip:

"We were entertained on the highest cultural level of the city. The Shapiros shared their circle of architects, musicians, ministers, administrators, and artists, and a Bolshoi ballet dancer, with us. We went from one great party to another. Because Shapiro saw my work as standing up to his, and the accomplishments of his people, his return was to feed us to bursting and give us opportunity to express the hope the Soviets shared that the nations would compete for cultural excellence rather than power with violence. Yakov's wife, Lucie, translated for us.

"Yakov is an impressive man, small, boyish, theatrical, brilliant, open, moody, affectionate. He is knowledgeable about power and people. He has friends the length and breadth of the Soviet Union. He is sentimental and cynical, smooth and proud, but above all is devoted to the ideal of beauty. Though a Ukrainian by birth he has adopted the traditions and values of the Uzbek people as his identity. He handles the academic realistic idiom with facility; he can capture the essence of the Moslem style with equal facility. His love of the life in Central Asia made us realize how much we prize the values and ways of the American West. I think amongst the people I have met in the sculpture business, he is the most

significant. The freedoms the Soviets are gaining may create space for him in time to create very great work. It is a gifted life in the vast machinery of the history of Central Asia. A saying has it that Truth and Beauty is all and is only what man is about. I felt that Yakov and I sat on either end of the seesaw, but, perhaps, were able to see what was the other's vision. Lucie is a dear: proud and loyal in the role that the culture assigns to women as servants and at the same time the moral authority and guardian of the family. She is an English teacher at the high school level. Her own children are overgrown teenagers who have a sense of wonder in their eyes and a personal sweetness that touches the heart. Lucie cooked indefatigably, did everything Yakov asked; walked to the market, answered the phone and translated our conversations. Margaret and Lucie hugged each other in admiration and fellowship; they both had to endure unpredictable husbands."

Rich's totem-like sculpture is not about ideologies, nor intellectual points of view. It is about people's lives, which are the same in both countries. It is a cast aluminum sculpture 16 feet tall:

On top is *Life*, the first 20 years. Two infants make a toast, Russian style, with their bottles.

Love is depicted by a couple in bed, no doubt with family ideas. This is the second 20 years of life.

Time, the third 20 years, between ages 40 and 60, is a period of toil and service. The man and woman endlessly push the hands of a clock.

Game depicts the years of age, 60 to 80. The two figures sit on their grave stones, playing "cat's cradle."

Rich wrote: "Perhaps by putting up the statue in Tashkent we have left a statement of our appreciation of their warmth and interest. Perhaps the statue can do this.

"It was a huge effort in the beginning to make. First there were 10-12 hours a day in the July sun [at Charlie's Moscow, Idaho, foundry], heavy work, casting, grinding, welding, fitting, but it seems to be a source of delight to people who see it. It is very different from anything the Soviets have produced in their tradition. It is truthful about what our lives are and is pleasant in its expression. I think I have gotten pomposity and obsequiousness out of the design, and propaganda and self-pity. So in expression of admiration of their great traditions and infinitely varied accomplishments, perhaps I can offer this."

■ *Sun Mountain Lodge (Bas-relief Panels)*, 1989
 Near Winthrop, WA
 wood (ponderosa pine)

The registration desk at Sun Mountain Lodge is 20 feet in length and fashioned from whole ponderosa pine logs. Rich's carvings consist of separate panels, set side by side, extending across the front of the desk and around a corner to face the fireplace area. The carved bas-relief figures are pairs of animals, who have taken rooms in the lodge; they include sasquatch and his wife, who have caught a mouse.

The concierge's desk, which is opposite to the front desk, was remodeled in the summer of 1998. Here, on a smaller scale, Rich has carved bas-relief panels titled "Animals Make the Weather." The story begins with grandma coyote telling the young coyotes how the weather comes about. From the left, Cougar makes it hot and deer make it rain. Frogs make fog, and mountain goat makes snow. Bear makes floods, and picas bend the rainbow. The little coyotes go out the door to see if what grandma coyote says is true.

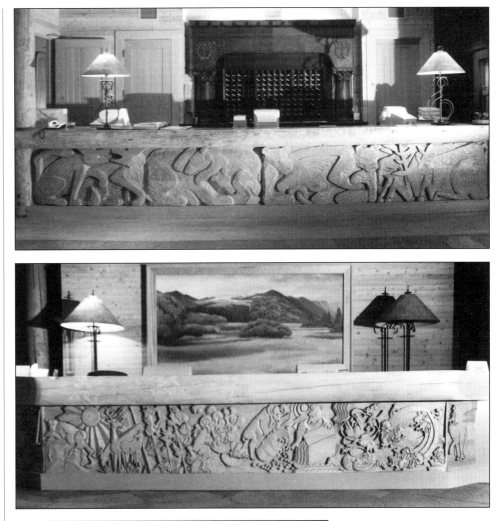

Sun Mountain Lodge (Bas-relief Panels)
Marie Hanak photos

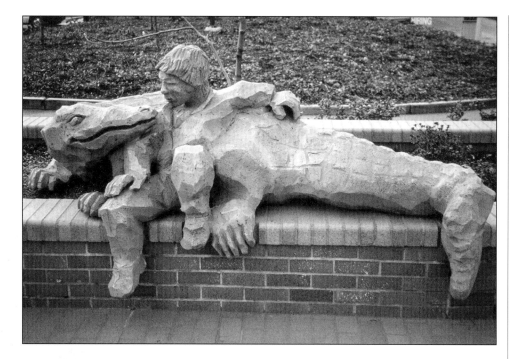

■ *Boy and the Alligator*

■ *The Coming of Books to Everett*
Marie Hanak

■ *Boy and the Alligator*, 1989
McDonald's Restaurant
Near 2780 78th Ave. S.E., Mercer Island, WA
cast aluminum

The City of Mercer Island helped direct Rich in placing another municipal sculpture at the same T-corner intersection where *Growing Up* was located. A new McDonald's restaurant was planned adjacent to the intersection. The city required the owner to provide requisite green space and an amenity for public enjoyment.

Rich chose to make a young boy with an alligator. Just why this was chosen, we will never know; I have just recently asked Rich about it. He doesn't know either, but said it was suggested that he sculpt an old bum on a bench reaching toward a little boy and his dog, in a gesture of sharing a hamburger. Such sentimentality Rich could not abide. Approval was granted by the owner and the city, and the result was the *Boy and the Alligator*. The viewer will see that it gives us a pleasant fantasy.

■ *The Coming of Books to Everett*, 1989
Evergreen Library
9512 Evergreen Way, Everett, WA
carved brick

In this 8' x 10' exterior wall sculpture, Rich worked closely with historian David Dilgard and the library director, Mark Nesse, to ensure accuracy in telling the Everett story.

Colby, Rockefeller, and Rucker in the upper center of the design came to exploit the woods and make fortunes in the Northwest, but it was the women who were concerned with morality and education of the people. Wives and children are portrayed in the center foreground, carrying books and pushing a shopping cart. The sculpture, too, signifies social progress, typified by the free speech movement; a protestor and placard can be seen at the upper left.

But, life today is a hurry to get somewhere, indicated by the boy at left center with his hand on a car. Lumbering always has been part of Everett's culture and economy; this is symbolized by the pickup truck at the right, carrying lumber piled over its tailgate. A parking lot, shopping cart, and strip mall signs all indicate commercialism as a dominating experience in our lives. Rich has portrayed books in this sculpture with ironic titles: *How to Win Friends and Influence People; On Human Nature;* and *City of God.*

■ *The Kiss*, 1990
Percival's Landing
Olympia, WA
cast aluminum

The Patrons of South Sound Cultural Activities (POSSCA) decided to provide the City of Olympia with a Rich Beyer sculpture. When Rich presented the idea of *The Kiss* to the city council, they voted unanimously to accept it.

A council member not up for reelection was quoted in the *Olympian* as saying: "These are difficult decisions. Public art always seems to be controversial! No matter what we do, we're going to catch hell for it. I'm riding off into the sunset, so I don't have to catch hell, but I think it's a good decision."

The sculpture depicts a large, statuesque woman kissing a shorter man in a business suit. Rich says he is a legislator and she is his secretary. The couple casually leans against the dock railing at Percival's Landing.

■ *Coyote Leads the Salmon up the River*, 1990
Walla Walla Point Park (PUD)
Walla Walla Ave., Wenatchee, WA
cast aluminum

One of the most important characters in Northwest Indian legends and myths is Coyote. He is cast as a male personality who makes powerful changes for the good of people. He has magical powers, and considers himself attractive, particularly to women. If not given his due attention, he is quick to retaliate on offenders with some magical misfortune.

In 1988, the North Central Washington Museum in Wenatchee presented an exhibit titled "The Upper Columbia River . . . As It Was." The exhibit was the inspiration of William Layman, who has extensively researched the history of the Columbia River before the dams were built, and who studied the rock art—pictographs and petroglyphs—made by natives in the area long before white settlers arrived. For the museum show, Layman asked Rich to illustrate a Coyote story in sculptural form.

Coyote Leads the Salmon up the River was carved out of cedar for the exhibition. By the time the exhibition ended, the sculpture had gained popularity among the public and there was interest in having a permanent Coyote sculpture mounted in a PUD park which was nearing completion on the river.

A special group, the Friends of Coyote, was formed with the help of the museum, William Layman, the mayor, and the Rotary Club. Allied Arts of North Central Washington agreed to act as the sponsoring agency. Alcoa of Wenatchee donated 2,500 pounds of aluminum for the sculpture, and the PUD donated the site. Many other individuals and businesses gave assistance and financial contributions.

"It's been very gratifying," Rich said. "The site is just wonderful and the cooperation of the whole town has been great."

The figures in the sculpture illustrate the Native American story of how the salmon came up the Columbia River. Coyote wanted to provide salmon for hungry people upriver, but learned that the salmon were trapped behind a dam that the swallow sisters had built downstream near Celilo Falls. Coyote tricked the sisters into leaving long enough for him to clear away the dam. The fish were then able to swim upstream. Coyote guided them, telling some to go up little creeks and some to go up larger streams like the Wenatchee, Entiat, and Methow. Coyote carries a baby salmon too tired to swim on its own. He turns to look back at two adult fish who seem more interested in spawning than the upriver trip.

■ The Kiss

In the 1980s, the preservation of spotted owl habitat became an important issue on the West Coast. The owls' habitat is old-growth conifer forest, which also has provided a valuable supply of logs for the timber industry. When it was decreed that much of the old growth forest was illegal to harvest, many small Northwest towns dependent on logging lost a key source of income.

Shelton was one of those towns. Loggers were out of work, and went searching for jobs. Shelton residents felt a need to honor timber workers and asked Rich to create a sculpture of a logger at the town's new library.

Rich's logger holds his small son on his shoulders, and looks up into the branches of tall evergreen trees standing near the library.

Rich said: "The awe the logger must feel as he walks into the old growth! And at the same time, the sort of paradox is that we've cut these trees down to make our living and support our families.

"So we wonder about ourselves. We're wondering about our responsibilities as human beings in the world around us. How do we preserve our trees and institutions and create, if you will, loving communities for our families?"

■ *The Logger*

■ *Coyote Leads the Salmon up the River*
Marie Hanak

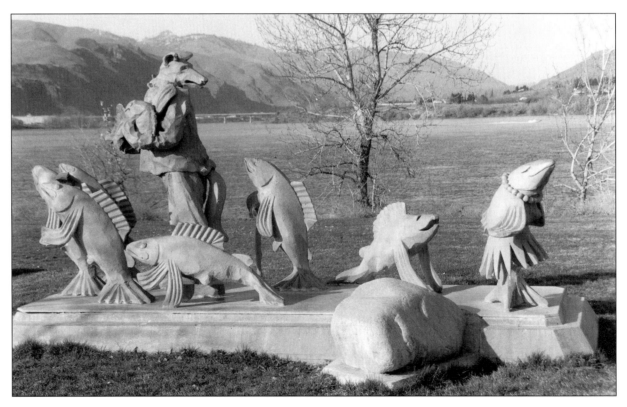

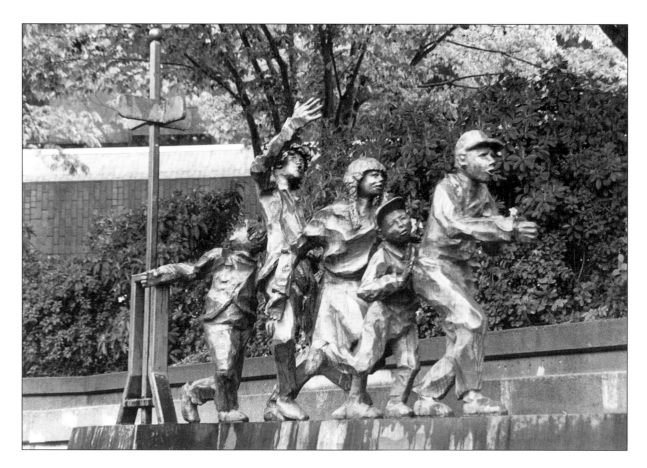

■ *Children Playing Train at the Switch*
Marie Hanak

■ *Children Playing Train at the Switch*, 1991
Auburn City Hall
25 W. Main St., Auburn, WA
bronze

In this composition, the railroad switch is the provocative symbol. It has inspired a line of children to joyously play train. The sculpture commemorates the history of Auburn as a main rail junction between Seattle and Tacoma. By the end of the 19th century, Auburn also was on a main transcontinental route to Puget Sound, connecting rail traffic to the eastern part of the state.

The last child in line is playing the caboose. He appears to ask, "Are we going the right way?"

The yard switch in the sculpture also represents the decision-making that will affect children's lives in future years. Rich would have them grow up well adjusted and responsible individuals in a sane and peaceful world.

Our own grandchildren were models for the five children in bronze. They cooperatively walked along railings for us, while Rich sketched and I took photographs of them.

■ *Climbing to Advantage*, 1991
Forum Hotel Lobby
International Hotels
Chicago, IL
steel

This artwork has been removed and is not pictured here. It consisted of eight cutout figures in steel, brightly painted, and mounted on two vertical I-beams.

■ *Fish Swimming over Old Pateros*, 1991
Pateros School
Pateros, WA
cast aluminum (by Rich Beyer and Margaret Ouinn Grant)

This sculpture is a good example of what can be done by a community with guidance from an artist who visualizes the end result. When Rich speaks of artist initiated public sculpture, he means just that. In this case, Rich had been impressed by the grief shown by a few older people in Pateros over the loss of the original town when Wells Dam flooded the upriver area in 1967.

When we moved to Pateros, twenty-one years after the riverfront town was inundated, local residents who had fought against the construction of the hydroelectric dam still were bitter that their cause was lost. They were sad that a generation did not know old Pateros, with its tree lined streets, the old hotel, and moorage for sternwheelers. They also grieved that their loss was easily forgotten by many. In recognition of this, and to keep the story of the drowned town alive, Rich proposed a sculpture in front of the Pateros School to commemorate the flooding.

The sculpture depicts fish swimming in a circular swarm over little buildings. A large frog, made by artist Steve Love from the Methow Valley, crawls out between two of the buildings. School children dug the pit for the sculpture's footing; Rich suggested that they put a "time capsule" in the hole before the sculpture was placed there. Some of the items that were offered, and which now are buried at the site, include a 1990-91 school budget, a Teen-age Mutant Ninja Turtle doll, a plastic Big Mac hamburger, a DARE emblem, and a poem by (then) 90-year-old Harold Otto, the city's unofficial poet laureate.

The sculpture was paid for by citizen donations. Rich contributed his time and the use of his facilities, and was aided by an assistant, Margaret Grant. The Pateros School Board and Superintendent Gary Patterson organized the fund raising.

Margaret Grant is a sculptress who earned her degree at the University of Chicago. Her senior year was spent at the Beyer Foundry, learning the skills of cutting styrofoam on a band saw, and casting and welding. She produced her senior project under Rich's guidance, part of which included casting aluminum fish. Rich noted her steady hand, and asked her to make the fish for the Pateros school sculpture. She willingly did so, and also gave a demonstration to the first grade class. She was able to show the children how a sculptor sees a subject within the raw material (in this case, styrofoam).

She cut each child a fish of his or her own, with styrofoam "swimming through the saw," Rich said.

The fifth grade class helped plan the placement of the fish in the composition.

Margaret said: "Once the kids watch the creative process it really opens up their experience. The children see that art is not only created by people in far-away cities, but by people in their own town, and that they can watch and participate in the process. The construction of the school's statue is something that will stick with the kids."

A score of community volunteers also donated time and materials to place the sculpture permanently on the school lawn.

According to Rich: "I see this work as an affirmation of community values. As I told the kids [who helped on the sculpture], people who make art don't make bombs."

■ *The Story of Reynard the Fox*, 1993
Bellevue Regional Library
110th Ave. N.E. at 10th, Bellevue, WA
bas-relief panels in aluminum

A sculpture depicting a well-known story passed from one generation to the next by word of mouth is especially fitting for a library. The legend of Reynard the Fox dates back to Charlemagne's rule in France (768-814 AD). In 1794, a version of the story was written down by the famous German author, Johann Wolfgang von Goethe.

Rich has illustrated this story on the south entry wall of the Bellevue Regional Library. It consists of about two-dozen sections of aluminum bas-relief plaques, each depicting a part of the fox's tale. This is hardly a children's bedtime story. Goethe, as a lawyer at the imperial court of justice at Wetzlar, undoubtedly saw a misuse of politics and power that was all too similar to events of a thousand years earlier in Charlemagne's time.

In 1993, Rich recognized that the story still rang true as a satire on our justice system. Rich included a plaque at the base of the panels, presenting his synopsis of Goethe's poem, *Reineke Fuchs:*

"Meeting on the Rhine, as young animals, the wolf in seminary school, the fox looking for his liking, the fox and the wolf make a compact to raid through the coun-

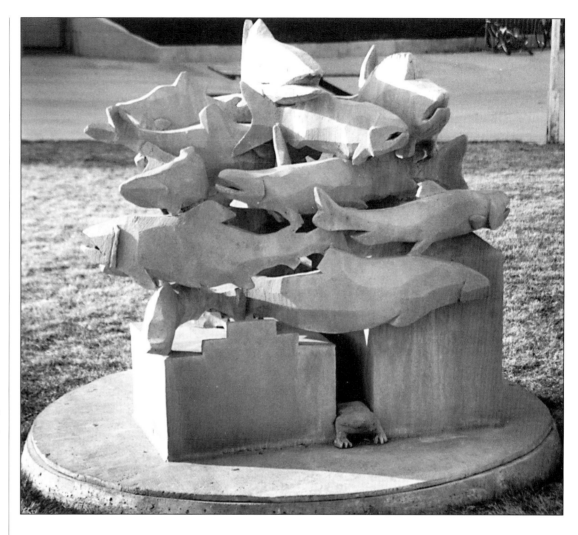

tryside, allying the fox's cunning with the wolf's strength—fraud and force.

"The fox cooks up the schemes but the wolf takes the plunder and the thieves in time fall out. The wolf becomes a great lord at the court, and the fox becomes an outlaw, harassing his fellow animals but particularly the wolf and his retainers, the cat and bear. The forest is becoming an anarchy, and the lion calls a council of the

■ *Fish Swimming over Old Pateros*
Marie Hanak

87

The Story of Reynard the Fox
Marie Hanak photos

animals to deal with the disorder. The fox does not attend, and first the bear, and then the cat are dispatched to fetch him, but return badly used and empty handed.

"The badger persuades the fox to appear at the court to defend himself. On the road the fox, concerned for the outcome at the court, asks the badger to hear his confession. They meet chickens with a board on which they carry the dead wife of the rooster, lamenting the fox's murder of her. The fox and badger scatter the chickens and eat their kill in the culvert.

"The fox is tried. The crow, the rabbit, the goat, the dog, and who you will, tell of his depredations. Despite the contradictory testimony of his partisans to his good character and his victims' stupidity, the fox is sentenced to be hanged.

"On the gallows he accuses his enemies the wolf, the cat and bear of treason, and the king, his greed wetted by the fox's story of sequestered treasure, incarcerates the wolf and bear and appoints the fox prime minister. The fox asks the king for allowance to go to Rome to atone for having turned the wolf to evil ways years ago, leaves the court, and contemptuously sends back the head of the good fellow, the rabbit, who had accompanied him the first mile of the pilgrimage and whom he and his wife and children have made a meal of.

"The fox, disguising himself as a French musician, goads the wolf by seducing his wife and battering his little children, and the wolf in the face of the king's incapacity to restrain the fox's rascality, takes it upon himself to end it, and challenges the fox to mortal combat. The wolf is trashed, and the fox taking a percentage of the bets that have been placed on the outcome of the battle, returns to his castle to fortify it against the next attempt on his life and property by his ubiquitous enemies.

"This story has no moral, this story has no end."

■ *Columbus (Four Images of the Man)*, 1993
Riverwalk Park
Columbus, GA
bronze

In Columbus, Georgia, planners for the city's Riverwalk Park wanted Christopher Columbus as the focus of a major sculpture, but they also requested a fresh, new approach to this oft depicted subject. A Los Angeles art consultant recommended 75 artists to the planners. Rich's proposal was selected.

In these four larger-than-life bronze postures of Columbus, Rich has depicted a spectrum of emotions. As one approaches through the park's entrance arch, a young Columbus is the first figure fully seen. He faces south down the Chattahoochee River, with his gaze to the sky. Here is the visionary. He is above the others, kneeling on a rectilinear form, like a pier. One of Rich's techniques of design is combining geometric shapes with organic ones; the plinth on which Columbus kneels does not have equal angles and thus causes an unsettling feeling when viewed. The vigor and youthful strength of this young sailor-pirate are conveyed in his kneeling pose. But Columbus was also pragmatic; he dressed up for his appearance at the Spanish court, spoke carefully with assurance, and pleaded for funds to carry out his explorations.

In the second figure, Columbus faces the river. His hands show that he speaks of the world as small and round.

Next, as the adventurer, Columbus is conceived as a mature man with the backing of power and authority; his elated confidence barely beaten back by awe as he steps out into the "New World." His splendid cape furls around him.

In the fourth aspect of Columbus, the viewer discovers a prisoner in disgrace and, by Rich's design, facing the park wall. Although the Queen of Spain gave Columbus the title Admiral of the Ocean Seas, he returned to Spain in chains. Rich shows the man sitting, bent beneath the chains of degradation and futility, with his attentive parrot going unnoticed.

Rich characteristically uses mammals, reptiles, and birds to enhance human expressions. Columbus' accompanying parrot in the sculpture is the symbol of his discovery. The flurry of the two flying parrots (in the first and third figures) enacts excitement. They also heighten the sculpture and open an inner axis that recalls the strong, stable verticality of a mast as a vessel courses the ocean. The design's dramatic action anticipates motion much like that in a closely choreographed dance. It is a bold design and a bold telling of the Columbus story. This sculpture was commissioned and paid for by Elena Amos, the wife of the late John Amos, founder of American Family Life Assurance, Inc. (AFLAC). A large fund also was given for the construction of the riverwalk and plaza areas.

Rich noted: "Columbus is not the triumphant figure he used to be—these heroes of the last century aren't heroes any more."

He said he wanted his sculpture "to tell the story of Columbus as a human being. Columbus had a vision, something he fought for most of his life, and realized it—only to discover that realization was different than he had anticipated. That is something all people can relate to. It's the story, really, of all our experience, as I see it."

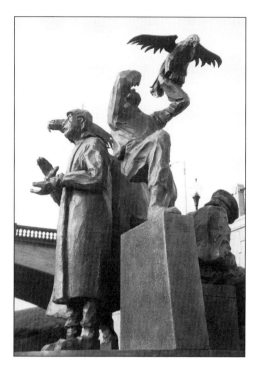

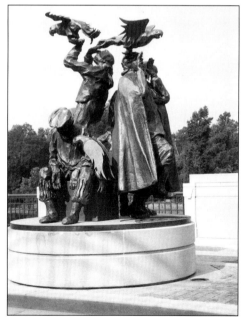

■ *I Knew It Was Coming*

■ *I Knew It Was Coming*, 1994
Antioch, CA
cast aluminum

In the fall of 1993, the Cultural and Arts Commission of the City of Antioch, California, asked Rich to visit their town to talk about placing a sculpture in a new residential section. The City of Antioch requires builders to provide open and green spaces, and sculptures, in new housing additions. The city's Cultural and Arts Commission selected the sites and sculptures to be commissioned.

I attended Rich's interview, as is our custom, because it has been useful for Rich to have another set of impressions. Over lunch, we discussed the project with members of the committee. Both of our recollections were positive, and one lady in particular impressed us.

She had lived in Antioch for about thirty years and dealt in real estate.

She loved her town, and with mixed feelings stated more than once in the conversation: "I knew it was coming. I knew it was coming!"

She described the wheat fields on which the new development would be built, the former tomato agriculture, the canneries which used to be on the Sacramento River, and the recent overflow of San Francisco residents who were looking for affordable housing. The Antioch development would be connected with San Francisco via the Bay Area Rail Transit. And she reiterated: "I knew it was coming."

Rich's sculpture gives the same words to the old farmer, who sits in his wagon gesturing toward the dramatic changes in the landscape.

■ *Students Playing 4D Tic Tac Toe*, 1994
Whitman College
Walla Walla, WA
cast aluminum

Whitman College's Class of 1954 commissioned Rich to create a sculpture as a gift to the college at their fortieth reunion, April 30, 1994.

Rich believes, "artwork should be a vehicle for meaning, directed to the mind, or it should be a way of exciting emotions. It should reincarnate some aspect of human feelings that people can enjoy and relate to."

The Class of '54 had suggested that the sculpture reflect not just intellectual experiences, but also the physical and playful aspects of college life. The sculpture depicts two students, a male and female, playing a game titled "4D Tic Tac Toe." While in intense concentration, they also play "footsy." As is typical for most of Rich's large sculptures, this one consists of aluminum cast from a styrofoam model.

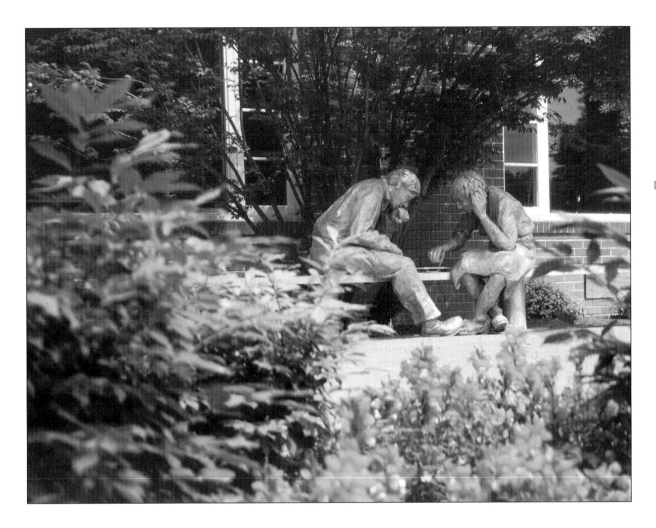

■ *Students Playing 4D Tic Tac Toe*

Rich said of the sculpture: "My work shows an interaction between figures that provides a stage for real life. I wanted something that the students could dress up, something that encouraged community creativity. I hope we have cooked up a game board that is proactive and promotes discussion."

During the design stage, Rich talked with a number of friends, trying to define 4D, or the fourth dimension, and how it could be put it into a game. What is the fourth dimension, anyhow? A paradox? A mirror image of life? The discussions seem to have settled on a definition that it was "an unknown element integral to being alive."

Rich explained the mathematical concept of the fourth dimension by saying we are looking at the figure from both inside and outside, as if it were afloat in the space of the mind. Although the sculpture centers on intellectual curiosity, it also is human and spontaneous—the couple appear ready to make the next move.

■ *The Big Catch*, 1994
City of Des Moines Park
218 Marine View Dr., Des Moines, WA
bronze

The legend of *The Big Catch*—Long ago, a beautiful young maiden fell in love with a handsome fisherman. To her dismay, the Wicked Witch of Puget Sound fell in love with him, too. The Wicked Witch cast a spell and turned the maiden into a fish. For years, the sad fisherman searched the waters of the Sound looking for his maiden, to no avail. One day while fishing at the Des Moines pier, he saw a big fish in his net. He knew it was his love. He pulled her up, kissed her, and she was transformed back into a beautiful maiden. They were married and lived happily ever after.

The legend, concocted to explain mammary glands on the fish, was printed on the dedication program by a helpful, if somewhat defensive, administrator. Initially, Rich declined to talk to the press about why the big fish had breasts, and perhaps that is why a whirlwind of bad and good opinions about the sculpture were sought out by the media.

Some of the fleeting negative comments they solicited included: "It's strange, it's a guy hitting on a fish."

Also, "It's disgusting, it's obscene."

On the favorable side: "It's cute, it's whimsical."

Also, "It's okay, after all this is the '90's: everything goes."

The Chamber of Commerce president said two or three people called his office after they had learned about the sexual nature of the fish.

Meanwhile, Rich said: "Precisely the point; every living being is sexual, and people would lead happier, more productive lives if they got beyond that fact."

More than a year before the sculpture was installed, Don Hannula, editorial columnist for *The Seattle Times,* wrote at length about the controversy on September 16, 1993:

"THE FISH-BREAST FLAP; MUCH ADO ABOUT NOTHING. To kiss a fish, that is the question; whether 'tis nobler in the mind to suffer the hooks and lures of outrageous fortune or to lay a smacker on a coho.

"That in the beginning, was what troubled the city fathers and mothers of Des Moines, Washington. Not Iowa. Iowa doesn't give a hoot about fish kissing. Maybe corn smooching. The Des Moines City Council commissioned Richard Beyer to do a sculpture for a new city park. He is the father of Fremont's beloved *Waiting for the Interurban* and creator of wonderful sculptures throughout our state . . . I love his stuff.

"Beyer unveiled a drawing he called 'The Big Catch,' an engagingly whimsical man dancing with what appears to be a salmon. They are dancing cheek to cheek. It appeared to some council members that the man was kissing the fish. For some strange reason, that bothered them. Kinky minds think kinky thoughts.

"Whether or not the man was kissing the fish is irrelevant. I want to go on record that I've never kissed a fish. But lots of people do. In Alaska, commercial fishermen kiss the first fish. It is not because of long, lonely nights in the north. It is for good luck, hoping it will multiply their bounty.

"When first questioned about kissing a fish, Beyer said the statue is intended to celebrate the cooperation between man and nature and the fisherman is reacting 'just in pleasure.'

"The City Council asked Beyer to show them an alternative to his original drawing. He produced a mean-looking father holding a beer can, a tough-looking mother and a son sitting in a tub with a crab or lobster, or something like that. It made the first option look great.

"So, *The Big Catch* was commissioned for $27,950, including tax. It's worth every penny of it, with the possible exception of the tax. The bronze sculpture will be about six feet tall and ready for the opening of a new park near this time next year. But now that a model has been completed 'The Big Catch' has touched off another controversy.

"The day before yesterday, John H. Stevens of *The Times* south bureau wrote: 'This fish is female, but you won't know it unless you squat down and look up through the fish's fins, where you'll see a set of human female breasts.'

"Oh oh. The story set the phones ringing in the Des Moines Chamber of Commerce, according to Executive Director, Donna Hake, no relation to the fish of the same name.

"Beyer was reluctant to talk about why he's putting breasts on fish. 'You'd get the whole women's movement after me . . . ,' he told Stevens. I couldn't reach Beyer to elaborate.

"He isn't the first artist to put breasts on fish. Copenhagen's *The Little Mermaid* attests to that. But salmon aren't mermaids. And I'm not sure whether or not mermaids are fish. I've never caught one.

"Once before, Beyer caused a similar stir with his anatomically correct bull on a bench in Ellensburg. He seems to be gender-specifically balanced in the rare instances he tends to offend some.

"Like Beyer's Auburn sculpture, *Children Playing Train at the Switch,* or Renton's *Donkey Runaway from the Mines,* the Des Moines sculpture has a joyous quality.

"When I first heard about Beyer's bosomed fish, I thought it was tacky and a gimmick not needed by such a fine artist. But it is a subtle addition hidden by fins. It would take a voyeur crouching and searching to find offense.

■ *The Big Catch*
Marie Hanak

"'If no one had ever pointed out the fish had breasts, no one would have noticed,' Hake said. 'It is not a buxom fish. It's hardly noticeable.'

"Don't lose sleep over this art flap. It shouldn't be blown out of proportion. It is a tempest in a crab pot."

■ The Farmers

■ The Peace Wolf

■ *The Farmers*, 1994
Quality Foods Centers, Inc. (QFC)
Near 2780 78ᵗʰ Ave. S.E., Mercer Island, WA
cast aluminum

The middle-aged couple stand on a corner of a T-shaped intersection on Mercer Island. The corporate commission for Rich's sculpture came from Quality Foods Centers (QFC) for their new Mercer Island grocery store. Two of Rich's sculptures already stood at the other two corners of the T-shaped intersection—*Growing Up* and *Boy and the Alligator.*

The Farmers are a Mercer Island couple who have prospered in the post World War II period of residential expansion on Mercer Island. They have raised their family on the island, supported schools, commuted daily to Seattle for forty years to professional jobs, and now rest and relax in retirement. Their avocation is gardening, and they have learned about the intrinsic value of the land, following the sun and the seasons, which nurtures their souls.

A local journalist in our home area where the sculpture was cast viewed the sculpture as a tribute to farmers, extolling their ability to produce the food that feeds the world.

The QFC's representative said: "The concept of raising fresh vegetables is in agreement with a grocery store."

■ *The Peace Wolf*, 1994
Privately owned
Seattle, WA
bronze

The first *Peace Wolf* was created in circa 1963 and carved from western red cedar. In 1994, a new sculpture was cast in bronze from the original wood sculpture.

■ *Coyote Telling the Story of Saddle Mountain to the School of Fish*, 1994
Lincoln Elementary School
Intersection of Methow and Marr, Wenatchee, WA
cast aluminum

This sculpture is a memorial to Frances G. Evans who taught at Wenatchee's Lincoln Elementary School for over twenty years before retiring in 1968. She died in December 1993. Her nephew and niece gave her bequest of $5,000 to the Lincoln School. The administration took little time to decide how to spend the money—not on computers, not on supplies or repairs, but on a sculpture.

"Coyote and the School of Fish will tie the school's past, present, and future with Saddle Rock," Principal Madalyn Mincks said. "This is a heart warming opportunity for all of us. It's a way to tie our past to right now and have something in perpetuity."

The sculpture group consists of a man sized coyote crouching amongst a school of fish. The coyote is pointing to Saddle Rock, located on a high ridge to the west of Wenatchee. Bill Layman, a parent at Lincoln and a collector of Native American lore, tells a story of "What Coyote Is Telling the School of Fish." It is the tale of Black Bear and Grizzly Bear who quarreled and competed so ferociously that Coyote put a stop to it by changing them into rock. It is an adaptation of a legend that Celia Ann Dicks of the Wenatchee tribe told her friend:

"In the early days the two large rocks and the small ones scattered around them at the place we now call Saddle Rock were two large bears and their children. They were Black Bear (*Smee ha*) and Grizzly Bear (*Stum tam el*) and they spent most of their time quarreling while the children played.

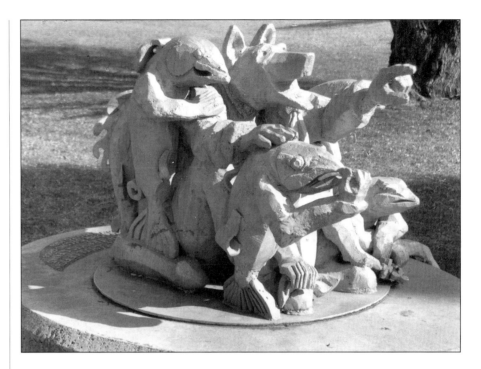

"Grizzly Bear was upset and jealous with Black Bear's ways. Black Bear asked Camas plant's permission before digging the roots carefully from the ground while Grizzly tromped on them without regard. Black Bear, too, served tasty meals for the family. Black Bear made nice clothes for everyone and never failed to help the children. Grizzly Bear had none of these traits. Grizzly Bear was grouchy and always suspicious. Grizzly Bear complained about everything and grumped around all day bothering the Animal People, constantly fighting and growling, particularly at Black Bear. Black Bear would growl right back at Grizzly, and Black Bear seemed always to be a jump ahead of Grizzly. Black Bear got up as soon as Light reached the sky. From the top of the mountain, Black Bear would take the belt of her digging pouch and throw it across the Columbia River *(Swa swa netqua)* near the rapids at

■ *Coyote Telling the Story of Saddle Mountain to the School of Fish*
Marie Hanak

Rock Island. In this way the belt became a bridge to get Black Bear across to Badger Mountain. By the time Grizzly woke up, Black Bear would already be on the other side of the river. This made Grizzly very angry and Grizzly would run down the mountain to catch up. When Grizzly came to the river, the bridge would be gone, as Black Bear by this time would have the belt back on. Grizzly would have no choice but to travel further downriver to find a safe place to cross *Swa swa netqua.* This made Grizzly angrier yet.

"Grizzly growled real loud at Black Bear and Black Bear growled right back. Grizzly then began tearing trees from the ground and throwing them around. This was not good. The trees did not like this for their place was to provide roosts for eagles and homes for the little ones. The young salmon looked up at the raging bear from their homes in the eddies. Their teacher calmly explained that Grizzly was having another terrible, horrible, no good, very bad day and told them they must learn to solve conflict without resorting to tantrums. The school of fish thought Grizzly Bear looked rather silly up there on the bank being so unruly and grumbly.

"One day Black Bear went to dig camas root. Grizzly spent that whole day in a very bad mood. Grizzly was so worried and upset about Black Bear finding more camas that all the Grizzly could do was chase Black Bear away from the good areas and spy and grouch instead of dig. When evening came Grizzly had nothing in the root baskets. Realizing this, Grizzly ran madly about digging large gaping ugly holes in the ground in search of enough roots to take home. Soon the camas lands were a big mess. Grizzly's ransacking tore those roots all up breaking the tender camas bulbs in half, leaving things terribly damaged and scattered about. Camas suffered. They knew they would have a harder time next year, and others might starve. When Grizzly returned home to feed the family, nobody would eat because the camas was not dug up in the proper way.

"Black Bear brought real good food home that night. The camas roots were all clean, whole and steaming hot. Ummm, Black Bear's family enjoyed that meal. This of course got Grizzly going into another rage and Grizzly started growling at Black Bear and Black Bear growled right back. This happened again and again. The quarreling between the two of those bears got so bad that Coyote wanted to put a stop to it. He called on Polar Bear, a peer mediator, but it seemed that Polar Bear had been called up North to attend a feast with some seals. One day, in the middle of another fight, Coyote couldn't take it any more so he changed them into rock. That certainly put a stop to the fighting!

"Look up and you can see them today; Grizzly Bear and Black Bear facing off, growling away at one another on top of the mountain. You can see the children, too, standing behind their parents, wondering when this foolishness will stop so they can play four square and wall-ball down at Lincoln Elementary School.

"Postscript: Coyote in turning the bears into stone was, as usual, being shortsighted. Some say he messed things up once again. In the hills above where the two bears lived there grew an extremely rare and beautiful plant with different colored flowers. This plant held power to stop all fighting among the Animal People. If Coyote had used that plant things would have turned out different for us all. What we would see up there today would only be a rounded top where Saddle Rock is today."

At the base of Rich's sculpture, one of the young salmon is holding that flower.

■ *Chelan Bear*, 1994
 Moved monthly amongst Chelan merchants
 Chelan, WA
 cast aluminum

The bear has been through life's changes, as many people have, ending up wiser. He now carries a lantern looking for an honest bear. Some say this Beyer bear has a lecherous look.

It originally was proposed for the Metro building in Anchorage, Alaska (where the *Lunch Break* sculpture, described earlier, was placed in 1986). The casting model was done in styrofoam, pictures of which were sent to the Anchorage art committee for approval. The committee, however, concluded that the bear appeared too threatening. Consequently, the bear chosen for *Lunch Break* is in a horizontal posture, at the same level as the bus driver who is sitting and eating a sandwich.

The second appearance of this design was in a sculpture show in Green Valley, Nevada, near Las Vegas. Rich was invited to show two pieces. One was this standing bear, which he cast in aluminum, fixing a window box under an upraised paw. It was titled *Bear Looking in a Cabin Window*. When we arrived at the show, we planted bright flowers in the window box. We thought it was just right.

However, the curator of the show, a young woman in a diaphanous green silk gown, was offended by the way the bear's lower paw hung at the front-center of the figure. She solved her problem by setting the bear behind a fork in the trunk of a slender tree. In her eyes, this moved the focal point of the sculpture to the bear's upper body as he peered out over the flower box.

In its third appearance, the bear stood in our front yard in Pateros, with the flower box removed and the arm changed in posture as if to shake hands. Our sculptor friend, Joan Rudd from Seattle, brought us a

■ *Chelan Bear*
Marie Hanak

fine rusty old train lantern, which immediately was given to the bear to hold.

At its final location in Chelan, even more creativity came into play. The Wapato Gallery owner, Gene Barkley, had the brilliant idea of having the Chelan Chamber of Commerce buy the bear, and rent it out to merchants on a monthly basis for a continuing income for the chamber. The idea took hold, and Rich cast the lantern in aluminum and welded it to the paw for security. When in Chelan, you will find the wise old bear somewhere in the commercial district looking for an honest bear.

■ *The Llama*, 1994
Threshold Housing
End of 170th St., off 108th S.E., Renton, WA
cast aluminum

■ *Joe Billy Sloan*, 1995
Columbia River
Near Pateros, WA
cast aluminum

A private corporation contracted with the City of Seattle to build a low cost housing development in this part of Renton. The architect wanted an exotic animal for children to play on, so Rich created a llama.

This uncommissioned sculpture was created for fun to preserve a local story. Rich used my mixed breed Pyrenees as a model.

Joe Billy Sloan, the dog that sighted and pointed steelhead at the mouth of the Methow River, achieved fame in the 1970s. A trucker had picked up Joe Billy in Indianapolis and kicked him out in Pateros. He was not a dog of refined habits, and people did not think much of him until he showed a talent for sighting and holding a steelhead on point. He soon was famous, not just locally but even nationally. Fishermen came from all over; the dog was rented out by the hour on their boats. But then one time he slipped on an icy gunwale, and the steelhead got him.

Rich made the image of Joe Billy to keep the story alive and well for posterity. The Pateros City Council approved the idea, and the Public Utility District, the U.S. Fish and Wildlife Service, and the U.S. Army Corps of Engineers permitted its siting on a flat rock near the Columbia River shore, at the site of the old Methow Rapids. It took Rich one year to obtain the necessary government permits.

A short time before installing *Joe Billy Sloan,* one agency questioned the sculpture's effect on boating safety. Wouldn't small boats run into the rock? Shouldn't the sculpture be lit at night? In answer to such unfounded fears, Rich painted Joe Billy Sloan a day-glow orange.

Today, *Joe Billy Sloan* points toward a beaver lodge built by the aquatic animals at one end of the small islet. The sun has faded Joe Billy's bright orange coat.

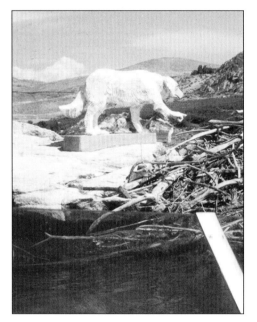

■ *Joe Billy Sloan*
Jane Hensel

■ *The Llama*

Our friends, Jane and Robert Hensel and their son Chris, recently visited the site by boat. Jane sent us the following letter:

"Our son, Chris, and Robert had partially fulfilled Chris' ambition to 'do' the Columbia River last summer when they launched above Grand Coulee Dam and went to the Canadian border. This year [1999] we did the mid section . . .

"Imagine our astonished surprise and great jubilation to see one of your . . . sculptures almost in the middle of the Columbia River near Pateros. Chris could not believe, at first, that it was a sculpture. Robert and I both knew immediately that that dog is one of your wonderful humorous jolts to your fellow man. We loved him . . . The perfect humor of having him pawing toward the beaver house only added to the fun and surprise. We both told Chris you did it all on your own for just such River Rats as we were that very day."

■ *The Carousel*, 1995
Kirkland Library
308 Kirkland Ave., Kirkland, WA
cast aluminum

The donors of *The Carousel,* the Shinstrom family, wished to show gratitude for their three generations of prosperity in the growing town of Kirkland. They asked Rich to emphasize the importance of "family" in a sculpture. *The Carousel* includes a father, mother, and little daughter who have been approached by a ticket taker with outstretched hand to receive their fare. The mother seems apprehensive of the man, shielding her daughter. The father is open faced and patient. The girl is oblivious of the adult drama, and strains eagerly to ride her beautiful pony when the carousel starts moving. The carousel's animals include a lion, a pony, and a wolf running while holding a book in her mouth.

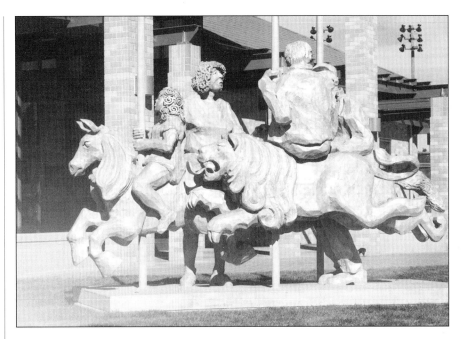

■ *The Carousel*

■ Wood models.

■ *The Precious Jewel*
Al Camp, Okanogan/Omak Chronicle

■ *The Precious Jewel*, 1995
Okanogan/Omak Chronicle
618 Okoma Dr., Omak, WA
polychrome design in concrete
(in cooperation with Gary Headlee, building contractor
and artist)

The *Chronicle*'s wheelchair ramp and mural were dedicated on May 18, 1995, in celebration of the newspaper's 85th anniversary and in honor of the people who would benefit from the ramp—people who are labeled handicapped or disabled, but are in fact dealing with and conquering the special challenges life has dealt to them. The dedication brochure explains the sculpture's tale (at left).

"An old man tells a story:
A man mines the sky
and finds a beautiful blue gem.
Holding it to the light he sees the world anew,
in 4 dimensions.
The governor is asleep,
The banks are closed,
Cattle have moons in their horns,
Children ride flying horses,
Angels fill the trees,
Rocks speak,
Coyotes dress in Wal-mart suits,
The snake pipes and the rabbits dance,
Fish and the wapato dance too.
He gives the stone to his wife to look through,
To see what he is seeing."

■ *Coyote Reading a Candy Wrapper*, 1995
North Central Washington Museum
127 S. Mission St., Wenatchee, WA
cast aluminum

This was Rich's entry to the Art on the Avenues program, first promoted in Wenatchee in 1994-95. The program seeks artists who are willing to show public sculptures on the streets of Wenatchee for one year. Toward the end of the year, members of the community are asked to vote for their favorite; the Wenatchee Arts Commission then arranges with the city to buy the most popular sculpture. Rich's coyote won the most votes and was bought the first year. The piece sits on the steps of the North Central Washington Museum, where it has become a mascot of the museum.

Rich was impressed by a book of poetry written by Blue Flute, a Native American. Blue Flute wrote about Coyote's adventures in Berkeley, and described Coyote sitting on a curb reading a candy wrapper he picked up from the gutter. Rich obtained a first-edition copy of Blue Flute's book and put it inside the

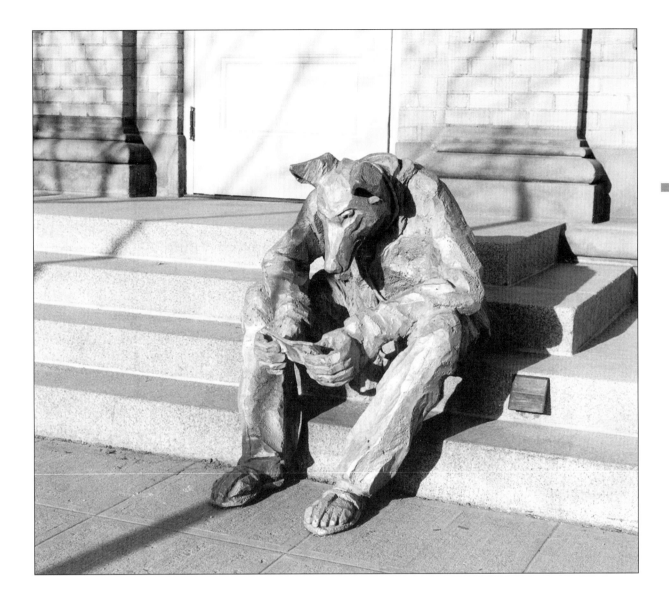

■ *Coyote Reading a Candy Wrapper*
Marie Hanak

hollow figure. Then, Bill Layman of Wenatchee wrote to tell him how Wenatchee had honored him and his book.

Affection for the coyote is widespread—two police officers, for instance, had their pictures taken with the coyote for their "cop cards." The museum uses the image on gift items, such as mugs, tee shirts, and note cards. It is verification of the concept of "the art people love" and a contribution by Rich to the North Central Washington Museum.

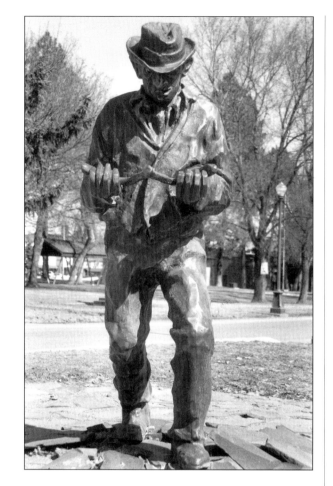

■ *The Dowser*
Marie Hanak

■ *The Dowser*, 1996
Douglas County Museum
On Route 2, west side of town
Waterville, WA
bronze

What is this man doing?

He is searching for water below the ground surface! As he holds a forked stick, most likely willow, he walks back and forth trying to find a likely location for a well to be dug. When the short end of the forked stick pulls downward and points to the ground, that is where there is moving water or an underground stream. Sometimes it is hundreds of feet down. Depth is found by the use of another rod, which also can be willow. The rod is held horizontally straight out from the body by the finger tips over the place where the presence of water has been indicated. The rod will begin to fluctuate up and down. The fluctuations are counted. If there are 50, water will be 50 feet down. If 100 fluctuations, water is 100 feet beneath the surface. This is not completely accurate, but it is found to be so within a few feet of the mark.

Water dowsing is thought to be a gift. It is not a learned art. Most people do not have the gift, and most who do just don't know about it because they haven't searched for water with a wand or divining rod. In the wheat land around Waterville, several dowsers became well known for this gift and some still practice it. Locating water on the plateau is, of course, a necessity. The geological formations of the high, flat plateau give little indication of where water can be found.

Dowsing is an ancient practice. Apparently, it dates to medieval Germany, and the practice spread throughout Europe and to England at the time of Elizabeth I. Later, dowsing was brought to America by settlers.

There is no scientific explanation as yet for this phenomenon, but good sources of water have been found, that fact is undisputed. Waterville pioneers depended on dowsers for well digging. Reportedly, they were successful at least 95 percent of the time. Descendants of pioneers comprised the community group that contributed financially to this sculpture. Over one hundred families donated money and most have written letters to the museum telling their personal stories about dowsers. The community enthusiasm for this project is a source of satisfaction to Rich.

Johnnie Appleseed, 1996
In a private orchard
Manson, WA
cast aluminum

Born in Philadelphia around 1810, Johnnie Appleseed was an American eccentric. As a youth, he was unlucky in love, and after this disappointment he took to the Swedenborg faith as consolation.

The sculpture shows Johnnie striding along with two angels on his shoulders. He believed that if he didn't marry in this life, he would have two wives in the next. The angels sing songs and read to him from the Bible.

Johnnie's life mission was to provide apple seeds for the pioneers. He walked from Pennsylvania to the Ohio Valley, and back again, for many years, carrying a bag of seeds at his side which he had gleaned from cider mills in the East.

Children in a Magic Tree, 1996
River Ridge High School
Lacey, WA
cast aluminum

River Ridge High School runs a successful program for an unusually diverse student population. The school administrators are proud of this and they wanted to emphasize the values of diversity. As they wished it, this sculpture portrays those values as they relate to students. River Ridge is a new school, arranged in independent sections within the larger school community. Each section has its own name, its own commons, and the rooms necessary for a smaller schooling entity. No student can be anonymous. The high school's cafeteria and gym are the only communal spaces used by all of the students.

Rich chose to use the theme of a magic tree, found

in Plains Indian lore and recorded in John G. Neihardt's book *Black Elk Speaks*, published in 1932. In the book, there also is mention of a magic plant used medicinally by early Native Americans; the flowers on it are each of a different color. Rich's first model had flowers configured in a sort of cup shape. He was informed by the security guard, who was on the art committee, that the flowers looked too much like peyote buttons, so Rich changed them to fortune cookie shapes. This works well because high school students are seeking "fortunes," are they not?

The students in the sculpture are teenagers, helping each other climb into the tree to enjoy magical fruit.

Johnnie Appleseed
Marie Hanak

Children in a Magic Tree

103

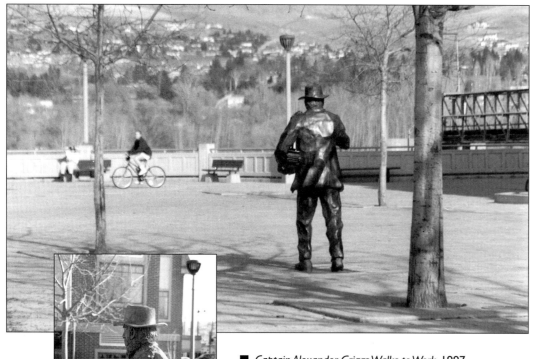

"thumbs up" sign to passers-by, indicating that today is a fine day for taking steamboats upriver through the Columbia's many rapids.

The project was sponsored by the North Central Washington Museum, but ran into opposition from the Wenatchee Arts Commission. After seeing the proposed model, their subcommittee determined it lacked "artistic merit." The arts commission members further declared that without their approval the statue could not be placed on city property. At the same time, not wanting to squelch the idea completely, they invited Bill Layman and Rich to submit a revised model at a later date. Twisp artist Cheryl Wrangle volunteered to help. Soon the threesome had produced a second model for the arts commission's consideration. Again, the subcommittee recommended that the city not accept the statue; in their view, it *still* lacked artistic merit. Clearly, underlying issues were at play.

In a tense meeting, the matter finally was resolved when an astute arts commission member asked Layman if the statue was intended to be a piece of art.

"No," Bill said, "we consider this to be an historical commemoration honoring one of Wenatchee's leading citizens."

One could almost feel the collective sigh of relief from the arts commission members. They quickly took a vote to let the museum use a public site for the statue.

The Captain Griggs sculpture illustrates Rich's belief that "place maker" art greatly enhances a community's understanding of itself. As park visitors walk, run, bike, and rollerblade alongside the Columbia, they see the captain heading in a different direction, walking directly toward the old shipyard, now lost to time beneath the impounded waters of Rock Island Dam. It is a walk Captain Griggs made routinely from 1892 to 1903, the year of his death. He carries with him the story of this place.

■ *Captain Alexander Griggs Walks to Work*, 1997
Sternwheeler Park
5th Ave. and Northern, Wenatchee, WA
bronze
(collaborative sculpture: William Layman, Richard Beyer, and Cheryl Wrangle)

This sculpture was inspired by Wenatchee's steamboating history and the colorful character, Captain Griggs. Alexander Griggs came to Wenatchee in 1892 at the request of railroad tycoon James J. Hill to establish sternwheeler service on the Columbia River. Bill Layman, who had worked with Rich on other Wenatchee based sculptures, wanted to give a statue of Griggs to the city as his 50th birthday present to himself. He asked Rich to "ghost" the sculpture with him. Bill raised the money for the production. He took up tools in Rich's shop, and Rich helped him make it happen. Cast in bronze, Captain Griggs carries a model of the *Selkirk* and gives a

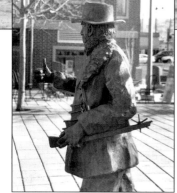

■ *Captain Alexander Griggs Walks to Work*
Marie Hanak photos

At the dedication, July 4, 1997, Rich spoke to the gathering about art. In part he said: "Art is one profession amongst others in a society organized by professions. It is concerned with the long term; with the expression of the values that shape our day to day activity. It seeks on the one hand to express the values that give us individual identity and on the other the values that create relationships.

"We think of art predominantly as the former activity, but this sculpture points to art as a service in the latter enterprise. Both have their ways of becoming: Individualistic art emerges from the schools and museum and recently has come to enjoy government subsidy. Community art has 'gone it' on its own.

"Public art and Art in public places are not the same thing. Though both have estimable value, the one is challenging us on the frontiers of the universal, the other is telling us who we are, where we are. It is regional and particular. We show it to our friends to tell them about ourselves. It affirms experience and community pride. Art as service in the community contrasts to the art of the ideology of patronage."

■ *Kitt Coyote*, 1998
Ellensburg Library
209 N. Ruby St., Ellensburg, WA
cast aluminum

This blended human-coyote figure has lost interest in reading a book as he leans against the library wall. The focal point of his gaze is directed toward the girls going in and out of the library. The sculpture was financed by the community, library, city, the Garden Club, and individuals in the town. The library organized a competition among Ellensburg's children to name the sculpture. "Kitt" is short for Kittitas County.

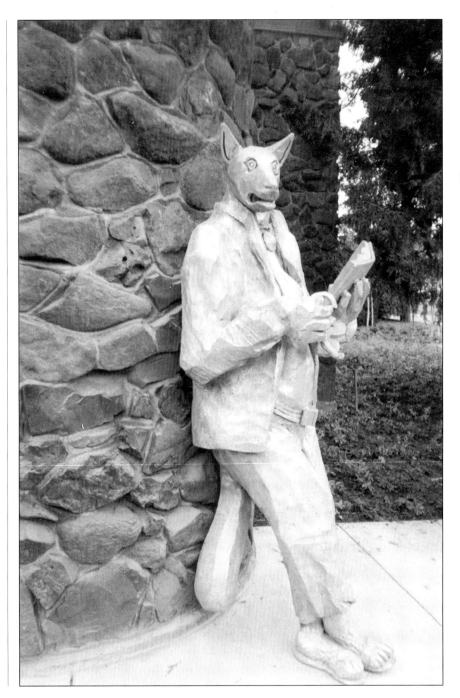

■ *Kitt Coyote*
Sidney Moe

 Children Playing
Liz Miller

■ *Children Playing*, 1998
Coulee Community Hospital
Grand Coulee, WA
cast aluminum

This sculpture of children hopping, skipping, and jumping stands in front of a rural hospital adding a touch of cheerfulness. The youngsters comprising the group are reminiscent to me of our grandchildren when they were small. The tower of figures reflects another of Rich's experiments in the totem pole form so dramatically developed in Northwest Indian art. An earlier example was Rich's *Life, Love, Time, Game* in the former Soviet Union.

A county lawyer in the little town of Grand Coulee liked the sculpture and purchased it. He was a long-time trustee of the hospital, his children had been born there, his wife had passed away there, and a son was now a doctor in its service. The sculpture's placement is in every way an affirmation of how artists have made significant contributions to community life over the years.

■ *Old Man with Birds in His Beard*, 1998
Puyallup Senior Center
212 W. Pioneer Ave., Puyallup, WA
cast aluminum

This old man is proud of the beard he has grown and tries to catch birds in it which represent good memories. One of the birds is in his pants pocket. In this regard, Rich likes to recite the following poem:

"Jenny kissed me when we met,
 Jumping from the chair she sat in.
 Time, you thief, who loves to get
 Sweets in your list, put that in.
 Say I'm tired, say I'm old,
 Say that health and wealth have missed me,
 But add, Jenny kissed me."

Puyallup fondly remembers the town founder, Ezra Meeker, who had a long beard. There is a little statue of him in the community's Pioneer Park. This was Rich's theme in creating the *Old Man with Birds in His Beard*. Today, however, people in Puyallup associate Rich's sculpture with a retired doctor, who for awhile drove around town in a red convertible sporting a similar beard. The doctor was a benefactor to the community's children in many ways—even endowing a Children's Museum. Thus, Rich's Ezra became an expression of Puyallup's gratitude for the doctor's good will, care, and generosity. It is not unusual for Rich to create a design for his own reasons, and then find that it has another significant meaning in other people's eyes.

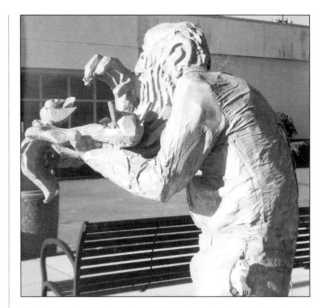

■ *Old Man with Birds in His Beard*

■ *The Fisherman*, 1999
City of Kirkland
Waverly Way at 6th St. S.W., Kirkland, WA
cast aluminum

Richard Shinstrom and his wife, Pat, received many compliments after donating *The Carousel* to the City of Kirkland in 1995. In further appreciation of their gratitude to the community, they commissioned another sculpture by Rich. When Dick Shinstrom was a boy, Lake Washington had great summer runs of silver salmon in its waters. Dick often went fishing at those times, launching from a dock in Waverly Park. He proposed the placement of a "fisherman" statue at the street intersection above the park. The finished sculpture portrays a multitude of circling salmon, while the fisherman in the boat holds up a great fish he has caught for all to see, and to share in the "good times passing."

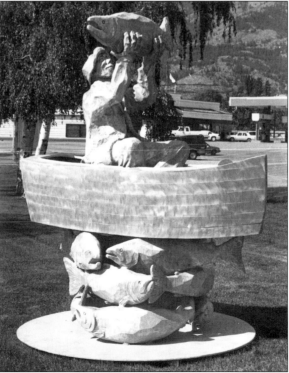

■ The Fisherman

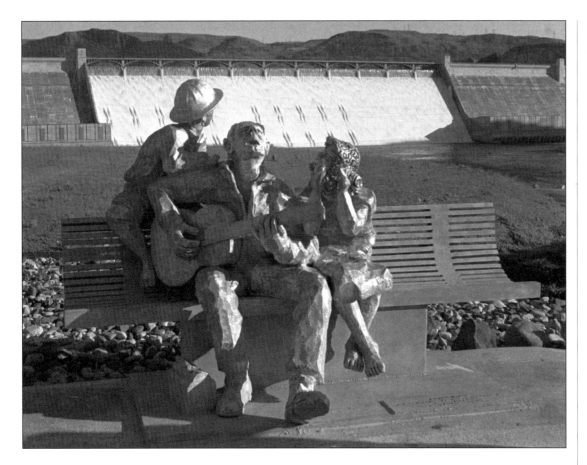

■ *After Work*
Scott Hunter, Grand Coulee Star

■ *After Work*, 1999
Park overlooking Grand Coulee Dam, WA
Grand Coulee, WA
cast aluminum

"The 8th Wonder of the World" is what the American folksinger Woody Guthrie called Grand Coulee Dam. The laborers who built the huge concrete structure in the 1930s and 1940s had come from far and wide, arriving singly or with their families. After the dam was built, some stayed on in the towns that had sprouted from the desert. A number of them later became businessmen or local government officials. The former

mayor of the town of Coulee Dam had attended the local high school when the dam was being constructed. For years, he had a vision of dedicating a sculpture to the workers he had known back then. He solicited funds from the high school's alumni, since scattered across the nation, and enlisted the Chamber of Commerce to have a sculpture made.

Rich was asked to come up with a design showing a dam worker reflecting on the significant contributions that his own hands had made in constructing the great dam.

In this sculpture, the worker's son has put on his father's hat and looks in awe at his father's handiwork. The daughter, too, claps her hands with delight as she sees her father's vision. The man might be singing a well loved Guthrie song about the river:

"She tore men's boats to splinters
But she gave men dreams to dream
Of the day the Great Grand Coulee
Would cross that wild and wasted stream.

"Roll on, Columbia roll on . . ."

When Rich was growing up in the 1930s, his father worked for the Interior Department, focusing on questions concerning Labor relations in the vast reclamation projects of those hard times. He brought back pictures of the Eastern Washington desert and the great river to the family home in Virginia, and an album of Guthrie's New Deal government propaganda.

At Grand Coulee in 1999, the opportunity had arisen for Rich to embody his feelings in this regard, in sculpture. This facet of American history has shaped the life of the land in which Rich and I now live, just downriver from Grand Coulee Dam.

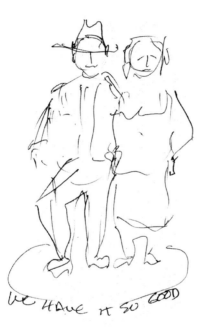

WE HAVE IT SO GOOD

Postcript / A Letter from Lyman Legters

When *The Art People Love* was being written, Rich and I asked Lyman Legters, Professor Emeritus from the University of Washington, to expand upon the subject of government intervention in the art market. Lyman's well organized letter gives the reader a picture of two friends—Lyman and Rich—thinking through a social problem in their own ways. I could find no place to cut it, so I reprint it in its entirety as a postscript to Rich's story:

"Dear Rich,

"One of the better news items of 1998 was the report that Margaret had undertaken to encapsulate your work as an artist in book form. It was, at the same time, immensely flattering to hear that you and she think I might add something to the book. That remains to be seen.

"That assignment has caused me to reflect on the twenty-five years of being near neighbors in Seattle and the subsequent decade of periodic contact after we both left Seattle. I cannot for the life of me recall just when our conversation on the arts began; I know only that it spread over most of that span of years and that it threatens to continue so long as we both draw breath. I suppose it is unlikely that we'll reach any final resolution, still less that we'll persuade anyone else.

"Here I must pause to mention how important that conversation has been for me. Holding strong views about the social role of the arts and about the democratic norms that should govern public subvention of the arts, I yet had only the standing of a concerned citizen with none of the fortification afforded by the experience of creative work in the arts. Even in my own eyes, a citizen's concern had inevitably a shallow and amateurish quality so long as the citizen in question had never painted a picture, composed a musical score, or written a poem. Encountering an artist whose outlook on public issues was at least similar to my own was a refreshing and confidence building experience. In all that I have said and written about the arts and public policy over the years, I have been greatly in your debt for the example and sounding board that you supplied.

"The dialogue we were having with each other seems to have been instrumental in animating two public episodes worth recalling here. One was the Seattle Artworkers Coalition of the 1970s, that little band of dissenters and critics seeking to raise issues of sound policy and legitimate procedure with respect to public support for the arts. I do not mean to suggest that the Coalition was our creature, for Channing, Nancy, Joan, and the others had as much to contribute as we did. But it was you who got me involved. And while it may have been a voice crying in the wilderness, the Coalition did nevertheless raise salient issues and did remind the authorities of the arts establishment

that they were being watched and that their decisions were not self-evidently the correct ones.

"The other, which would not have happened without your intellectual and moral support, was the program on Government and the Arts that I conducted in 1975 under a grant from the Washington Commission for the Humanities. The world has little noted nor long remembered what was said in those six public discussions, but the program was, I still believe, the first critical examination, with extensive citizen participation, of public arts policy in Seattle. And the little red booklet that was my report on the project may yet be consulted by anyone wishing to think seriously about public art ["Government and the Arts, Report of a Public Discussion," Institute for the Study of Contemporary Social Problems, Seattle WA, 1981].

"All of which brings me back to the substance of our shared concerns. We seem always to have accepted the sharp distinction between public and private in both of its dimensions: the private world of the artist at work in studio or workshop versus the artist accepting public largesse in fashioning a work or performance for that public; and the private collector or patron spending his own money on an acquisition versus the public functionary allocating public monies to acquire artwork for consumption by that public. The first artist is not and should not be the object of public scrutiny; and second willingly subjects himself to public accountability and the rules of the game. Similarly, the collector or connoisseur is free to distribute his own funds as he pleases; the public representative—bureaucrat or arts commissioner—is responsible, and should be responsive, to the public whose resources he is allocating. This distinction was of small importance so long as governmental incursions into the art world were limited mainly to the design of coins, stamps, and public monuments. It became crucial the moment official policy decreed that the arts merit public encouragement, most especially when the ensuing programs centered on the purchase of works of art.

"Now one can think of a large number of public programs that would have left the private artist undisturbed in his studio or workshop. A sound public policy might have determined that arts education should be strengthened in our schools or that more facilities should be made available to amateur artists, just as we once decided on the importance of improving mathematics education by means of public support. We might have had a policy and corresponding programs to offset unemployment among artists in their position as a segment of the workforce and the national economy, measures somewhat analogous to governmental bailouts of banks, automobile makers, and municipalities. Any of these could have been justified as encouragement to the arts without significant encroachment on the private world of the artist.

"However, when arts policy at national, state, and local levels took as its principal form the acquisition of artistic products—objects or performances—for the enhancement of public spaces and audiences, the whole relationship between government and the arts became problematical. So much so that many observers, you included if I am not mistaken, at least at times, have wished to reverse policy and remove government from the artistic realm altogether. I would argue—and I think that you have mostly agreed—that the problem is one of democratic implementation. The primary point is not that artists must surrender their freedom to a set of bureaucratic decrees, but rather that those who design and implement governmental programs must surrender their private taste, however enlightened and elevated, to the norm of democratic accountability.

That necessarily alters the position of the artist too, making him accountable as well for the work he elects to perform with public subvention. But in this altered position, he should not become the plaything of arbitrary bureaucratic decision making, but should rather enter into a healthy, balanced relationship with the purveyors of public largesse—healthy and balanced because all parties to the relationship are subordinate to democratic norms.

"Among my favorite examples of such a healthy relationship at work is the installation that I witnessed of your wonderful animal sculptures in Madison Park in Seattle, the work having been commissioned by the immediate community for its neighborhood park. That community is not a government in the way we usually think of government, but it illustrates a healthy relationship regulating the acquisition of public art and could function as a model for governments to emulate.

"Another example would be the acquisition by the Warm Springs Confederation of your handsome router designs and sculptures to grace the resort at Kah Nee Ta. That is a government, albeit a tribal one, and its choice of artist came, as was the case in Madison Park, from the community that was the recipient and 'consumer' of your work.

"By way of contrast, the pattern that has obtained for the most part in the implementation of a national arts policy finds the organs of government, as they try to effectuate their assignment, turning to experts from the private sector. These connoisseurs then acquire the privilege of ratifying their personal taste or fashions of the moment by allocating public funds instead of their own. Citizens may then approve or disapprove of the result—but only after the sculpture has been emplaced or the mural painted. Thus does democracy give way to bureaucratic arbitrariness in its affirmation of the pref-

erences of the arts establishment (collectors, galleries, agents, and that tiny minority of highly successful artists chosen as window dressing on juries and panels).

"Many years ago and in a completely different venue, I was chatting with a linguist about language teaching and its improvement. He cautioned that we should not get hung up on an ideal of perfection but should ask simply, what will improve the situation. If, as I believe, there is a viable and desirable role for government to play in enhancing the position of the arts in our society, it is probably counterproductive to dwell upon an elusive goal of perfection. Far better that we look for ways of improving the situation.

"One problem in this regard is the rather inchoate condition of the profession of artist. When governmental programs are designed to deal with medicine, education, or law, it is all but unthinkable that the corresponding professional associations not be consulted, even though their advice may be ignored. Should an organ of government at any level seek the advice of artists in the design of programs in support of the arts, it is very hard to imagine how an official might establish useful contact with that profession. It is much easier to confer with more organized groups such as arts administrators or with prominent individuals, including noteworthy artists of course, for the simple reason that artists have no professional organization. It is not for me to urge artists to organize themselves, but they should be aware of the need, when dealing with governmental bodies that disburse the public funding, for artists to find a voice of their own and not allow the aforementioned arts establishment to speak unchallenged in their behalf.

"In relations with government agencies, the public too is often voiceless. This is a permanent problem of representative government in what passes for a de-

mocracy. Citizens have the same opportunity, and perhaps obligation as well, to enunciate their interests and concerns about the arts that they have with respect to Social Security or health care. So long as they remain passive, unlike the Warm Springs Confederation or the Madison Park community, it will remain a constant temptation for officials to design and inflict programs with little regard for the wishes of the citizenry. And for their part, officials are not without means to ascertain what the public wants—if they are motivated to use them.

"In short, the three-way relationship involving artist, public, and the mediating organs of government is permanently problematical. Nowhere is this more visible than in the efforts of congressional philistines (and sometimes of equally philistine public constituencies) to impose canons of taste on public art. On the whole, the civil servants who administer public arts programs have avoided the widely feared tendency to dictate in matters of artistic taste—except when their programs are threatened by congressional critics less scrupulous than themselves concerning freedom of expression. We believe that parents should play an active role in schools and educational policy and can, therefore, not completely avoid the threats to intellectual freedom when groups of parents meddle on ideological grounds in the selection of textbooks. Just so, we cannot avoid the possibility that some publics will prefer comic strips to painting of high quality, popular music to chamber music. These are among the inevitable sticking points in any attempt to foster public art. We must

of course struggle constantly to protect freedom of expression—to the point of artistic secession if there is a threat of an official imposition of a particular taste in public art. I believe, and believe that you believe, that public arts programs should be democratic. That too is a struggle and, moreover, one in which popular preferences may often threaten the integrity of the professional artist. That European governments have long pursued programs of public support for the arts, for the most part without stumbling fatally over problems of the sort mentioned above, suggests that we should be able to do so, as well. Meanwhile, we can at least insist that decision making in public arts programs be done with the fullest respect both for the artist and for the art-consuming public.

"I know, Rich, that I have not done justice to all of your concerns in the foregoing remarks. It would take many more pages to summarize all that we have discussed over the years. I am not even sure that you will agree with all that I have said, though I do hope that my recollection is reasonably faithful to our continuing discussion. What I know for sure is that your kind of work belongs in the public arena and that the public has consistently been more receptive to it than has the arts establishment. I wish, not so much for you as for the rest of us, that your work may continue to delight even as you continue to offend the enemies of democracy.

"Sincerely yours,
Lyman H. Legters"

Index